Smoothing the Jew

Smoothing the Jew

Abie the Agent *and Ethnic Caricature in the Progressive Era*

JEFFREY A. MARX

RUTGERS UNIVERSITY PRESS
NEW BRUNSWICK, CAMDEN, AND NEWARK, NEW JERSEY
OXFORD AND LONDON

Rutgers University Press is a department of Rutgers, The State University of New Jersey, one of the leading public research universities in the nation. By publishing worldwide, it furthers the University's mission of dedication to excellence in teaching, scholarship, research, and clinical care.

Library of Congress Cataloging-in-Publication Data

Names: Marx, Jeffrey A., 1953– author.
Title: Smoothing the Jew: "Abie the agent" and ethnic caricature in the progressive era / Jeffrey A. Marx.
Description: New Brunswick: Rutgers University Press, [2024] | Includes bibliographical references and index.
Identifiers: LCCN 2023047800 | ISBN 9781978836341 (paperback) | ISBN 9781978836358 (hardcover) | ISBN 9781978836365 (epub) | ISBN 9781978836372 (pdf)
Subjects: LCSH: Abie the agent (Fictitious character) | Hershfield, Harry, 1885–1974—Characters—Jews. | Hershfield, Harry, 1885–1974—Political and social views. | Jews in comics. | Jewish wit and humor, Pictorial. | Jews—Cultural assimilation—United States—History—19th century. | Jews—Cultural assimilation—United States—History—20th century. | Comic books, strips, etc.—United States—History and criticism. | BISAC: LITERARY CRITICISM / Comics & Graphic Novels | SOCIAL SCIENCE / Popular Culture
Classification: LCC PN6728.A2 H43 2024 | DDC 741.5/697309034—dc23/eng/20231031
LC record available at https://lccn.loc.gov/2023047800

A British Cataloging-in-Publication record for this book is available from the British Library.

Copyright © 2024 by Jeffrey A. Marx

All rights reserved

No part of this book may be reproduced or utilized in any form or by any means, electronic or mechanical, or by any information storage and retrieval system, without written permission from the publisher. Please contact Rutgers University Press, 106 Somerset Street, New Brunswick, NJ 08901. The only exception to this prohibition is "fair use" as defined by U.S. copyright law.

References to internet websites (URLs) were accurate at the time of writing. Neither the author nor Rutgers University Press is responsible for URLs that may have expired or changed since the manuscript was prepared.

♾ The paper used in this publication meets the requirements of the American National Standard for Information Sciences—Permanence of Paper for Printed Library Materials, ANSI Z39.48-1992.

rutgersuniversitypress.org

In memory of my grandfather, William A. Marx, in whose cluttered basement, at the age of seven, I discovered old copies of The Katzenjammer Kids *that started my lifelong love of comics.*

Hath not a Jew eyes? Hath not a Jew hands, organs, dimensions . . . ?
—*Shakespeare,* The Merchant of Venice

Contents

Introduction 1

1 Caricatures and Smoothing Efforts 17

2 Censoring Attempts 46

3 Smoothing Abie 63

4 Becoming American 105

Conclusion 132

Acknowledgments 139
Notes 141
Bibliography 165
Index 189

Smoothing the Jew

Introduction

In M.C. Escher's well-known illustration "Drawing Hands," it is difficult (nay, impossible) to state with certainty which hand has drawn which (figure I.1). This ambiguity expressed by Escher is true of artistic works in general. That is, material culture—paintings, illustrations, sculpture, music, literature, and the like—arises from a particular time and place. The artistic work, though it may be unique, still has not been created ex nihilo. It has been influenced by productions that came before it as well as by political and socioeconomic forces that surrounded its construction and shaped its creator's personal history.[1] At the same time, the artistic work does more than merely reflect the forces that have shaped it; it also may reinforce, challenge, or even transform the culture from whence it arose.

This book is about one hand drawing the other. It explores how a particular moment in time and place—America in the first two decades of the twentieth century—gave rise to and influenced the work of a number of Jewish playwrights, actors, writers, and cartoonists. Specifically, it explores how social, economic, and political forces at that time resulted in a new image of the Jew that appeared on the stage, in short stories, and in cartoons. At the same time, it will also examine how these works, in turn, impacted American culture and influenced the nascent American identity of the newly arrived Eastern European Jewish immigrants. While, accordingly, a number of Jewish artists will be examined, I focus primarily on one artist, Harry Hershfield, and the comic strip that he created, *Abie the Agent*. This was the first (and only) Jewish comic strip to appear in syndicated newspapers throughout America, beginning in 1914 and continuing, almost without interruption, until 1940. In its first seven years, Hershfield drew over two thousand strips, providing a rich resource that reflects American nativist concerns and immigrant hopes from this time.

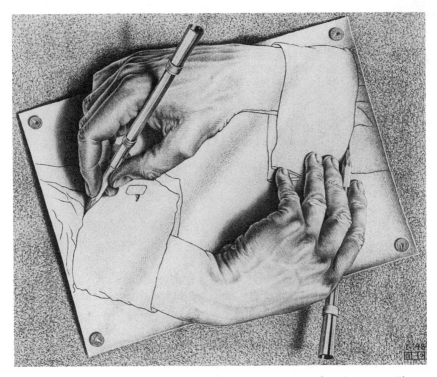

Figure I.1. M.C. Escher's "Drawing Hands" © 2023 The M.C. Escher Company—The Netherlands. All rights reserved. www.mcescher.com.

Comics

Comic strips, as material products of a specific cultural moment, are as worthy of consideration as the "highbrow" arts of literature, poetry, drama, and painting. As one cultural historian noted: "Perhaps the most important facts about people and about societies have always been encoded within the ordinary and the commonplace."[2] Comic strips were a vital part of early twentieth-century culture's intertextuality: stage productions and silent films flowed from comic-strip characters, comic-strip writers appeared on entertainment stages, and magazine short-story illustrators utilized the comic-strip style.[3]

A comic strip is a multi-panel continuity strip containing caricatures with a limited form of narrative, incorporating both text and image, printed so to fill the width of one newspaper page. (When it is a single frame with caricatures, it is a cartoon; when multi-panel strips appear in bound pages, they are defined as comic books.)[4] By the beginning of the twentieth century, newspapers loaded with comic strips appeared in urban centers across America. In New York alone, there were more than 160 different newspapers serving a growing urban population; two million of them were printed each day. Thanks to changes in

INTRODUCTION

print technology—the fall in the cost of pulp-based newsprint; the rotary press, which allowed faster printing; and the introduction of halftone illustration and photoengraving, which reduced the need for hand illustrations—pages previously filled with rows of gray print were now filled with bold headlines, illustrations, advertisements, pictures, cartoons, and comic strips. Moreover, the replacement of horse-drawn carts with automobiles and trains enabled more efficient distribution of the papers. It was not just in urban centers that newspapers, carrying comic strips, were read. In 1900, there were 2,190 daily papers found throughout America, with a circulation of fifteen million.[5]

At the opening of the twentieth century, Joseph Pulitzer and William Randolph Hearst—owners and publishers of the two largest American newspaper conglomerates—aware of white, Protestant Americans' curiosity, fascination, and unease with seemingly exotic immigrants who filled the streets of New York and other urban centers, began to feature comic strips with ethnic characters, such as *Hogan's Alley* and *Happy Hooligan* (Irish), *The Katzenjammer Kids* (German), *Alphonse and Gaston* (French), *Yanitor Yens Yenson* (Swedish), *Sambo and His Funny Noises* and *Pore Lil Mose* (Black American), and *Little Ah Sid the Chinese Kid*.[6] At the same time, neither Hearst nor Pulitzer (who was a Jewish immigrant) wanted to overly offend ethnic readers. The cartoon strips that appeared, respectively, in the *New York Evening Journal* and the *New York World*, containing stereotypes offensive by today's standards, were still less egregious than cartoons of ethnic characters that appeared at that time in humor journals and on the vaudeville stage.[7] It was, therefore, unsurprising that the first comic strip featuring a Jewish character could debut successfully, especially given that, by 1915, Jews constituted 25 percent of New York City's population.[8]

While there exist no formal studies before 1924 of who was reading comic strips, several reasonable conclusions can be reached concerning comic readership in the early years of the twentieth century.[9] Most historians who have studied the topic have stated that the comic strips appearing in the "yellow journals" (namely, Hearst's and Pulitzer's publications) were read not only by long-settled Americans but by newly arrived immigrants as well. The comic strip, they claim, was particularly well suited to immigrant readers whose primary language was not English: its "simple language, its images literally illustrating the printed words that accompanied them, made of the comic strip a daily lesson in rudimentary English, its heavy use of expletives and vernacularisms introducing immigrant readers to the basic street vocabulary essential for urban survival."[10] Though it is conceivable that the newly arrived immigrants, not yet understanding English, did buy an Anglo newspaper to look at the pictures, political cartoons, and comics section, which conveyed a story of sorts, it is more likely that they would have turned not to English publications but to the ethnic press. Hearst's *Morgen Journal* (Morning Journal), for example, published

for the German American immigrant community, offered by 1911 the comics *Mutt and Jeff*, *Happy Hooligan*, and *Bringing Up Father*, all renamed and translated into German. (*Abie the Agent* was not similarly adapted and printed in the *Morgen Journal*, probably because, by that time, the German Jewish population was thoroughly assimilated and comfortable reading newspapers in English.) Another comic, *Gimpel Bainish der Shadchan* (Gimpel Bainish the matchmaker), explored later, was published in *die Warheit* (The Truth) for Eastern European Yiddish readers.[11] Ethnic comics in the English press were, in all probability, read by those with more familiarity with English—the more settled immigrants and their children. In addition, ethnic comics, by virtue of syndication, would also have been read throughout the United States by working-class and middle-class Americans (as evidenced by fashion and home-goods advertisements as well as theater reviews found in these papers).[12] Thus, there was a large readership available for ethnic comics, not only among more settled ethnic enclaves in large cities but also among long-settled Americans throughout the United States.

Abie the Agent, immediately following its introduction in 1914, enjoyed an enormous reading audience, not only because of Hershfield's cartooning talent but also due to the large circulation of the *New York Evening Journal* and, shortly thereafter, its appearance in major city newspapers across America through Hearst's extensive syndicated network. The mostly uninterrupted run of *Abie the Agent* for twenty-six years made it—along with *The Katzenjammer Kids* (published under various titles) and *Bringing Up Father*—one of the longest-running ethnic comic strips in American comic-strip history. It was also the *only* long-running comic strip in English featuring a Jewish protagonist that was printed during the first half of the twentieth century.[13] Hearst's sponsorship helps explain why other Jewish comic strips from this period did not fare as well in the Anglo press. Bert Levy's *Samuels and Sylenz* (1915) existed for just ten weeks, and Joe Irving's *Potash and Perlmutter* (1926) came out for less than one year.[14]

As a result of the popularity of *Abie the Agent*, its protagonist, Abie Kabibble, appeared in other cultural manifestations. Addison Burkhardt's 1916 song "My Yiddish Matinee Girl" referred to him, as did Jo Swerling's 1924 song "Abie! (Stop Saying Maybe)." There was a scissors-step pattern used in jazz and tap dance known as "Abe-Kabibble." Abie also appeared on phonograph records, in stage productions, and on radio shows. The Marx Brothers mentioned him in their film *Animal Crackers*, as did the author James Farrell in his books.[15]

IMMIGRATION

Though a detailed examination of a Jewish comic-strip character may appear, at first, to be a narrow, almost arcane, topic, Abie Kabibble's successes, failures,

INTRODUCTION

and efforts as a newly arrived immigrant to become an American have much to reveal about the concerns of immigrants and of nativists in the closing years of the nineteenth century and in the opening decades of the twentieth. In 1883, the Jewish American poet Emma Lazarus, in her now-famous poem "The New Colossus," had Liberty proclaim: "Give me your tired, your poor, your huddled masses yearning to breathe free, the wretched refuse of your teeming shore."[16] Just nine years later, however, the poet Thomas Bailey Aldrich took exception to Liberty's welcome: "Wide open and unguarded stand our gates, and through them passes a wild motley throng."[17] What had radically changed during this short period of time, and what was alarming American nativists such as Aldrich, was the sheer number of the "huddled masses" emigrating from Europe to the shores of America. By 1900, 37 percent of New York City residents were foreign born; in Chicago, 34.6 percent; in Boston, 35.1 percent. By 1920, of 105 million people living in the United States, one-third of them (36 million) were immigrants and their children.[18] While there had been a continuous flow of immigrants to America over the previous centuries, ever since the European colonialization of the continent began, those numbers were small compared with the flood from Eastern and Southern Europe beginning in the closing decades of the nineteenth century and the opening decades of the twentieth.

One-third of the country now consisted of immigrants and their children! The American patrician and author Henry James, following a visit to the lower East Side of New York in 1907, wrote with alarm of the "immensity of the alien presence climbing higher and higher."[19] By the opening decades of the twentieth century, the number of increasingly visible immigrants who had arrived in the United States engendered enormous distress on the part of previously settled white, Protestant Americans. It was not just that workers feared that cheap immigrant labor would take away their jobs, nor was it just the sheer alienness of these immigrants—their looks, their dress, their incomprehensible tongues, their poverty—that disturbed these settled American nativists. Influenced by the new pseudoscience of race that combined social Darwinism and eugenics, lumping together national origin, hereditary propensities, and character under its aegis, political scientists, historians, economists, sociologists, and eugenicists saw the immigrants—Jews, Italians, and those of other Mediterranean races—as inferior to America's Nordic, Anglo-Saxon stock. They were convinced that the racial makeup of these immigrants led them to lives of debauchery, laziness, sexual immorality, and criminal activity and that they were carriers and spreaders of disease. In their minds, these immigrants would remain as aliens unfamiliar with the processes of democracy and suspicious of government, and some would seek to overthrow the democratic institutions of America.

At the same time, other American nativists worried that the immigrants would be too successful: their superior Nordic stock would be overcome and

weakened by these inferior races intermingling with their blood. Everything that they and their ancestors had established in America would be first damaged and then, ultimately, destroyed. In 1916, for example, the anti-immigration writer Madison Grant bemoaned the immigrants who "adopt the language of the native American; they wear his clothes; they steal his name; and they are beginning to take his women."[20]

Thus, while the powerful industrialists who needed cheap labor to run the factories and build the infrastructure of the country continued to support immigration, nativist writers, political leaders, and academicians sounded the alarm that America was in grave danger of being overrun, polluted, infected, fractured, or destroyed by an alien population that would continue to stubbornly endure.[21] What would happen to "traditional" American society if Americans were no longer unified by their countries of origin, language, or culture? Accordingly, these nativists called for the government to step in and control the types of immigrants who were arriving by establishing literacy standards for admission and, ultimately, by closing the gates of America altogether.

As a result, the first two decades of the twentieth century saw a renewal of previous efforts to restrict immigration to the United States. In 1901, the bipartisan US Industrial Commission issued a report that new immigrants depressed wages and, in general, lowered the standard of living and raised crime rates. In 1903, Congress, supported by the American Federation of Labor, the Immigration Restriction League, and other business groups and patriotic societies, passed the Anarchist Exclusion Act, which excluded from admission those who believed in or advocated the overthrow of the US government. The year 1911 saw the Dillingham Commission, a joint Senate–House committee, release a forty-one-volume report on the immigration situation in the United States that, in essence, stated that new immigrants, due to their racial constitution, were not as physically fit or as intellectually capable as earlier American settlers and were thus unassimilable into American society. By 1913, both the Democratic and Republican parties had some aspect of immigration restriction in their platforms.[22]

PROGRESSIVE REFORMERS

In contrast to the anti-immigration activities of American nativists, there were the efforts of Progressive Era reformers, who believed that the immigrants could be assimilated into American society and would be no threat to the established white Anglo-Saxon Protestant values of the nation.[23] During the first two decades of the twentieth century, the forces that had been set into motion in the last two decades of the nineteenth century, the Gilded Age, became matters of concern expressed by sociologists, educators, middle-class women,

INTRODUCTION

and, finally, politicians. Among these concerns were that industrialization and the rise of capitalism had resulted in great economic and social gaps between the wealthy and the poor and had created substandard living, health, and safety conditions for those crammed into urban neighborhoods. Progressive Era "muckraking" articles exposed slum housing, child labor, illness, alcohol abuse, political graft, and crime in urban centers. The government, which had heretofore assumed a laissez-faire attitude toward these conditions, was now called on, together with civic involvement, to step in and reform, mostly in moderate ways, many of these social ills.

Progressive Era reformers rejected the false eugenic theories that claimed that the newly arrived racial groups were intrinsically flawed and instead held that not biology but, rather, environment—both in the Old World and in America—was the primary shaper of character. Slum neighborhoods promoted disease; poor nutrition resulted in stunted bodies; poverty led many to crime. However, whether the etiology was thought to be environmental or biological, both the Progressive reformers and the nativists supporting anti-immigration policies linked immigrant communities with social ills. Joined by former president Theodore Roosevelt, the Progressive reformers advocated that the solution to the immigrant problem was that the immigrants be Americanized. In return for the improvements to their health, housing, and education brought about by the establishment of settlement houses that taught English, hygiene, and nutrition classes, they were to jettison their Old World ways and attachments and, instead, embrace the opportunities that were being extended to them to assimilate into American culture (namely, white Anglo-Saxon Protestant middle-class values) with its attendant economic opportunities.

Both the Progressive reformers and the nativists were concerned with the challenges facing American identity in the face of a massive influx of foreigners. The worry about the inability of these immigrants to assimilate into American society; the fear that they would be socially and economically successful, displacing long-settled Americans; and even the hope that they could be reformed were conveyed not only in attempts to pass anti-immigration legislation or to establish compulsory public education but also through cultural manifestations. Plays, novels, songs, vaudeville stage presentations, newspaper and journal cartoons, and ethnic comic strips of this time either directly or indirectly explored these concerns. Often, in doing so, as will be explored, the representations of the immigrants were grotesque and demeaning and perpetuated stereotypes as to their low character.

In response to the charges that they were racially inferior and the concerns about their inability to assimilate into American society, some settled-immigrant community leaders declared that the recently arrived immigrants were not a threat: they would be quickly absorbed into a metaphoric melting pot, in which they would lose all their foreign ways—language, dress, and

8 SMOOTHING THE JEW

customs—and become fully American.[24] Other immigrant spokesmen, concerned that their ethnic identity would be lost, proclaimed that though they would not be completely melted down, they would at least become part of and further help to create a multicultural society, lending their voices to the "symphony of America" or "orchestration of mankind."[25] In addition, settled-immigrant leaders and communal organizations directly involved themselves in political action, lobbying against restrictive immigration bills.

This is the zeitgeist from which *Abie the Agent* emerged and that it, in turn, both influenced and reflected. More specifically, *Abie the Agent* helps illustrate the process of Jewish acculturation to America in the early decades of the twentieth century. It highlights a complex dynamic that included the desire of some immigrants to assimilate into American society while maintaining elements of Jewish identification. *Abie the Agent* illustrates, during this time, how Jews viewed America, how Jews viewed themselves, how other Americans viewed Jews, and how Jews viewed other Americans viewing them.

But it is not just the Jewish world alone that *Abie the Agent* highlights, for Abie is also a synecdoche for the general immigrant experience at the turn of the century. Though there were aspects of Jewish immigrants' encounter with America that were unique to them as a distinct ethnic group, some of their experience was also representative of those of other ethnic immigrant clusters. The large influx of Jewish immigrants into America mirrored the larger overall immigration from Europe that was taking place at that time, and some of the subsequent hostility and mistrust directed toward the Jews by American nativists was also directed toward other immigrant groups. Just as the Jews, due to their alien language, dress, and folkways, were derogatorily presented in print and on the stage, so, too, were other ethnic immigrant groups such as the Irish and Italians as well as racially defined non-white populations: formerly enslaved Black Americans, Native Americans, and Chinese. This study's close examination of how Jewish community leaders sought to censure these derogatory images and how Jewish artists sought to smooth them will also illustrate how other ethnic communities sought to do the same.[26]

Of course, though immigration was the primary cultural force at the beginning of the twentieth century, there were other significant movements and events, such as the rise of visual culture (the daily newspaper with lurid headlines and photographs of city life, the nickelodeon theaters introducing silent movies, electric lights) and the growing appeal of consumer culture (mass-produced household appliances and ready-to-wear clothing, cars, and the concomitant rise of advertising and packaging). This period saw the entry of women into the workplace (not just as domestic servants and factory laborers but as office clerks, teachers, and settlement-house workers), into new aspects of the social sphere (restaurants, dance halls, amusement parks, vaudeville shows), and into the political realm (suffrage, birth control, labor organizing).[27] Urban

INTRODUCTION 9

life, not rural, now ruled America. Its slang, culture, and politics were shared among city dwellers through the telephone, daily newspapers, phonograph records, and stage and were transmitted to small cities and tiny towns across the country through telegraph wires and the railroad system.

The opening decades of the twentieth century began with the waning of the Victorian period and its genteel values and ended by ushering in the roaring twenties. If the American frontier was declared closed at the beginning of the twentieth century, a new world frontier opened with the entry of the United States into the Spanish-American War in 1898 and the Great War in 1917. The conclusion of the First World War also brought the Progressive Era to a close, since the horrors of the war wrought by science and technology undermined the Progressives' belief that these branches of knowledge were the tools that would create a glorious future society. Then, too, in 1919 violent labor strikes and fears of anarchists put a damper on Progressive political activities on behalf of workers, and Theodore Roosevelt's death that year removed their most powerful spokesman. Many of these cultural movements are reflected in the cartoon-strip panels of *Abie the Agent*.

THE BOOK'S FOCUS

The late 1890s until 1920, then—the rough time period that encompassed the Progressive Era—will be the parameters for this study, as I explore how the issue of immigration and the concomitant debates about immigrant assimilation influenced the creation of specific productions by a number of Jewish artists. Within this time frame, this study will also examine how these plays, sketches, short stories, and comic strips reflected the concerns of new immigrants looking to acculturate or assimilate, the fears and reactions of nativists, and the well-meaning yet self-serving attempts of Progressive Era reformers and already established immigrants who supported Americanization efforts. In addition, it will suggest how these cultural productions may have influenced both the immigrants and the nativists who encountered them. Since *Abie the Agent* will be the key text under discussion, 1914, the year wherein it was created, will serve as the point around which to situate key events.

The late 1890s to 1920, is, of course, a porous designation. Most of the phenomena that took place in these decades were influenced by earlier events. Political ideologies, demographic shifts, economic changes, and social movements of one decade cannot be cleanly bifurcated from the previous or subsequent one. Instead, they continue to permeate the new decade(s), sometimes mutating into slightly different iterations, at other times coexisting with new ones. The social, political, and economic issues of the early twentieth century had their origins in earlier years. When it came to immigration, for example, nineteenth-century fears about immigrants, and the anti-immigration

movements active then, affected the decades to come. Anti-Catholic sentiments, directed mainly against the Irish, beginning in the 1830s and continuing into the 1850s were carried over into the early twentieth century; the Immigration Restriction League, which was formed in 1894, crusaded tirelessly for a literacy test to be used as a basis for limiting emigrant entry into the United States, finally resulting in its enactment into law in 1917.[28] Immigration acts in 1885 and 1891 that erected barriers against potential immigrants with contagious diseases, with disabilities, and with the likelihood of becoming public charges, as well as against political radicals, all paved the way for the passage of the 1924 Johnson-Reed Act, which severely reduced immigration to the United States.[29] The same process of earlier events influencing later ones also applies to the end period of this study. The Progressive Era did not come to a total close in 1920. Some of its reforming spirit continued in social programs through the 1920s.

At the same time, a concluding date of 1920 for this study means that there are a host of later significant historical events that will not be examined, such as Prohibition (1920–1933), the closing of the immigration gates (1924), the Great Depression (1929–1939), and the onset of World War II (1939). Regarding the Jewish community specifically, the rising mobility of second-generation Jews, their movement out of the city into the suburbs, their increased assimilation into American cultural life, the anti-Semitic pushback against them, and new efforts to smooth the image of the Jew on radio and television must be the subject of a future work. Fortunately, the Progressive Era, taking place between the late 1890s and 1920, is a more than rich enough historical period in which to base this study. Hershfield, by the early 1920s, had achieved in his comic strip a successful formula to depict Abie's physiognomy and elucidate his characteristics. He continued that presentation, with little change, for the next twenty years. It is in the first half-dozen years of his strip, which fall within the time period being examined, that the smoothing choices he initially made and experimented with can best be seen.

While *Abie the Agent* is the primary focus of this book, its purpose is not the explication of this comic strip per se (e.g., technical aspects of its drawing style, such as cross-hatching, will not be investigated).[30] Though this book presents a more complete picture of Hershfield's life than previous biographical entries in cartoon-strip histories—gathering together all of the available records about him: newspaper and magazine articles, interviews, published comic-strip histories, and memorabilia—the result is not a biography or, most certainly, a hagiography.[31] Hershfield's creation of *Abie the Agent* was not sui generis. As will be explored, he was not alone in seeking to create a smoothed-over image of the Jew, and he was influenced by others who had done so before him. Hershfield was also guided by leading voices in the Jewish community who called for censoring images. While the influence on *Abie the Agent* from its creator's

INTRODUCTION

personal history and from various societal and cultural phenomena will be noted, what is of more importance for this study is what those phenomena reveal about that time, using *Abie the Agent* as their reflection.

Accordingly, chapter 1 explores American nativist fears and concerns that resulted in negative representations of ethnic and racial groups, particularly the Jews, in print and on the stage. The enormous influence vaudeville played in the dissemination of derogatory caricatures will be highlighted. It also investigates one different response to these derogatory images: an attempt on the part of some Jewish artists to modify those presentations—retaining some while smoothing others—on the stage, in short stories, and in illustrations. This chapter also illuminates how these artists, as the children of immigrants, were personally wrestling with their own assimilation into American society, at times self-conscious and anxious about how they were fitting in. Chapter 2 examines organizations within the Jewish community, influenced by social reformers and anti-vice crusaders of the Progressive Era, who sought to completely censor those representations of the Jew they deemed demeaning and harmful. It then details how these groups, in their censoring efforts, were at times at cross-purposes with Jewish artists. Chapter 3 examines, in detail, the process of smoothing the appearance, speech, and personal qualities of the Jew, using *Abie the Agent* as its primary source. It also investigates how both Hershfield's personal history and the vaudeville stage affected the shaping process and examines the claims for traditional Jewish humor upon the comic strip. Chapter 4 will highlight how the concerns and fears of American nativists about the ability of the immigrants to fit into America influenced, both explicitly and implicitly, the smoothing process, again using *Abie the Agent* as the primary text. It will also explore what messages the strip, in turn, communicated to both Jewish immigrants and nativists concerning Jewish assimilation into American culture and society.

The Process of Culture and Identity

Any attempt to explore issues of identity is not without its challenges. In addition to the dubious concept of race—used during this period through its white–Black binary designation to continue the oppression of Black Americans and to oppose, as well, the massive entry of immigrants into America and then into American society—are other categories that, upon examination, should not be treated in an essentialist way. The indeterminacy of the meanings of caricatures, the amorphous nature of culture, and the shifting meaning of identity make it difficult to arrive at causal connections among them. While the concepts of "culture," "identity," "ethnicity," and "assimilation" may be represented by material objects such as clothing, food, popular songs, stage representations, and print caricatures, these concepts themselves are not fixed entities but,

rather, are fluid designations.[32] Culture, for example, is never static but rather is a process, an interplay between the dominant culture and the subordinate culture. Once again, hands drawing hands: the hegemonic culture affects the immigrant, and the immigrant affects the hegemonic culture.

To give a few simple examples: Yiddish words brought by the Eastern European Jewish immigrants crept into English (e.g., *schmooze*, to chat), and English words entered Yiddish (e.g., *allrightnik*, a Jewish parvenu); Jewish immigrants incorporated the American banana into their diets, while the Jewish bagel, over time, became a staple throughout the United States. Though a hybrid culture results through the interplay between two cultures, this is not to say that the power of the two cultures is equal—it is not. After all, it was English, not Yiddish, that became the dominant language of Eastern European Jewish immigrants. However, it may not be too far-fetched to suggest that a dominant culture may not actually exist. From the beginning, American culture was made up of ethnic groups, and it continues to be shaped by them. It is variegated, with different languages, food, and national backgrounds.

The same is true with the concept of identity. It is not an essentialist, inherited reality; rather, it is a social construct, affected and shaped by such forces as geographic location, economics, and power relationships. When one's situation changes, it throws into sharp relief that identity is always in process, and this is especially true for immigrants. Though they physically stand in a new geographic location, psychically and emotionally they are in between two worlds. Their new world exerts enormous pressure and influence on them, as it calls for adaption to its ways to first survive and later to better themselves. Yet, at the same time, the immigrants may seek to fall back on the Old World ways on which they had previously constructed their life so as to sustain themselves in the face of a new, bewildering, and alienating majority culture in which they feel lost. To speak of a dual identity is much too simplistic, as identity cannot be neatly divided into two separate compartments. One is transformed from a Jewish immigrant from Europe who is living in America to a Jewish American formerly from Europe, not through a stamp on a document but through a process that takes place over time. This transformation was not limited to immigrants but continued with their children and their children's children as well. Over the decades, both the Jewish community and already established Americans first referred to the Jewish immigrants as Jews or, slightly more obliquely, as Hebrews and Israelites. Next, they were referred to as Jewish-Americans—the hyphen suggesting that they were not yet assimilated—and today as Jewish Americans or even American Jews.

For Jews, the question of identity is especially problematic: while Jews, historically, have sometimes been seen by themselves and others as either a distinct religion or ethnic group, at other times their identity has been defined as a combination of both with no clear, distinct boundaries between them.

INTRODUCTION

In addition, during the early twentieth century, while the members of the Jewish community, amid charges from nativists that they (together with Italians and Greeks) were Black, were united in their efforts to be defined as white, they were also divided on the question of whether they should be categorized as a racial group to begin with. Some, though they rejected the stereotypical negative racial traits that nativists assigned to them, still accepted this racial designation, while others vociferously rejected the label of race altogether, declaring that they were solely a religion.[33]

Amid the confusion of whether they were a religion, a race, or an ethnicity, there was also the fact that the American Jewish community was not a uniform group. The Eastern European Jews, for example, were differentiated both linguistically and economically from the Sephardic and German Jewish communities who had arrived earlier to America. Nor were the Eastern European Jews unified at the time of their immigration to the United States. Immigrants (from all ethnic groups) arrived with their specific family constellations, social positions, wealth or lack of it, and distinct personalities. Some became toilers, others became leaders; some took risks, others played it safe; some became masters of the English language, while others struggled to get by. The experience of leaving one's homeland and striving to survive in and make sense of a new, radically different world was unique to every individual within the Jewish community.

Intersections of class and gender further complicated the idea of community, as some women worked outside the domestic domain, while others lived domestic lives in personal homes. Religious practice added yet another dimension: some immigrants jettisoned traditional dress and food mores, while others attempted to hold fiercely on to them.[34] In addition, designations of "first-" and "second-generation" immigrants are less solid than they appear. As American sociologist David Riesman has noted, "It is not easy to say when one generation ends, and another begins . . . for people are not produced in batches, as are pancakes, but are born continuously." This is especially true for the more than forty-year span of Eastern European immigration to the United States, resulting in newly arrived immigrants meeting adult second-generation Americans in the 1910s and 1920s.[35]

In the same way that the immigrant community comprised different sexes, ages, skills, and socioeconomic levels, so, too, "nativists" and "Progressives" did not comprise monolithic blocs. Nativist concerns varied widely, from fears that the newly arrived immigrants were unassimilable to fears that the immigrants would be able, all too readily, to mix in with long-settled Americans. Progressive reformers championed different approaches to solve the social ills that they believed held back immigrant assimilation, and they had varying opinions as to whether vestiges of ethnic identity should remain or be "melted down." The use of terms in this work such as *nativist anxieties*, *Progressive reformers*, and

immigrant community should be understood, then, as generalizations for each group's range of behaviors.

If "race" is a social construct and if "culture," "identity," "ethnicity," and "generation" are fluid designations, it follows, then, that concepts like "assimilation" or "acculturation" are as well. Exactly at what point has one crossed over from acculturation to assimilation, and is total assimilation ever possible? Henry James's observation in the early twentieth century that "the assimilative force itself has the residuum still to count with" is apt here.[36] Sometimes there are factors that summon one back from what was assumed to be a steady progression forward to becoming an American. For example, though Eastern European Jewish immigrants had no love of Russia and few had any desire to return there, nonetheless, the Kishinev pogrom in April 1903 resulted in Jewish protests across America on behalf of their murdered coreligionists and the formation of relief organizations for the survivors. Suddenly, what was happening in the old country became of enormous concern to the immigrants. A decade later, when there was great suffering of Jewish civilians caught between German and Russian forces at the outbreak of World War I, the energies of the Jewish community in the United States became focused on relief efforts to aid their family members, friends, and villagers.[37] But it did not require the tragedy of war or of pogroms to maintain ties with their former world. Family members were separated from one another due to immigration: husbands from wives and children, adult children from their elderly parents. The enormous popularity of *brivele* (little letter) songs among the Jewish Eastern European immigrants in the opening decades of the twentieth century, such as "A Brivele der Mamen" (A letter for momma), attests to the continued ties between the immigrants and those they left behind.[38]

Thus, it should be kept in mind that "acculturation" and "assimilation" do not describe a fixed reality but, rather, are part of the ongoing process of identity formation, a give-and-take between the minority individual or group and the dominate culture. Accordingly, the anachronistic identity term *Jewish-American* will sometimes be used in this study, not only because it was a key term that appeared during this period but also to call attention to the hyphen as an important symbol representing the dialectical tension between ethnic and American identities. Though some today view the continued use of the hyphen as offensive—marking one as Other, as not fully American—it can be also seen as connective, representing the conversation and negotiation taking place between two cultures. Both the Jews and earlier-settled Americans would, together, create a new image of the Jew, as will be explored in the chapters ahead.

Understanding Humor

There is also a vexatious indeterminacy when it comes to determining the meaning of humor—whether in joke telling, cartoon drawing, or article and

INTRODUCTION

novel writing—especially if it is at a far remove from its time of creation. First, the meaning of humor depends on its sites of reception—that is, its audience. A diverse audience will result in multiple meanings: an American nativist worried whether the flood of immigrants pouring into the country at the opening of the twentieth century could assimilate; a recent immigrant attempting to learn a new and confusing way of life; and the child of immigrants who had lived for some time in the United States, poised between their American identity and the Old World habits of their parents, might each take away a different meaning from the humor being presented. Moreover, humor can also contain multiple meanings, even oppositional ones. Immigrants might understand the humor being presented as expressing both the positive value of striving to rise economically *and* disdain for those who sought to jettison their past to do so. Nativists might understand that the appearance of a particular ethnic group onstage clearly marked them as an Other *and* receive the reassurance that this group was assimilable into American society. When it came specifically to humor about Jews, the Jew could appear as intelligent *and* underhanded, industrious *and* scheming, loyal *and* clannish.[39]

Second, the meaning of humor may depend on who is creating it: Is it an outsider or an insider? When ethnic and racial caricatures are being created by members of their own group, it may be claimed that they are challenging stereotypical representations, they are enacting a form of resistance, or the caricatures are being presented for purposes of identification or idealization. It is also possible that these artists, though not being deliberately subversive, were, through repetition or a skillful presentation, destabilizing harmful stereotypes by rendering their characters as more sympathetic.[40] Conversely, it may be that economic necessity led some actors to fill stage roles or led artists to produce caricatures that demeaned their own racial and ethnic group or they were led to these productions due to their burden of "double consciousness"—that is, the expression not only of self but of how one believes one is seen by the dominant culture.[41]

Third, there is the difficulty in arriving at the alleged intent of the humor. It is often difficult to distinguish between good-natured humor and demeaning representation. Was it a release from tension, an expression of incongruity, or a social critique? Was it presented to render a character sympathetically, express social superiority, or reinforce another's status as an alien?[42] The difficulty of determining intention is because, in part, certain representations have a history—they are haunted by their past associations. This has been the case, for example, with presentations of Shakespeare's Shylock on the American stage.[43] The same character, however, may now be imbued with different meanings and interpretations than it previously held. When it came to nineteenth-century America's perception of the Jew, "Older and newer, often contradictory, perceptions of the Jew existed side by side. The image ... was a compound of class

attitudes and ancient stereotypes."[44] Moreover, there were times when a stage caricature of Jews or other ethnic groups was not static: its presentation might shift depending on its geographic location and the composition of its audience, making its meaning even harder to pin down. As a result, some writers, artists, or dramatic actors, when charged that they were putting forth damaging representations, claimed that their characterizations were not at all meant to be demeaning but, rather, were sensitive portrayals or gently humorous ones. As burlesque historian Robert Allen has noted, "Popular text and performance are sites of multiple, sometimes conflicting meaning, and that apprehension of a text involves multiple appropriations of it by different groups of readers or viewers for different purposes."[45]

With that said, though the designations "culture," "identity," and "ethnicity" are fluid; though "acculturation" and "assimilation," too, are processes; though the meaning of "caricature" can be difficult to ascertain; and though definitions of humor prove to be subtle, there still was a "there" there in the early decades of the twentieth century. The smoothing efforts of the Jewish artists who appear in this book provide an important snapshot of that moment in time—providing we are cautious in handling it—by illustrating the varied ways that Jews were seen by others in America and how they saw themselves in that light.

CHAPTER 1

Caricatures and Smoothing Efforts

You cannot picture a Jew without making him Jewish.

—Life, *1908*

Caricature is a visual shorthand that presents an individual whose identity can be immediately grasped by the viewer. Caricature is differentiated from stereotype in that a stereotype is a generalization about what all in a group are like, while the caricature is an exaggeration so to make identification easier.[1] Among the caricature's cues are appearance (including face, form, and dress), speech, and character (qualities). Other cues may involve their name, the foods they eat, and their profession. These cues are not essentialist qualities, but, rather, they are cultural constructs, both reflecting the culture of a time and contributing to that culture as well.

Caricature has a long history in American culture. In the early nineteenth century, caricatures of tramps, Black Americans, and Chinese immigrants appeared in print and on the stage in American minstrelsy shows.[2] In the last decades of the nineteenth century, there also appeared caricatures of other racial—what today we would call "ethnic"—types. Scholars have advanced many reasons to explain the appearance of these caricatures. The primary one is that they reflected the fears and insecurities of a white Anglo-Saxon Protestant population facing the movement of Black Americans into Northern cities in the years following the Civil War and facing the waves of immigrants—Germans, Irish, Italians, Poles, and Jews—who arrived in the United States throughout the nineteenth century.[3] The caricaturizing of each ethnic group served to reinforce the binary concept of we–they and, at the same time, attempted to uphold the hegemonic standard of the more settled population. As Martha Banta has detailed, the caricature serves as proof "of the presumed rightness and literal value of the eternal ideals it visually challenges."[4]

Another suggestion from scholars is that these caricatures were created for the benefit of these racial and ethnic groups: they were a way to introduce the

17

groups to one another and relieve tension between their immigrant communities.[5] A third possibility is that the intent was not to focus on immigrants per se but rather to relieve, through humor, the tensions felt by city dwellers that arose from living in a new, bewildering, heterogeneous urban environment.[6] Finally, others have suggested that these caricatures were simply an exaggeration of the American burlesque tradition, "based in a sense of fun or playfulness, not of punitive ridicule."[7]

Though Daniel Wickberg has suggested that humor by the late nineteenth century had moved from "laughing at" toward "laughing with" and though Jean Lee Cole has contended that group laughter is an expression of "solidarity, commiseration, and communal empowerment," these caricatures, when set against the backdrop of growing anti-immigrant and anti–Black American sentiment during the early twentieth century, were not based on a sense of fun, nor were they unintentional slights, merely presenting stock characters that did not tax the mind and that were open to multiple readings. The laughter brought out by many of these representations was anything but kind and did little to situate these minority groups as sharing universal qualities. The primary message of these caricatures was one of not empathy but, rather, antipathy toward immigrants and Black Americans, depicting in grotesque ways their alienness, inferiority, and inability to be part of American society.[8]

Early American Caricature of the Jew

When it came, specifically, to caricatures of the Jew during the late decades of the nineteenth and opening decades of twentieth century, playwrights, actors, and illustrators took their model from earlier representations of the Jew that had appeared in print and onstage in America and, before that, in Europe, which utilized a hooked nose and beard.[9] The staging of Shakespeare's *The Merchant of Venice* occurred in America as early as 1752 and was a popular presentation during the nineteenth century. Though some productions portrayed, at times, a more sympathetic Shylock the moneylender, rendering him less malevolent and more pathetic, he was still pictured, in all renditions, as grotesque. In addition to Shylock, versions of Charles Dickens's Fagin, a villainous Jew from *Oliver Twist*, also appeared on the stage. Melodramas that required a villain (who would ultimately be overcome by the dashing hero) often cast that villain as a Jew, known as a "sheeny." The villain's identification as a Jew was indicated by his name (e.g., Moses or Solomon) and, as noted previously, the visual markers of a hooked nose and black beard.[10] Also onstage at that time was the *belle Juive*, the beautiful Jewess, presented as an objectified, alluring Other. Sometimes, a father–daughter structure was utilized, presenting the ugly, nefarious Jew with his beautiful, nobler daughter, such as Shylock and his daughter, Jessica. If she was not young and unmarried, the female Jew was then presented onstage as a

CARICATURES AND SMOOTHING EFFORTS 19

hag, a masculinized female—in essence, more of a man than her sheeny husband. In addition to dramas, derogatory presentations of the Jew also appeared in light comedy productions.[11]

As Jewish immigration to America increased in the closing decades of the nineteenth century and continued into the first two decades of the twentieth—in New York City alone, the Jewish population went from 80,000 in 1870 to almost 1.5 million in 1915, constituting 28 percent of the city's population—there was a concomitant increase in the number of derogatory caricatures of the Jew.[12] In January 1881, for example, as Jewish immigration to the United States began to increase, *Puck* printed a cartoon of the "New Trans-Atlantic Hebrew Line," featuring an all-male boat filled with the familiar caricature of big-nosed Jews—even the boat and the fish have hooked noses (figure 1.1).

Puck, *Judge's Library*, and *Life* cartoons often presented the Jewish family with exaggerated large noses and grotesque features, wearing gaudy jewelry, and speaking with thick accents, while the non-Jews who were placed with them had pleasant features, were properly attired, and spoke flawless English.[13] This

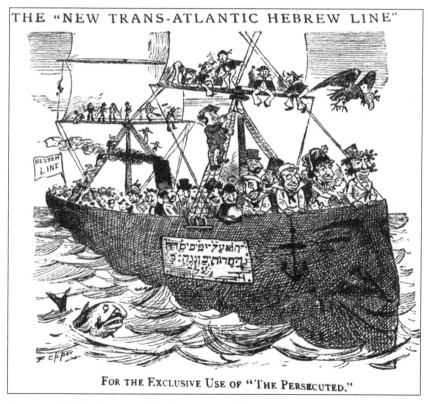

Figure 1.1. Frederick Opper, "The 'New Trans-Atlantic Hebrew Line,'" *Puck*, January 19, 1881.

increase of derogatory caricatures can be attributed to the fact that the Jews, at that time, came to be seen by American nativists as the symbol, par excellence, of the forces of urbanization, industrialization, and commercialization that were transforming America at the close of the nineteenth century. Unease and fear about these changes—the lessening of patrician power, the movement from the farm to the city, the laborer as a replaceable part in the midst of mechanization, the growing disparity in wealth between the upper and lower classes—were projected onto the Jews, given their concentration in urban areas, their clear anti-rural ways, and the alacrity and seeming ease by which they participated in the new economic order.

Though the offensiveness of these caricatures in print and on the stage is easily apparent, determining the intent of their authors is more difficult. Some historians suggest that many of the caricatures of the Jew, though cruel, were not deliberately anti-Semitic. Oscar Handlin suggested that they were "merely" hostile sentiments due to "competition for places," while John Higham stated that these images were a "distorted mirror" of the Jews' "strong competitive drive and remarkable social mobility."[14] Leonard Dinnerstein, Michael Dobkowski, and Matthew Baigell, however, disagree, seeing the negative print caricatures of the Jew as evidence of unremitting anti-Semitism in America.[15] Hasia Diner and Deborah Varat take a more positive position, stating that though anti-Semitic images were sometimes presented, Americans held overall favorable opinions of the Jews.[16] Louise Mayo follows this position as well, holding that the presentation of the Jew was often an ambivalent one—for example, hardworking and resourceful yet cunning and greedy. Christie Davies, too, in his examination of jokes, suggests that jokes about "canny" ethnic groups told by members of the outside culture are actually flattering to that group, reflecting their ability to succeed in competitive areas of society, though Davies also notes that there is a difference between "canny" jokes about the stinginess of an ethnic group versus their dishonesty.[17]

Roger Fischer, moreover, on close examination of *Puck*, found that the demeaning Jewish caricatures that appeared in its cartoons were often at odds with its more sympathetic editorials about Jews. It seems that *Puck* simply purchased filler cartoons from freelance artists to fill its pages.[18] In addition, when the cartoons expressed editorial opinion, they were not always reflexively anti-Semitic. An 1881 *Puck* cartoon (by the same artist who drew the "New Trans-Atlantic Hebrew Line," figure 1.1) presented a character who spoke in Jewish dialect and appeared with a large nose and a prominent gold watch chain. Yet the cartoon inveighed against Jews being refused admittance to East Coast hotels as he proclaims, "Two new hotels closed against the Hebrews, dis year! Vere can I dake the fam'ly, I vonder?" (figure 1.2).[19]

In addition to the difficulty in determining the intention behind these images, there is also the issue of how much influence they exerted at the time. Though,

CARICATURES AND SMOOTHING EFFORTS 21

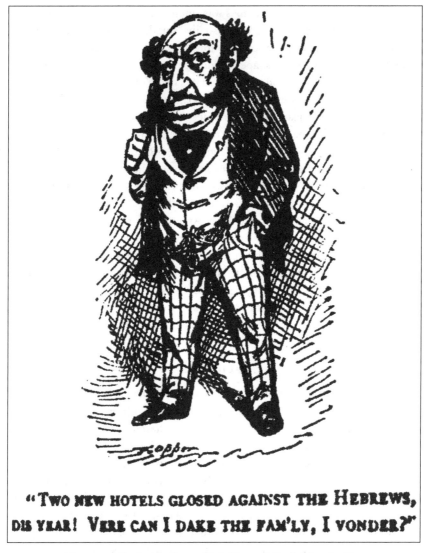

Figure 1.2. Frederick Opper, "A Soliloquy," *Puck*, May 18, 1881.

during the last two decades of the nineteenth century, both *Judge* and *Puck* had enormous political influence, by the start of the twentieth century, their circulation was reduced due to the rise of daily newspaper readership. *Judge*'s national circulation, for example, does not seem to have increased from 1901 to 1912 and was at 100,000 by 1912. *Life*, by 1916, though it was not yet in decline, was at 150,000.[20] Compare this to Hearst's 1913 syndicated newspaper readership from three major US cities of 1,500,000 and that, by World War I, nearly one in every four households bought a Hearst publication. It then becomes clear that the

readership of these humor magazines was small.[21] In addition, Varat notes that the cartoons that depicted Jews were usually "small, badly drawn, and hidden away deep into the back pages of the publications."[22] Moreover, Davies argues that jokes do not regulate or shape human behavior "but are social thermometers that measure, record, and indicate what is going on."[23]

These caricatures, however—reinforcing the notion of the Jew as Other, not assimilable into American society, and deeply, intrinsically flawed as a racial type—acted as additional voices in the early twentieth-century national debates about immigration, which resulted in the Johnson-Reed Act in 1924, closing the gates of America. While Diner notes that in America the state "stood aloof" from discriminatory practices against the Jews—that is, America's courts, legislatures, and laws were not directed specifically against them as they were against Black Americans, Chinese, Japanese, and Native Americans—nonetheless, though not specifically singled out, Jews were included in the list of those nationalities whose numbers were greatly reduced as a result of anti-immigration legislation in 1924. The role of the derogatory presentations of Jews over the decades cannot be ruled out as an influence for the passage of that legislation.[24] Moreover, in presenting the Jew as boorish and ill-mannered, these cartoons supported anti-Semitic efforts to bar Jews from entry into American social facilities and institutions.[25]

VAUDEVILLE

Just as caricatures of the Jew had appeared on the American dramatic stage and in newspapers and journals during the late nineteenth and early twentieth century, so, too, actors on the vaudeville stage offered comic presentations of what came to be known as the "stage Jew." Vaudeville, begun in 1881, arose as a result of massive societal changes that occurred in the second half of the nineteenth century. Urbanization, due to both the general movement away from the farm and into the city and the massive foreign immigration to the cities, made large audiences possible; workers had increased leisure time and some increased income to spend on entertainment. Urban life itself, with its multiple foci, speed, and movement, and modern technology (telegraph, railroad, gas lighting, color printing) contributed to vaudeville's phenomenal growth.[26]

Vaudeville was the sophisticated development of the American variety show, influenced by the circus, minstrelsy, natural curiosity museums, and concert saloons, in which a range of acts were presented.[27] While not as culturally elevated as the dramatic stage and opera house, vaudeville positioned itself as superior to the lower-class stag and burlesque shows. It was run as big business: large-scaled, nationally organized, and applying rational business models, such as ostensibly cleaning up bawdy acts to attract women and children, as well as offering continuous and tightly structured entertainment.[28] It utilized railroads to connect to theaters across America, creating both local and national vaude-

ville circuits (that the Vaudeville Managers' Association controlled) and employed the telegraph to arrange advance bookings (that the United Booking Office ran as a centralized operation).[29] In 1905, it was estimated that more than 12,000 people were employed in vaudeville and that $26 million had been invested in the over 300 vaudeville theaters across America, with an income of approximately $50 million a year. By 1910 it is estimated that the vaudeville circuits served 2,000 small theaters. A small number of conglomerates owned many of these theaters, just like they owned drama theaters across America.[30]

Vaudeville was not just a form of entertainment by the closing years of the nineteenth century, it was *the* primary entertainment platform. To and from it flowed blues, jazz, and classical musicians, as well as actors, singers, comedians, artists, and joke writers. They came to vaudeville from burlesque, minstrel shows, and the circus.[31] The variety of stage presentations was enormous. Among the list of over ninety possible acts in a 1913 instruction manual for aspiring vaudevillians—in addition to the usual singers, dancers, musicians, comedians, and jugglers—were barrel jumpers, ladder balancers, gun spinners, axe and boomerang throwers, bird imitators, and bell ringers.[32] Many vaudeville stars went from vaudeville to what they called the "legit" stage, such as the upscale Palace Theatre in New York.[33] Other vaudevillians made phonograph recordings and starred in silent movies and musical comedies, and, later, the talkies and radio.[34] At the same time, some performers moved from the upscale theaters to the vaudeville stage, as they discovered that vaudeville not only provided good publicity but was financially lucrative as well. Until movies and radio became the dominant forms of media, vaudeville paid the highest salaries in show business: stars like Lillian Russell could earn up to $3,000 a week in the early 1900s, equivalent today to $80,000.[35]

In addition to its stage entertainers, vaudeville also connected all entertainment media. For example, a popular vaudeville stage song would be published as sheet music and then etched onto phonograph records, which were later shipped to cities and towns across America, where they were purchased and subsequently played on home pianos and phonographs.[36] Other times, at vaudeville shows, song slides containing words from sheet music would be projected onto a screen and then sung by a vocalist and accompanied by piano music. Vaudeville cast members, operating as "stooges," encouraged the audience to sing along.[37] Often, music publishers would pay vaudeville performers to "plug" their songs.[38] Vaudeville also blurred the lines between reporting and entertainment. For example, Jacob Riis, a police reporter on the *New York Tribune*'s staff, employed a "vaudeville model" in 1888 for his lantern-slide presentations (the precursor to his book *How the Other Half Lives*) that exposed the miseries of tenement life. While showing his slides, he would give an improvisational talk adapted to his audience, tell ethnic jokes, and conclude with singing or organ music.[39]

Vaudeville and Comic Strips

Vaudeville's reach also extended to the comic-strip world. First, the papers in which the comics appeared (published by both Hearst and Pulitzer) were themselves a variety presentation of sensational news and vivid pictures, offering amusement and excitement. Second, it was not uncommon that caricatures of ethnic groups found on the vaudeville stage were utilized in comic strips. Vaudeville's broadly sketched, easily recognizable characters, often dressed in outlandish, clown-like clothes, were easy to transfer to the comics panel.[40] It also influenced how comic strips were presented. Vaudeville was a variety show: one turn (act) followed another. Though it had a logic all its own—one singing act or one dumb (silent) act, for example, would not directly follow another—there was no narrative link between them. In that same way, the Sunday comics page that Hearst popularized was also a variety presentation, with one strip following an unrelated other.[41] Just as the vaudeville sketch was meant to be not a narrative but rather the delivery of a joke to trigger the emotional reflexes of the audience, similarly, many comic strips had a punch line delivered at the end of each strip. Other strips—following the vaudeville convention of slapstick—had, literally, the punch, such as McManus's *Bringing Up Father*, in which Jiggs's wife, Maggie, regularly hit him over the head with a rolling pin.

The delivery of a joke in print, of course, was not quite the same thing as a joke delivered on the vaudeville stage. While some of the joke-telling aesthetics could be duplicated using names, accents, length of setup, and exact wording of the punch line, the preciseness of the timing and the pitch of the voice that added to the humor was not possible. A guide to foreign dialects for actors, for example, advised that "the pitch of Yiddish speech is much higher than in American."[42]

Vaudeville and Immigrants

Vaudeville also reflected the great and growing ethnic diversity that now comprised urban centers, and it helped shape the reaction of both nativists and immigrants to the changes that were taking place in American society. It was a primary means "by which the disruptive experience of migration and acclimatization was objectified and accepted."[43] It did so by presenting comic skits that mocked these strange people, which at the same time made them increasingly familiar. It is possible that the audience's laughter was not just ridicule—expressing a sense of superiority to the hapless immigrants—but was sympathetic laughter as well, as they reacted to the incongruous interactions between the newly arrived immigrants and the language and culture of America.[44] For these settled Americans, the fluidity of the ethnic and racial representations onstage, as costumes came on and off, as one ethnic actor played a different one—Jews masqueraded as Germans, Irish as Jews, everybody (even some Black Americans) in

blackface—was reassuring, suggesting how malleable identity was; the immigrant would be able to be shaped, molded, acculturated, and ultimately assimilated into the American melting pot. At the same time, these fluid representations were a safe way to express nativist fears that American identity might be less solid than it appeared. How—to continue the melting-pot analogy—could the new ingredients in the pot *not* change the "flavor" of America?[45]

In addition to settled Americans, vaudeville also provided a space for new immigrants, especially since it was affordable. Though very recently arrived immigrants would not have been able to follow the fast-paced, complicated malapropisms that constituted many vaudeville comic routines, there would have been plenty of singing, juggling, and instrumental acts that they would have enjoyed.[46] Some historians suggest that the more assimilated immigrants in the audience would have laughed at the comic skits, recognizing their own difficulties in speaking the language, and would also have come to vaudeville shows to be introduced to American culture and manners, since comic routines held up acceptable and ridiculed unacceptable social behavior.[47] For newly arrived Jewish immigrants, there were also variety formats based on vaudeville that were offered in Lower East Side theaters, such as the Houston Hippodrome. The comic skits were presented in Yiddish, which, joined with the knowledge that the audience consisted of one's fellow immigrants, was no doubt a source of support to new immigrants wrestling with adjustment to a new, unfamiliar world.[48] Thus, vaudeville brought together all the participants in the American conversation about immigration: the long-settled Americans, the recently arrived immigrants, and those immigrants who were more acculturated.

In addition to visual markers such as clothes and various props, dialect was utilized on the vaudeville stage to label each of the ethnic groups: "gwine" to indicate Black Americans, "just-a lak-a dat" for Italians, and "velly good" for Chinese are but a few examples.[49] The presentation of these dialects on the vaudeville stage, however, may possibly be seen not as demeaning humor but as high art—as a faithful representation of actual speech. A number of writers and stage performers stated that they had assiduously studied the speech patterns of New York Eastern European immigrants. Indeed, dialect, at that time, was not just on the vaudeville stage but also in literature, in newspaper comics and cartoons, and on phonograph records. Its presence reflected the great cultural changes that were occurring due to massive immigration to America. The use of foreign dialects—Italian, German, Irish, and Jewish—whether by Jewish or non-Jewish artists, writers, and actors, mirrored the growing heterogeneity of American society. Just as a variety of foreign tongues was now heard on the city streets, so, too, dialects were now represented in all the entertainment venues.[50]

But the dialect heard on the city streets was more than simple variety: it was a cacophony. This bewildering admixture of foreign voices was affecting the English language; immigrants, in their efforts to learn English, bent the

language, with strange results. This, too, was reflected on the vaudeville stage, through comedy skits in which English was "murdered," as one ethnic dialect was piled on another or as performers appeared in the dress of one ethnic group while utilizing the dialect of another.[51] In addition, these comic dialect sketches that made fun of the immigrants' corrupted English and cultural cluelessness helped render harmless the immigrant "teeming hordes," who were viewed with suspicion by more-settled Americans.[52]

It may also be that these dialects arose as a manifestation of immigrant concern. The dialect comedy skits in which English words were mispronounced, misused, or rendered in grammatically awkward ways would have mirrored immigrants' anxiety regarding the difficulties in acquiring competency in the English language. After all, becoming proficient with a new language is never easy. Not only must vocabulary, grammar, and pronunciation be mastered, but appropriate word usage in social settings and proper voice modulation for specific phrasing as well. This mastery of English was a key element that separated the accultured from the greenhorn.[53]

While the rapid-fire dialect comedy routines on the vaudeville stage would not have been understood or appreciated by those immigrants who had recently arrived, they would have appealed to those immigrants who had been settled for some time or to their children.[54] These dialects may have represented their anxiety about "passing"—in other words, a fear that one's mouth would give one away. (The classic Jewish joke of a fashionable Jewish woman attempting to pass in gentile society, who spills hot soup on herself at a non-Jewish country club and yells out, "*Oy vey!* Whatever that means," comes to mind.)[55] Moreover, these dialect skits could have been delivered only by those who had competence in English and in ethnic dialect. No surprise, then, that many of these performers were the children of immigrants.[56]

Vaudeville's Negative Side

Alongside its popularity, there were, however, several concerns expressed by theater critics, public moralists, and ethnic and Black American community leaders about vaudeville. First, there were worries, going back to the nineteenth century, about the morality of the theater in general: for example, that "nothing genuine or refined could come from a sphere of activity devoted to false representations and masked identities."[57] When it came to vaudeville in particular, there were concerns about its "purity" and its acceptability for women and children.[58] In addition, this period marked the beginning of the distinction between highbrow and lowbrow. The new humor of vaudeville was not genteel, highbrow humor that produced titters and chuckles, but, rather, it was meant to elicit loud and overly expressive laughter that swelled up from the body, appealing to the viscera and not

the head. Worse, this unrestrained, conspicuous laughter took place in mixed company. It was as if the saloon had moved onto the traditional stage.[59]

Moreover, the leaders of ethnic and racial groups considered vaudeville's presentations of their communities to be problematic. Because the vaudeville stage demanded a visual shorthand—one act quickly followed another, and each turn was only allotted a few minutes onstage—caricatures prevailed. Performers, accordingly, learned to prominently display quickly recognizable symbols of the character they were playing, such as appearance and style of dress. These visual cues were often not flattering and included ill-fitting clothes, rumpled hair, and oversized ears and noses. The ethnic characters portrayed appeared in ridiculous attire and were often of grotesque appearance. When it came to dialects, though they mirrored the cultural changes caused by massive immigration that were taking place in America, they also served to make it clear that these immigrants did not talk like "real" Americans. There was nothing subtle about these visual and aural cues, and, thus, they were often offensive and demeaning, calling attention to the Otherness of the character being presented. In short time, through repetition on the stage and through adoption by other stage performers, these cues, performed before audiences across America, became stock presentations for each racial and ethnic group.[60]

Just as in print, the vaudeville stage Jew appeared wearing an unkempt beard. Since, at the turn of the nineteenth century, men's faces, for the most part, were clean-shaven—denoting hygiene, professionalism, and eagerness as workers to be part of a business team—the Jew with not only a beard but an untrimmed one, at that, signaled to the audience that he did not possess those qualities that made for business success.[61] Like the Jew in print, the stage Jew was dressed in a derby hat pulled way down on the head so the ears stuck out, a long black coat, a pair of oversize shoes, and an exaggerated hook nose. The character would walk onto the stage with a limp to demonstrate his flat feet (a centuries-old motif) and gesticulate wildly with his hands. Open palms were used to represent exaggerated gesticulation (figure 1.3).[62]

The Jew on the vaudeville stage was also identified by his use of German dialect, substituting "v" for "w" ("vell" instead of "well") and replacing the "ah" sound with "eh" ("hev" instead of "have," "bleck" for "black").[63] Though these aural cues were identical for both a German character and a Jewish one, on the vaudeville stage, the German "spoke out with assurance," while the Jew had "a wheedling tone to his voice."[64] A guide to foreign dialects for actors stated that for the Jew, "The falsetto is reached many times, especially under the stress of emotion."[65] In addition, the performers used inverted English word order, misused adjectives and verbs, and comically confused English words. Finally, codeswitching was employed, in which Yiddish words or phrases were inserted into English speech.[66]

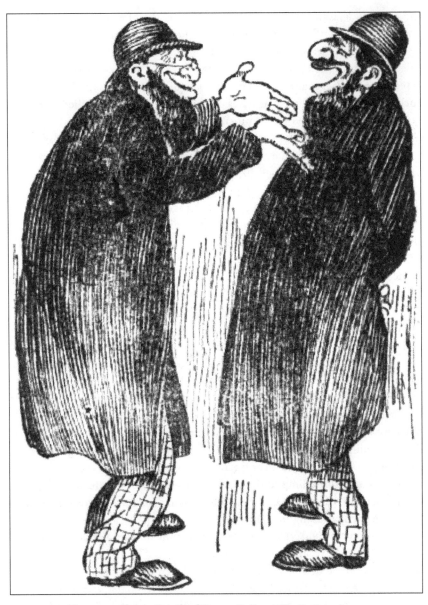

Figure 1.3. Cover, *Standard Dramatic Comic Recitations*, 1904.

Alongside their appearance and speech, the character (that is, the personal qualities) of ethnic and racial groups was also presented on the vaudeville stage in a derogatory manner: "Mexicans and Turks were viewed as crapshooters, Germans as agitating socialists. . . . Asians as opium-addicted. . . . Irish as lazy drunks. . . . Negroes wield razors and dine on watermelon." There were "canny Scotsmen, dumb and dirty Poles, cowardly Italians . . . uptight Englishmen."[67]

If, during the nineteenth century, the Jew had been presented on the dramatic stage and in newspapers, magazines, journal cartoons, books, and dime novels—inexpensive paperbound books read largely by the working-class population—as moneylender, pawnbroker, or fence, now he was presented on the vaudeville stage (and in newspaper cartoons) as a clothing salesman attempting to swindle the customer or plotting to burn down his business to collect the insurance money.[68] He had the negative qualities of greed, dishonesty in business, cowardness, and unmanliness.[69]

Though Yiddish theater of that time had its own visual shorthand for Jews who were on the stage—"a villain, Jew or Gentile, had to be redheaded; a *Hassid* (pious one) wore a colored kerchief; a sexton carried a snuff box; a marriage-broker an umbrella; the doctor must have spectacles"—and though it also had stock characters, employing the Eastern European types of the *schmendrick* (fool), *Kooney Lemel* (clown), and *schnorrer* (beggar), along with the American *griner* (greenhorn) and *allrightnik*, their appearance and their character traits, in contradistinction to the vaudeville stage, were not presented as demeaning.[70]

But the great popularity of vaudeville, its domination of all entertainment venues, and its operating as the primary cultural manifestation and influencer of that time drowned out these criticisms. Vaudeville, with its ever-changing presentations of acrobats, jugglers, singers, musicians, and quick sketch artists was truly *vaux de ville*, the "voice of the city," reflecting the rapid pace and visual spectacles of metropolitan life. Its enormous popularity at that time meant that the negative caricatures presented would not go away.

The Jewish Character in Print

In addition to the vaudeville stage, there appeared at this time articles citing pseudoscientific racial theories about the inferior characteristics of ethnic groups, arguing that, by their mere presence, they were detrimental to America.[71] The Jews were most certainly targeted in these articles. Some writers portrayed them as a public health menace by stating that their undersized bodies made them more vulnerable to disease. Others suggested that they were carriers of tuberculosis, even though they had developed an immunity to it over time.[72] In 1908, the *North American Review* carried an article by New York City police commissioner Theodore Bingham that estimated that roughly half of New York City's criminals—"firebugs [arsonists], burglars, pickpockets, and highway robbers"—"came from the Hebrews." George Kibbe Turner, in a 1909 muckraking essay, falsely charged that Jews dominated the "white slavery" trade: an international network to procure girls and women for prostitution.[73] Other articles on Jews and crime followed over the years, and though the Jewish community refuted many of the charges made against it, the sensational coverage in 1912 of the Herman Rosenthal murder as well as the arrest of Izzy the Painter, a

member of an arson gang, brought actual Jewish criminals of New York's lower East Side to national attention.[74]

At the same time, in the early twentieth century, Jewish entry into legitimate enterprise and their rising economic and political power alarmed nativists who worried that the Jews were too rapidly moving into all social spheres of American life and thus upending white Anglo-Saxon Protestant genteel traditions.[75] Given their overwhelming presence in New York City—as noted previously, by 1915 Jews comprised over one-quarter of the population—it is not surprising that it seemed to American nativists that the Jews were "taking over." In 1905, for example, it is estimated that roughly half the people working in the entertainment industry in New York—actors, managers, agents, songwriters, musicians, and theater owners—were Jewish. In 1906, Jews were the majority of the one hundred thousand New York City students taking evening classes. They dominated the apparel trade as well, comprising 75 percent of all its workers. Though the Jewish immigrants' ascent from impoverished sweatshop workers to middle-class business owners or professionals would, for the most part, take several decades to achieve, nonetheless, their real income rose annually by 1.3 percent during this time.[76]

Thus, Burton Hendrick, a Progressive muckraker, wrote two articles for *McClure's Magazine*, "The Great Jewish Invasion" (1907) and "The Jewish Invasion of America" (1913), detailing a fictitious conspiracy involving Jewish takeover of the clothing industry, the civil service, the public schools (through the presence of both Jewish students and Jewish teachers), and the theaters and department stores, as well as a concerted move by Jewish investors to buy up the old family estates of prominent non-Jewish families in New York. He wrote of the Jew's "restless ambition, his remorselessness as a pace-maker" that threatened established white Protestants.[77] In 1914, University of Wisconsin sociology professor Edward Ross wrote of another fictitious conspiracy in which Jews endeavored to control US immigration policy: "The systematic campaign in newspapers and magazines to break down all arguments for restriction and to calm nativist fears is based by and for one race." Ross also claimed that Jews were taking over the civil service: "Already in several of the largest municipalities and in the Federal bureaus a large proportion of the positions are held by keen-witted Jews." These weren't even his most serious accusations. Following the false charges in Southern newspapers that Leo Frank, the son of Russian Jewish immigrants, had molested and strangled a fourteen-year-old factory worker in Atlanta, Ross portrayed the Jew as sexual predator: "The fact that pleasure-loving Jewish businessmen spare Jewesses but pursue Gentile girls excites bitter comment."[78]

The Fourth of July 1912 issue of *Life* echoed this concern. It carried the cartoon "The Noon Hour on Fifth Avenue," which suggested that the Jewish hordes would soon supplant long-settled Americans. The cartoon showed a never-ending, packed stream of Jewish men—identified by their bowler hats; upraised, gesticulating hands; and a Yiddish (that is, non-English) newspaper—indifferent

CARICATURES AND SMOOTHING EFFORTS 31

Figure 1.4. Excerpt from "The Noon Hour on Fifth Avenue," *Life*, July 4, 1912.

to or ignorant of correct manners, crowding an alarmed upper-class woman (clearly not Jewish) and her child, forcing them off the sidewalk and into the street (figure 1.4). The fact that it was a woman who was being displaced, together with the absence of Jewish women or children in the cartoon, reinforced an even deeper nativist fear that their women were not safe from Jewish men.

Though at this time, in Appel's words, "hardly any group escaped humorous, satiric, and often condescending, demeaning and even hostile stereotyping," one newspaper editorial in 1903 opined that the Jews were "the most evilly caricatured people of all."[79] Whether or not the caricatures of Jews were presented more frequently or with a greater degree of opprobrium when compared to other ethnic groups, the fact is that when a Jewish character during this time was brought

forth on the vaudeville stage, it was in opposition to an ideal (namely, white Anglo-Saxon Protestant) body. When journal articles discussed the character of the Jew, it was often presented in ways that "perpetuated humiliation, degradation, and marginalization."[80]

Smoothing Efforts

Not all the caricatures of Jews presented to the American public, however, were negative ones. By the close of the nineteenth century, a few sporadic efforts took place on the part of Jewish novelists, illustrators, playwrights, and actors to avoid the heretofore mean representation of the Jew that had been presented to American readers and audiences. David Belasco's play *Man and Woman* (1890), for example, presented Israel Cohen, a Jewish banker of great integrity, and M. B. Curtis's reworked *Sam'l of Posen* (1894) featured Curtis (Maurice Bertrand Strellinger) as Samuel Plastrick, an honorable stock clerk.[81] The opening decades of the twentieth century would provide many more creations that smoothed the caricature of the Jew.

For some actors, this smoothing took place since the road out of the burlesque and vaudeville world and onto the more refined "legit" stage involved abandoning the odious personal qualities (e.g., greediness, dishonesty) of the stage Jew and, instead, presenting a more smoothed character.[82] One example of this is provided by the vaudeville star David Warfield (1866–1951), who appeared in the 1901 staging of the Broadway play *The Auctioneer*, fashioned for him by the producer David Belasco.[83] Levi, the hero of the play, still appeared onstage with vaudeville's stereotypical bowler hat, splayed feet, and stage Jew accent, yet he was also presented as a sympathetic Jewish character: an honest man who was devoted to his family and who cared for others. Though he rose in social status, he did not deny his Jewish identity. He reassured both the Jewish audience that success in America was possible without completely losing one's Jewish identity and the gentile audience that the Jew was not threatening to them.[84]

The illustrator, writer, and entertainer Bert Levy (1871–1934) provides a second example of a Jewish artist presenting smoothed-over presentations of Eastern European immigrants. Levy, born in Australia, began his writing and cartooning career with theatrical pieces for newspapers and satirical journals in the early 1890s. Often, he penned "Jew gags" that he later (in 1907) characterized as "drawing libels on Jews," though a contemporary writer stated that they were very funny. A common example is this dialogue between Jewish father and potential son-in-law: "Menser Motzerkleis: 'My daughter has £20,000; if you close your business on Saturdays, I'll make it £30,000.' Simcka Abramovich: 'Vell, make it £50,000 and I'll close it altogether."[85]

Levy immigrated to the United States in 1904 and settled in New York, where he drew illustrations for the *New York Times* and the *New York Morning*

CARICATURES AND SMOOTHING EFFORTS 33

Figure 1.5. Jacob Epstein, "Working Girls Returning Home," in Hapgood, *The Spirit of the Ghetto*, 1902.

Telegraph. Many of his sketches were of recent Jewish immigrants living on the lower East Side of New York. He stated that his secret ambition was "to illustrate the pathetic and serious side of my race."[86] Unlike his contemporary, the artist Jacob Epstein, whose drawings profiled the diverse inhabitants of the lower East Side, Levy's sketches focused primarily on Old World Talmudic scholars and Orthodox Jews (figures 1.5 and 1.6).[87] His later writings illustrated the great sentimentality he had for these inhabitants. Quite aware of how alien

Figure 1.6. Bert Levy, "A Study from Life," in Levy, "A Stranger among His People," *Broadway Magazine* 13, no. 11 (February 1905).

they appeared to American nativists, he proclaimed their worth as scholars who scorned the pursuit of material advancement, in the same way that novelist and playwright Israel Zangwill indicated, in *Children of the Ghetto* (1892), that the Jewish ghetto of London, "with all its poverty and misery, is the true spiritual and ethical center of Judaism."[88] Calling them "real Jews," Levy proclaimed that their great passion for "the dead and gone past . . . lends to their lives a

religious grandeur which the uptown tourist . . . would never suspect."[89] His presentation of these "exotic" characters, however, was not novel. A number of writers in the late nineteenth century, in observing Jewish neighborhoods, also presented them as remnants of an ancient, oriental past.[90] Levy's romanticizing of these Orthodox Jews would have reassured American nativists that those Jews who were not assimilating and who were continuing to cling to their Old World ways and religious practices were essentially harmless.

In 1905, Levy began to appear regularly on the vaudeville stage, performing as a quick-sketch artist using a device he invented: an early version of the modern overhead projector. His vaudeville experience influenced his creation of *Samuels and Sylenz* (1915), the second Jewish comic strip to appear in syndication (though its run was brief and its readership limited). Levy's strip featured two smoothed-over Jewish protagonists who followed the vaudeville format of the two-act, which will be explored in detail later. In the first four panels, Samuels, the tall straight man, set up the joke. In the last panel, Sy, who up to now had been silent, delivered the punch line.[91] Levy eliminated the vaudeville caricature of the Jew dressed in baggy pants with a derby hat pulled over his ears, instead portraying Samuels and Sylenz in more fashionable attire. Gone, too, were large noses and scruffy beards. To identify them as Jews, Levy gave them Jewish names and retained the vaudeville Jewish dialect.

> SAMUELS. I'm vorried about my vife. She talks so in her sleep. Last night she vas vorse than ever. She called me awful names.
>
> SY. Maybe she wasn't asleep. (See figure 1.7.)

The writer Bruno Lessing (1870–1940) provides a third example of smoothing over. He published almost one hundred short stories in the opening decades of the twentieth century that appeared in the popular magazines *Cosmopolitan* and *McClure's*. During that time, Lessing also served as an editor of cartoon strips for Hearst's *New York Evening Journal*. In Lessing's short stories, he sympathetically portrayed Jewish characters from New York's lower East Side, and the illustrations that accompanied his stories also did not represent those characters in derogatory fashion. To identify his characters as Jews, Lessing, like Levy, maintained the vaudeville Jewish dialect. In his short story "Bimberg's Night Off" (1912), for example, his character, Bimberg, states, "Der only chob vot I got is for a man to come sometimes unt take care uf der customers' umbrellas."[92] Lessing, however, was not presenting the vaudeville dialect to demean his characters; rather, he used it simply to signal that they were Jews. When he had Bimberg converse with an acquaintance in Yiddish, he rendered the conversation in grammatically correct, flowing English sentences: "I don't like the job in the theater, and I guess you can give me a better job in your big dry goods store."[93]

The writer Montague Glass (1877–1934) in 1909 introduced two Jewish characters, Potash and Perlmutter, to the growing field of popular and positive

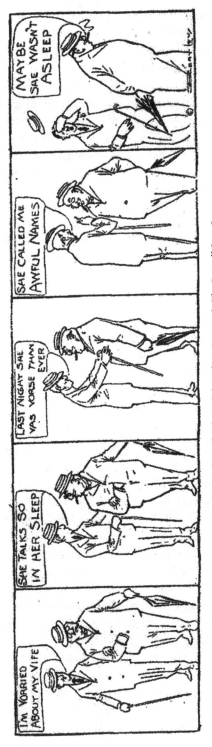

Figure 1.7. Levy, Samuels and Sylenz (*The Silent Partner*), The Lowell Sun, June 22, 1914.

CARICATURES AND SMOOTHING EFFORTS
37

Jewish fiction. His two Jewish immigrant businessmen with smoothed-over accents and appearances quickly achieved critical and commercial acclaim. Glass was born in Manchester, England, and came with his family to New York in 1890.[94] His humorous short stories centered on two Jewish immigrants, the previously mentioned Abe Potash and Morris Perlmutter, who worked in the New York cloak and suit trade. Beginning in 1909, Glass's stories appeared regularly in the prestigious *Saturday Evening Post*, with sixty-nine stories over a five-and-a-half-year period.[95] In a typical story structure, a business dilemma—a problem employee, a client refusing to pay a bill, a risky clothing venture—was presented. Comic twists and turns then took place before the dilemma was finally solved. Though they are almost forgotten today, Glass's Potash and Perlmutter characters received enormous acclaim in the 1910s and 1920s. The cultural critic and writer H. L. Mencken proclaimed in 1913 that Potash and Perlmutter "are now as familiar to most of us as the characters of Dickens."[96]

Like many vaudeville routines concerning unassimilated immigrants, the quest for money was a dominant and reoccurring theme in the Potash and Perlmutter stories. In a 1914 review of the Broadway show featuring Glass's characters, the American author Willa Cather called Potash "the old-fashioned Jewish merchant . . . who is always salesman, always pushing his line, always a two-price man."[97] Though consumed with doing business and making profits—the primary setting for the stories was the business office—the two were models of honesty, responsibility, generosity, and loyalty to their employees and friends. Other of the major themes of vaudeville were conspicuously missing from these stories. The humor was most decidedly not physical. Potash and Perlmutter did not engage in any of the slapstick antics of the burlesque stage: there was no hitting or pushing and only an occasional raised voice. The closest they got to violence was when Potash occasionally banged his thumb with a hammer. Nor were there the vaudeville run-ins with police or misadventures in trying to procure booze or sex.[98]

Glass primarily used three markers to identify his characters as Jews: names, food, and dialect. With rare exceptions, the friends, family members, employees, buyers, sellers, competitors, lawyers, brokers, and restaurant owners who comprised the world of Potash and Perlmutter bore Jewish names. Cohen, Federmann, Feinholtz, Samet, Vessel, Wasserbauer, and Zudworsky, for example, all appeared in a single Glass story, "The Early Bird." Even Philip Noblestone, it turns out in that story, was once Pesach Edelstein.[99] The food and drink that the characters consumed was identifiably Jewish (e.g., zwieback, gefilte fish, matzo, *mohn* (poppy) cake, schnapps, salt herring and onions, tongue sandwich on rye). In addition, these foods were vestiges from their Eastern European world, thus marking the characters not only as Jews but, more specifically, as Jewish immigrants.[100]

Glass also conveyed the immigrant origin of the characters by relying on inverted English word order ("Plenty of money, you got it") and misuse of adjectives, prepositions, and verbs ("I'm glad you look at it so sensible"; "One was worser as the other"; "Then they makes big money"). Sometimes, he introduced mispronunciation (e.g., "philantro" for "philanthropist"), malapropisms ("It aint no use crying over sour milk"), and, less often, the vaudeville stage accents that indicated a Jewish character (e.g., "dat" for "that"). In addition, Glass employed insertional code-switching, having his characters occasionally utter Yiddish words (e.g., *schlemiel, ganef, tzuris, schnorrer, oder*).[101] He preferred, for the most part, to let the accent be imagined, unlike later humorous writers such as Milt Gross, Mac Liebman, and Leonard Ross, who indicated Yiddish accents both with these devices and by using phonetic spelling.[102] While there were occasions when Glass used this style of spelling (e.g., "Mawrus," "theayter," and "oitermobile") to indicate an accent, he generally avoided it, stating in a 1917 interview that "grotesque misspelling" indicated a coarser form of humor than the one he strived to create.[103]

Their difficulty with English did not prove to be a stumbling block between Glass's Jewish characters and the American world they were trying to negotiate. This was unlike earlier vaudeville routines (such as Weber and Fields) or in 78 rpm comedy monologues, such as Hayman's "Cohen on the Telephone" (1913), which featured such jokes as "I'm your tenant, Cohen . . . No, not your lieutenant, your tenant."[104] The most daunting challenge of America that the characters faced was the "oitermobile," though this was only a challenge for Potash, who refused to ride in one. Perlmutter, on the other hand, soon owned a succession of automobiles and was able to talk about "light runabouts fixed up with removable *tonneaus*, thirty horse-power, two-cylinder engines."[105]

Since a number of his stories were illustrated, Glass, at first, in addition to the markers of names, food, and accents, also provided visual signs, such as clothing and physiognomy, to help establish Potash's and Perlmutter's immigrant identities. In his first two Potash and Perlmutter stories (1908), for example, Abe Potash had just begun the transition to clean-shaven Jew. While he did not sprout the typical beard of the stage Jew, he was, however, pictured with "muttonchops." In a 1909 *Saturday Evening Post* story, he had lost all his facial hair except for a thick mustache, and by 1911, in Glass's second short story collection, his mustache was trimmed and barely noticeable. If, in 1909, Potash was portrayed as short and cheaply dressed, wearing the stereotypical black bowler hat used in vaudeville routines, in 1911, he stood tall, was fashionably attired in a well-fitting suit, and wore expensive shoes (figures 1.8 and 1.9).[106] Some of these changes may be attributed to the lack of control that Glass had at the beginning of his writing career concerning the depictions that accompanied his stories since—as he recounted in his autobiographical submissions, he was simply grateful to have his stories published. Later, once he was a successful

Figure 1.8. Abe Potash. *Saturday Evening Post*, May 22, 1909.

author and assembled his published stories into collections, he undoubtedly had more control.

As popular as his short stories were, the greatest impact of Glass's work was due to a 1913 Broadway play, *Potash and Perlmutter*, based on his characters. Glass cowrote the play with Charles Klein (1867–1915), who, like Glass, had spent his childhood in England before coming to the United States. Klein

Figure 1.9. Abe Potash. In Montague Glass, *Abe and Mawruss*, 1911.

CARICATURES AND SMOOTHING EFFORTS 41

Figure 1.10. "Stanley D. Jessup, Alexander Carr, and Barney Bernard in the stage production Potash and Perlmutter." New York Public Library Digital Collections, Billy Rose Theatre Division, New York Public Library for the Performing Arts.

already had experience softening the image of the stage Jew, as the writer of *The Auctioneer*, mentioned previously.[107] The actors who appeared onstage in the title roles (Barney Bernard and Alexander Carr, both seasoned vaudevillians) maintained the vaudeville two-act model. Their characters had the stage Jew profession of clothes salesmen. Though they did not, for the most part, talk in dialect, they did speak with inverted English word order and occasionally used Yiddish words, signaling their immigrant status. They had no beards and wore fashionable business clothes (figure 1.10). In short, they were smoothed-over versions of the stage Jew.[108]

The play was a smash hit, running for over 440 performances on Broadway. Willa Cather wrote that during its long run, "the great Jewish population of the city packed Cohan's Theater night after night, roared at and applauded the play." Cather, however, went on, in a snobbishly nativist vein, to note that "people like plays that deal with their own social environment, written in the speech and idiom of their own class," and commented in an earlier review of the play that "there is not an American in the piece."[109] While Esther Romeyn suggests that the play was the first "to position itself squarely in terms of the Rehabilitation of the Stage Jew," Belasco's 1901 stage production of *The Auctioneer*, as well as Glass's short stories from 1909 to 1911, already helped prepare the way for the softening of this caricature.[110]

Passing Anxiety

Why, in the early twentieth century, was this smoothing process taking place? After all, images of the Jew on the stage and in print had already been prevalent for several decades before these smoothing processes began. It is notable that the artists who were doing the smoothing were second-generation immigrants. It may have been their anxieties about their own identity as Americans that drove them to this process, reflecting their attempts to smooth their own identity as Jews. These artists seemed to have had passing anxiety: the worry that their self-presentation as Americans risked being uncovered before the critical eyes of the more firmly established white, Protestant American nativists.[111] While their English betrayed no foreign accent, their clothes were fashionable, and their professions were often respectable, they still worried that they would be exposed as not fully American. After all, their names (both first and last) often gave them away. They grew up hearing two languages, perhaps not in equal measure, but two languages nonetheless; they knew that the stock they came from was not American.[112] In the second decade of the twentieth century, amid the outcry against hyphenated Americans (i.e., Italian-American, Jewish-American), they may have had concerns that they still would be viewed as harboring dual loyalties. Moreover, many of these second-generation children born in the last decades of the nineteenth century entered adulthood during the continuing immigration of Eastern European Jews. At exactly the time they proclaimed their identity as Americans, they were confronted by their brethren in alien garb, coming off the boat in numbers too large to be ignored. In this, their difference from the anxiety of the already settled Jewish German community—also alarmed by the hordes of "unwashed" Eastern European Jews coming off the boat—was only a matter of degree.

Though these artists and performers put on the costume of the unassimilated immigrant Jew in their creations—utilizing their clothes or accent or names—and smoothed them over in sympathetic treatment, at the same time, they were quick to publicly proclaim: "This is not me; this is a character study; I am not them." For some of these second-generation immigrant Jewish artists, what appeared to be an embrace of their fellow Jews who were less assimilated was more like a holding at arm's length. Some would deny completely that they were Jews. Others who did not deny being Jewish nonetheless made little mention of their original birth names, their own immigrant parents, and their knowledge of Yiddish. Thus, the smoothing over of a previously offensive stereotype of the Jew was sometimes rendered by those whose own Jewish identity was still in the process of being smoothed.

The actor David Warfield, mentioned earlier, presents one example of artists' intent to distance themselves from their creations. Warfield (who had changed his name from Wohlfelt) claimed that his stage Jewish accent and gestures came

CARICATURES AND SMOOTHING EFFORTS 43

from visiting and observing Jewish daily life on the lower East Side of New York. Moreover, in speaking to reporters about Jews, Warfield always referred to them as "they."[113] Sam Bernard (Barnett), the English-born American vaudeville performer, claimed that he picked up the dialect for his "Dutch" (German) impersonations by observing others in the German American community in New York. He gave no indication, however, that he also might have been influenced by his father, a Jewish immigrant from Suvalk, Russia.[114] Alexander Carr, who starred on Broadway in Glass's hit *Potash and Perlmutter*, stated that he learned to imitate Jewish dialect and mannerisms from watching Jews on Wall Street, neglecting to mention that he was an immigrant himself and that his father was a Russian rabbi.[115]

If, for actors, their public distancing from their own Jewishness can possibly be attributed to their desire not to be typecast and thus limited only to Jewish roles, the distancing of artists and authors might be explained by the trend of that time to present visual spectacles of metropolitan life. Often, this would involve so-called slumming: providing readers and viewers access to little-known places while relieving them of the need to experience those places firsthand. Jacob Riis, for example, did this in his reportage of life in New York's Jewish ghetto, presenting exotic Others while simultaneously holding them at arm's length. Often these artists and writers, while sympathetic, were also patronizing to the groups they presented and would position themselves as socially superior.[116] Some of these Jewish artists and writers even seem to have gone out of their way to provide a cover story for their creations. Lessing, for example (born in New York as Rudolph Block, to German immigrant parents), never stated publicly that he was Jewish and claimed that it was not until the early 1890s that he became familiar with Jewish life on New York's lower East Side, realizing "their poverty and frightful sufferings, and finally their picturesqueness."[117]

Bert Levy, in his writing and drawings of New York's East Side Jewish neighborhood, appears, at first, like Riis, to have been merely another dispassionate writer of realism. Just as Henry James, an unsympathetic viewer of New York's Jewish immigrants, wrote of his 1907 visit to the Bowery that it was a "look-in," Levy made it clear that he was "wandering" around the streets of the Jewish neighborhood, "gazing at the scene." Though he rendered sympathetic, sentimental portraits of Orthodox Jewish immigrants and though he did not deny his heritage—standing among them as "a coreligionist" and desiring to cry out to them, "I am a Jew!"—he, nonetheless, simultaneously took pains to distance himself from his subjects. He was quick to state that he felt like "a stranger among my own people." He claimed that this was because he did not understand their tongue, yet both his parents were Russian immigrants, and it is highly likely that he heard Yiddish being spoken in his home while growing up. Moreover, in a short essay about his time in the New York "ghetto," he translated the Yiddish murmuring of an old man. It is likely that Levy, a fully assimilated Australian

with an immediate ease in American society and with English as his native tongue, was made uncomfortable by the difficulty these immigrants had in speaking English, as well as by their clothing, which immediately marked them as unassimilated immigrants; he wanted to make clear his own position as an assimilated Jewish-American.[118]

Montague Glass, like Levy, utilized literary devices that underscored the distinction between the author and his creation, such as his "pointed sense of irony" and use of a socially superior narrator who spoke in impeccable English (and sometimes used French words such as *bonhomie* and *avoirdupois*). This served to distance him, as author, from his two characters whose command of English and grasp of American culture was still not fully formed. Like Levy, Glass presented sympathetic Jewish characters and stated that he was Jewish.[119] Yet Glass also seems to have had some anxiety about his Jewish identity. In a 1917 interview, he stated, "I had intimate knowledge of the psychology of the Jew, his religion, his humor, his tragedy, his whole attitude toward life."[120] Here, the "his" functioned to distance Glass from his Jewish subjects. Moreover, while Glass stated that his characters were drawn from his years as a commercial lawyer working with partnership and bankruptcy cases that involved Jewish members of New York's garment district and that, as a Jew, he was familiar with their idioms and dialect, he conspicuously neglected to mention, once his short stories were published, that his ear for immigrant speech also came from his own experience as the son of a Russian immigrant father. While he provided his father's very English-sounding name (James D. Glass), he did not mention that his father was from Telz, Russia, and had only arrived in England ten years before Montague's birth. Though he passed over his father's background, Glass did make sure to make known that his mother's family had lived in England since the early 1700s (establishing his English pedigree) and that his New York–born wife, Mary Caroline Patterson, could trace her ancestry back to the Mayflower (asserting his American bona fides).[121]

The passing anxiety expressed by these artists suggests that some of them may have been less "at home" in America than Dash Moore's work on second-generation American Jews suggests.[122] Though it is true that these artists were able, through their creations, to synthesize American urban culture and immigrant Jewish culture, the anxiety over their ability to fully pass seems to have still remained in spite of their thriving careers, fame, and economic success. This anxiety, however, was not manifest in their artistic productions, which reached a wide audience and presented to the American public for the first time a new, less derogatory, and, at times, noble image of the Jew.

There was also a second strategy at work during this time to achieve an improved presentation of the Jew. Faced with derogatory caricatures of Jews on the stage and negative discussion of their character in journal articles, Jewish self-defense organizations led by the more settled German Jews sought the

elimination of those caricatures and stereotypes they deemed to be offensive. The results of these censoring efforts would serve as a measure of the Jewish community's influence when it came to making changes in American society. Before turning to a detailed examination of Harry Hershfield's smoothing efforts in his long-running comic strip *Abie the Agent*, it is first necessary to examine this second approach to combatting the negative caricatures of the Jew, especially since it affected a number of the artists undertaking smoothing efforts, especially Hershfield.

CHAPTER 2

Censoring Attempts

The stage Jew is a stench in our nostrils, a disgrace to the country, an insult to the Jew, and a discredit to the stage. —Rabbi Joseph Silverman, 1910

In the closing decades of the nineteenth century, there had been some attempts to publicly protest the derogatory appearance of the stage Jew. These included criticism from the *American Hebrew* in 1881 of the portrayal of the Jew in the comic play *Sam'l of Posen* and a challenge from Chicago's *Jewish Messenger* in 1886 against the presentation of a Jewish caricature by the noted vaudeville performer Frank Bush.[1] In 1899, the *Buffalo Courier*, before reviewing a number of Jewish plays due to be presented in 1900, stated of the stage Jew: "The more offensive he can be made, apparently the better. He is usually presented on the vaudeville stage in old clothes which are filthy, with unkempt hair and beard, stooped and his conversation limited solely to fires which he has started for the sake of the insurance, the loss of some money . . . or a bargain in which he has cheated the person who placed confidence in him." While acknowledging that other nationalities and ethnicities, including Germans, Black Americans, Irish, and Chinese, were also ridiculed on the stage, the article stressed that their "peculiarities" were shown to be honorable, while the Jew was presented "in any but an agreeable manner." The *New York Dramatic Mirror* made the same point in an editorial a few months later.[2]

The Jewish community's general response in the early years of the twentieth century to derogatory caricatures of the stage Jew continued to be muted, confined largely to editorial pieces in city newspapers. For example, when David Warfield appeared in 1901 on the Broadway stage as Simon Levi in *The Auctioneer*, the *New York Evening Journal* pointed out that the play still contained vaudeville stereotypes of the Jew. In 1902, the play's director, David Belasco, sensitive to adverse publicity, invited a group of Chicago clergy from different faiths to attend a performance to vet Warfield's stage characterization. In this he was successful, since afterward, Rabbi Tobias Schanfarber, head of a large Reform congregation, strongly endorsed the production.[3]

CENSORING ATTEMPTS

These positive responses, however, were isolated reactions. In 1901, the *Indianapolis News* opined, "It is a curious thought, with the growing influence of Jews in theatrical matters, so little respect is paid on stage to the Jewish character of the Jewish tradition." Following a 1903 incident in which the Ancient Order of Hibernians organized to throw eggs at comedians doing Irish caricature, an editorial concluded, "But who ever heard of Jews . . . making themselves ridiculous by taking these caricatures in dudgeon and solemnly organizing to drive them from the stage?"[4] Contrast this, however, with the response of Jewish communities in major cities across America who, thirty years earlier, in 1867, organized boycotts against those insurance companies that falsely claimed that Jews had a high incidence of arson claims.[5]

One reason for the subdued response is that Jewish actors and entertainers presented many of the caricatures. In a 1907 public lecture in New York, the Reverend Dr. Madison C. Peters, while criticizing comic papers and vaudeville performers who caricatured the Jew, stated, "It is about time the Jews themselves protest against the lampooning of themselves on the stage, not alone by cheap rate Christian actors and mimics but by Jewish burlesquers as well. How can a people expect respect when they laugh at their own degradation?"[6] There have been many reasons advanced as to why Jewish performers would elect to portray stereotypical, often degrading, images of Jews. Such reasons include self-hatred and self-deprecation, created to deflect dangerous Jewish aggression away from their persecutors and onto themselves.[7] Other explanations put forth are that these presentations by Jewish performers were due to the tension between the advantages of assimilation and the wish to preserve their ethnic and religious identity or reflected the struggles of recent Jewish immigrants to reach their full goals of American acculturation.[8] Still others argue that the presentation of the stage Jew was not due to unique issues facing Jews per se but, rather, was due to factors shared by all vaudeville performers from various ethnic groups, such as economic necessity. Further, their characterization was but one of several a single performer would be called on to present on the vaudeville stage, and especially through dialect comedy, their performance reflected the changing speech patterns of a new, heterogeneous American society brought about by massive immigration.[9] Finally, these presentations might have been the means for performers from various ethnic and racial communities to strengthen their attachment to their community or might be seen as subversive, seeking to ultimately undermine the stereotypes being presented.[10] Regardless of these performers' reasons, while latitudinarianism was a fine principle when it came to Jewish *religious* life in America—Jews were free to worship where they wanted and how they wanted, if at all—when it came to how they portrayed their fellow Jews, a number of communal leaders and Jewish community organizations soon stepped in to intervene.[11]

INFLUENCES ON ORGANIZED PUSHBACK

Several factors led to an organized pushback from the Jewish community. First was the sensitivity on the part of already settled German Jewish community members as to how they were now being perceived by other Americans. Just as there had been a socioeconomic divide in the Irish community beginning in the late nineteenth century between those born in America and those newly arrived, so, too, there was a tension during that time between the previously arrived Jews from Germany and their newly arrived Eastern European brethren. By the early decades of the twentieth century, this socioeconomic divide was also present between the second-generation Eastern European Jews—already settled in the United States for several decades—and the newly arrived Eastern European Jews. Just as the settled Irish community saw themselves, and wanted other settled Americans to see them, as "lace-curtain Irish" and not as the "shanty Irish" associated with the new immigrants, so, too, did the German Jews who had already moved into the middle class and the children of newly arrived Eastern European Jews who were just beginning to do so (and did not want to be viewed as greenhorns) want to be seen in the eyes of American nativists as successful, fully assimilated Americans.[12]

While some anti-immigration writers in the opening decades of the twentieth century distinguished between the well-assimilated German Jews and the newly arrived Eastern European Jews, others simply referred to both as "Jews." Consequently, the leaders of the already established Jewish community worried that their fellow Americans would not distinguish between the two groups; as a result, their hard-won success in America felt threatened. The German Jewish community had already experienced social discrimination by American nativists in the 1870s, such as when Joseph Seligman, the well-known Jewish banker, was barred from the Grand Union Hotel in Saratoga, New York, in 1877, and when Austin Corbin, a railroad robber baron, excluded Jews from his Manhattan Beach resort in Brooklyn in 1879.[13] Leaders of the German Jewish community also worried about surplus visibility: the feeling that whatever they said or did was too much and too conspicuous. Starting in the 1880s and 1890s, Jewish newspaper commentators warned that "ostentatious Jews, the loud and flashy parvenus and their jewel-bedecked women" were responsible for fueling anti-Jewish sentiment.[14] The artist Bert Levy, whose work was explored in chapter 1, provides an example of this sensitivity. He wrote of his discomfort with his "hurrying, pushing, shoving brethren" and their "aggressive personalities." He wished that they would "behave modestly . . . talk less, and appear less ostentatious," "stand back and keep quiet," and attempt to suppress themselves.[15]

In addition to their sensitivity about surplus visibility, members of the German Jewish community had a genuine concern for the plight of Jews overseas.

CENSORING ATTEMPTS 49

During the nineteenth century, they held rallies and lobbied Congress, speaking out, for example, against the Damascus blood-libel affair of 1840 and the Catholic Church kidnapping of Edgar Mortara in Bologna in 1858–1859.[16] They formed the American Jewish Committee (AJC) in 1906 to counter anti-immigration legislation in the United States, primarily through behind-the-scenes lobbying by their economically successfully and politically connected leadership. In 1914, when the literacy-test act was established, German Jewish community leaders were able to have an exemption inserted within it for those fleeing religious persecution, allowing Eastern European immigration to continue. From the point of view of the AJC's leaders, negative characterizations of the Jew made it harder to combat anti-immigration prejudices and fight against anti-immigration legislation.[17]

Moreover, the concern by leaders of the German Jewish community and by the more settled Eastern European Jews over how Jews were seen by previously settled Americans was magnified by the rise of modern media. Syndicated wire services, such as the Associated Press, the United Press, and International News Service, flowed across 240,000 miles of telegraph lines, providing inexpensive copy for newspapers throughout the United States; this copy often contained sensational stories, such as the Rosenthal murder trial, mentioned in chapter 1. Vaudeville performers appearing on circuit stages, which were linked to one another through an extensive, transcontinental railroad system, spread demeaning caricatures of Jews not only in major cities but also in smaller towns. The railroads also served to distribute copies of *Punch*, *Judge*, and *Life*, which carried cartoons portraying Jews as cunning and dishonest businessmen, to homes across America. As noted earlier, articles appeared in nationally distributed journals by sociologists and eugenicists who presented "scientific" arguments for the racial inferiority of Jews, by Progressive Era muckrakers detailing Jewish criminality, and by nativist writers issuing jeremiads concerning the Jews' takeover of traditional American institutions. Phonograph records mocked the Jews' struggle with English and their acculturation to American ways; silent movies presented the scheming, unscrupulous Jewish merchant. All these forms of media and entertainment—mass-produced and mass-distributed—were listened to and watched by Americans throughout the country.[18]

While some historians suggest that offensive presentations of the stage Jew also had the advantage of making Jews more familiar to long-settled Americans and that situating them on the stage in relationship with white Anglo-Saxon Protestants made them more sympathetic characters, the German Jewish community at this time did not share this perspective, especially since there was no advantage to familiarity when the Jew was repeatedly presented as greedy and unscrupulous, nor was the stage Jew's relationship with others meritorious when it involved cheating them. Accordingly, concerned by both how they were seen and how this would impact their efforts to keep the doors of immigration

open to their beleaguered coreligionists in Europe, the leaders of the German Jewish community stepped forward to counter the negative presentations of Jews, seeking through their censoring efforts to render the Jew invisible as a racial type from the gaze of others.[19] Just as the vaudeville booking offices served as an intermediary between the performers and the public, deciding which acts would have entertainment value, the German Jewish community in America sought to operate as intermediaries, deciding which ethnic presentations, jokes, and songs would be acceptable to present to audiences.

In addition to concerns that demeaning presentations of the Jew negatively affected them, the established German Jewish community may have also had some aesthetic unease about these presentations. A Boston Jewish weekly paper, the *Advocate*, in an editorial denouncing the stage Jew, stated: "We protest against the invasion of the better class theaters by the low-browed and degenerate bewhiskered clowns. Their audiences do not deserve to suffer their 'turn.'"[20] Superior Court judge Hugo Pam, who would help form a Jewish censoring organization in Chicago, stated that some of the representations of the Jew were "undignified."[21] As will be explored, the leaders of Chicago and New York Jewish vigilance committees were primarily composed of judges, politicians, and wealthy businessmen—most of them upwardly striving German Jews. It may be that their concerns about the presentation of the stage Jew were class ones, similar to the earlier so-called protectors of Victorian standards, and that they were alarmed by the lower-class nature of vaudeville.[22]

Another reason for the rise of these Jewish vigilance groups was the influence of various civic, social reform, and censorship groups and organizations that arose in major U.S. cities during the Progressive Era to regulate visual representations, dubbed "the reign of the spectacular," that appeared on the stage and in film.[23] Anthony Comstock's New York Society for the Suppression of Vice, first formed in 1873 to fight pornography, sought, by the early 1900s, to monitor the burlesque stage and motion pictures. In 1907, Chicago passed a motion-picture censorship law; the National Board of Censorship of Motion Pictures was created in New York in 1909; and in 1910, Chicago turned to stage songs, banning "Her Name Was Mary Wood but Mary Wouldn't" and "I Love My Wife, but Oh, You Kid."[24] Comic strips were also scrutinized. In 1910, the League of American Pen Women, consisting of women authors, created the Committee for the Suppression of the Comic Supplement. Perhaps realizing that total elimination of the comics was not possible, their group was soon renamed the League for the Improvement of the Comic Supplement. In 1911, they held a mass meeting in New York where they sought to refine the content of the comics presented in Sunday newspapers.[25] In Chicago, for example, it is difficult to ascertain who influenced whom at the turn of the century: whether it was Jewish community leaders affecting Chicago's censorship efforts or Chicago's censorship efforts affecting Jewish stage policing. The same individuals active in Jewish

vigilance groups also served on the Chicago censorship board and on citizen censorship juries and were active in Democratic Party politics.[26]

Another reason for the rise of these Jewish censoring efforts was that their formation was part of a general trend in America during this time in which ethnic, racial, and religious groups established national organizations that lobbied for their specific concerns. Catholic and Protestant groups had organized in 1905 to protest vaudeville productions held on Sundays. The National Association for the Advancement of Colored People began in 1909 to combat negative images of Black Americans, and the Irish formed the Society for the Prevention of Ridiculous and Pervasive Misrepresentation of the Irish Character in 1907.[27]

ORGANIZED JEWISH CENSORING

In April 1907, Maurice Weidenthal, the founder and editor of Cleveland's *Jewish Independent*, led the first organized attempt to combat caricatures of the Jew onstage. A few months earlier, he had spearheaded a successful effort to eliminate Shakespeare's *The Merchant of Venice*, which contained, as noted earlier, anti-Semitic stereotypes of Shylock as avaricious moneylender and Christian hater, from Cleveland's public-school curriculum.[28] After this, Weidenthal turned his attention to the stage Jew, urging his readers to pressure local theater managers not to hire "Hebrew comedians" by boycotting their theaters.[29] Nor was his ire directed solely against non-Jewish performers. In August of that year, he proclaimed that "a Jewish stage Jew is worse than a thousand non-Jewish 'Hebrew' impersonators. He is the worst of the miserable tribe of 'comedians.'"[30] A number of Jewish publications in major cities throughout the United States subsequently echoed Weidenthal's sentiments. Charles F. Joseph, for example, the editor of the *Jewish Criterion* in Pittsburgh, declared, "The idea of having a man come upon the stage with his hat over his ears, his shuffling walk and his vulgar actions is an outrage on self-respecting people."[31]

However, though the *Jewish Independent* regularly splashed calls for boycotts of theaters and reprints of letters sent to theater managers across its front pages throughout 1907 and 1908 (and less frequently but steadily from 1909 to 1910), this only resulted in few and small changes in Cleveland and other cities. The Jewish community of Youngstown, Ohio, was able to pressure the manager of the Grand Opera house to cut a scene involving three stereotypical stage Jews, representatives of the Cincinnati Jewish community convinced city officials to remove a billposter of a Hebrew comedian whose appearance they deemed offensive, and a performance by the "Hebrew comedian" Joe Welch was canceled in Atlanta when a rumor arose that Jewish attendees were going to throw rotten eggs at the actor.[32]

Overall, the *Jewish Independent*'s campaign resulted in little more than pious sentiments. Several theater owners responded that they were "heartily in sympathy" and would try to prevent "anything offensive" from being presented

to local theatergoers, and the manager of Keith's Theatre in Boston framed the letter of concern written by the *Jewish Independent* and placed it backstage where all his artists could read it.[33] The campaign did not lead to substantial changes in acts. Los Angeles, San Francisco, St. Louis, and Albany chapters of the Independent Order of B'nai B'rith, a social service and philanthropic organization founded by German Jews, sent circular letters to theater managers from 1908 through 1912 but fared no better.[34]

The same tepid results occurred in response to an attempted New York campaign in 1910. Two years prior, in 1908, Rabbi Joseph Silverman of New York's prestigious Reform congregation Temple Emanu-El, who had previously joined with the Actors' Church Alliance to "clean up" the theater, made a proposal to B'nai B'rith for an agency to be established for the "defense of the Jewish name." Specifically, like Weidenthal, he sought to eliminate the stage Jew from the theater and eliminate Shakespeare's *The Merchant of Venice* from the public schools.[35] In 1909, he called on the Reform movement's Central Conference of American Rabbis (CCAR) to address these issues, and in a 1910 Sunday-morning lecture that was covered in several New York newspapers, he called for a campaign against the caricaturing of the Jew in print and on the stage. No campaign, however, materialized, and only one vaudeville manager, Percy Williams, responded, publicly stating that he would not engage any vaudeville act who offensively caricatured the Jew in any of the eight theaters he controlled.[36] The show went on, however, and the caricatures continued. Moreover, a few months later, the stage newspaper *Variety* carried an article that suggested that both Silverman and Williams were simply publicity seekers.[37]

The CCAR, however, did respond to Silverman's call. In 1910, its Committee on Church and State corresponded with the New York Managers' Association, but that resulted in little more than assurance that the association would "discourage" demeaning caricatures. Undaunted, the committee continued to press its case, writing letters in 1911 and 1912 to the National Theater Owners' Association and to managers of vaudeville circuit operations. Rabbi William Friedman, president of the CCAR, subsequently declared that the CCAR had received responses from theater managers across the country and claimed that the CCAR had "eliminated from the American stage, caricatures of the Jew that tend to offend members of the Jewish religious faith."[38] The popular magazine *Judge*, which had been a source of derogatory cartoon portrayals of Jews for decades, now opined that "there should be no form of caricature in the theater . . . tending to offend any race or make light of any religion. The caricatures of the Jew against which pertinent complaint is made have no place in plays, in songs or in journals."[39]

Yet such a response was rare. While it is true that the committee received prompt replies from theater owners and producers such as J. J. Shubert, Martin Beck, Alex Pantages, and the William Morris company stating that they were in "hearty accord" and pledging their support to remove objectionable carica-

CENSORING ATTEMPTS 53

tures of the Jew, the meaning of "objectionable" was undefined, as were the lines between caricature and character. Thus, despite Friedman's claims, the committee in its 1912 report to the CCAR was only able to mention some vague success and stated that the problem was not eradicated. In 1913, continuing to substitute words for actions, the committee reported to the CCAR, "From communications from many sources we know that the theatrical profession, for the most part, recognized the justice of our protests." In 1914, the committee moved on to other issues, recommending that the work of protesting the stage Jew now be left to B'nai B'rith's recently formed Anti-Defamation League.[40]

A 1913 Chicago campaign against the stage Jew, however, had much greater success than the Cleveland, New York, or CCAR crusades. In March 1913, Mollie Osherman, managing editor of the *Chicago Israelite*, responded to two critical reviews of the Jewish caricature actor Barney Bernard, who, as noted in chapter 1, would soon star on the Broadway stage playing Abe Potash. One of the reviews stated that "a gentile can never cease to marvel why the Jews . . . permit the outrageous blackguarding of their race." In response, Osherman declared, "When two well-known critics stigmatize a Jewish characterization as outrageous and incredibly offensive, it seems that there is a clanging call for action."[41] She turned this call into deed during the next month, convening a town hall meeting that called not just for a letter-writing campaign to theater managers, producers, and playwrights but also for boycotts of theaters that presented demeaning portrayals of Jews. One of speakers there was James O'Shaughnessy, former president of the Irish Fellowship. Though one of the attendees proclaimed that the group would adopt the same methods as the Irish societies that had vociferously protested Irish stereotypes on the stage with eggs, potatoes, and bricks, the leadership settled on more restrained activities.[42]

A second town hall meeting, in June, was attended by over two hundred delegates from Chicago Jewish clubs and organizations.[43] Joining with Osherman in leading this campaign were judge Hugo Pam; Reform rabbis Tobias Schanfarber and Joseph Stolz; Adolf Kraus, president of B'nai B'rith; Hannah Greenebaum Solomon, first president of the National Council of Jewish Women; Congressman Adolph Sabath; Senator Samuel A. Ettelson; and a half-dozen other Chicago civic leaders and businessmen.[44] Most of the committee were Jews who were either German born or the children of German immigrants and were part of Chicago's German Reform Jewish elite. Mollie Osherman, however, who led the group, had been born in Russia and was the daughter of a tailor.[45]

At first, the campaign seemed to follow the exact trajectory of those that came before: members of the group wrote to theater managers expressing their concerns about the stage Jew and received back from them nebulous expressions of support. Yet the Chicago campaign was different from its predecessors. Unlike both Weidenthal's and Silverman's "one-man operations," it had, from the outset, enlisted support from some of Chicago's prominent Jews and from

54 SMOOTHING THE JEW

individuals who had real political power as councilmen or elected officials, and it attracted influential women who had previous experience in organizing for Progressive causes, all of which resulted in initial town hall meetings attended by hundreds. Due to its numbers and, especially, to its prominent members, the campaign was covered not just in the local Jewish papers but also by the city's chief paper, the *Chicago Tribune*; from there, the campaign was noted in papers across America. This would be a movement that theater managers, theater owners, vaudeville-circuit booking agents, and even the performers themselves could not ignore.[46]

The campaign's first successful boycott occurred that May, when the manager of the Victoria Theatre announced an end to Jewish caricature on the theater's stage. A few weeks later, the manager of the American Music Hall, a Shubert property, altered a sketch after the committee complained about a caricature involving "Hebrew dialect." Eva Tanguay, a notable vaudeville performer who was also appearing at the theater, offered her support. In August, the Majestic Theatre announced that it would ban "obnoxious Hebrew comedians."[47] The group, by this time, also had a name: the Chicago Anti Stage-Jew Ridicule Committee. In several circulars issued in September, it called for Jews to avoid theaters and nickel shows where offensive stereotypes of the Jew were presented and to protest to the management about these issues.[48]

During that summer of 1913, the New York Jewish community acted as well, based on the Chicago model of organizing. Rabbi Joseph Silverman now gathered the support and alliance of powerful Jewish philanthropists Jacob Schiff, Nathan Straus, and Solomon Guggenheim and arranged a mass meeting. They were joined by Congressman Henry Goldfogle, Senator Henry Pollock, and Mark Eisner, a member of the New York legislature, who also addressed the gathering.[49] In addition, also in 1913, the New York Kehillah, a conglomeration of several hundred New York organizations, appointed a lawyer, Morris Simmons, to head its Committee for the Protection of the Good Name of Immigrant Peoples, believing that "the protection of the good name of immigrant peoples was not a Jewish matter alone." The committee sought to suppress films, performances, and publications that it deemed to be offensive to any of the immigrant groups.[50] The prominent members of the Kehillah executive board, including Jacob Schiff, Louis Marshall, Felix Warburg, and Cyrus Sulzberger, who were powerful bankers, businessmen, and financiers, gave the committee some clout. Soon after its creation, following an advertisement by the Jewish vaudeville performer Fannie Brice (Fanya Borach)—famous for her Jewish caricatures—that she would be appearing at Keith's Palace Theatre during Yom Kippur, Simmons wrote to Edward Albee, the vice president of Keith's, intimating that Brice's actions contributed to "the recrudescence and continuance of the spirit of Anti-Semitism in America." Albee quickly wrote back stating that he would call on her to apologize and that if she did not, he would refuse to book her for performances.[51]

CENSORING ATTEMPTS 55

By the fall of 1913, yet another Jewish defense organization was started. B'nai B'rith formed a National Caricature Committee, which soon became the Anti-Defamation League of America (ADL). It seems likely that Adolf Kraus of Chicago, international president of B'nai B'rith, formed the National Caricature Committee due to his involvement with the Chicago Anti Stage-Jew Ridicule Committee.[52] Though its initial goal, like that of the Kehillah committee, was opposing prejudice against all racial and ethnic groups, the ADL's focus soon shifted to protesting anti-Jewish stereotypes on the stage. Following the lead of the Anti Stage-Jew Ridicule Committee, the ADL's strategy was to approach theater producers and managers with the goal of eliminating offensive Jewish stereotypes from proposed performances before they were staged. In addition, the ADL also monitored journals and newspapers. For example, Adolf Ochs, the publisher of the *New York Times* and a member of the ADL's executive committee, sent letters to newspaper editors around the country with guidelines for mentioning the Jew in print.[53]

While the ADL had some initial success in removing derogatory presentations of the Jew on the stage, it was more difficult for the group when it came to eradicating Jewish stereotypes presented in silent films.[54] In the second decade of the twentieth century, a number of early silent films featured the Jew as a scheming merchant whose cleverness was "unethical, morally dishonest, or illegal" as he sought to get ahead in business.[55] *Foxy Izzy* (1911), for example, involved a Jewish peddler who tricked a group of tramps who had robbed him, while *A Flurry in Diamonds* (1913) presented a Jewish patent-medicine salesman who sold fake diamonds. Other films like *Cohen's Fire Sale* (1907), *Levitsky's Insurance Policy* (1908), and *The Firebugs* (1913) portrayed Jewish businessmen who attempted to burn down their workplaces for insurance.[56]

Boycotting silent-film theaters proved even more difficult than boycotting vaudeville performances since the former were more ubiquitous. Hundreds of copies of a single film could be quickly made and disseminated to nickelodeons in cities across the United States.[57] In 1908 in New York, there were more than six hundred of these theaters, with daily attendance estimated at a minimum of two hundred thousand. By 1910, there were at least twenty thousand nickelodeons in the Northern cities alone. Unlike stage theaters, the simpler nickelodeons took little capital to establish since they consisted of one room containing a phonograph, a cinematograph (movie projector), a canvas hung on one wall to serve as a screen, and chairs. Rather than one or two shows a day offered by the theater, the nickelodeon could run the film ten to fifteen times in a row. Personnel consisted of a cinematograph operator, a cashier, and possibly a barker to lure moviegoers inside. (The more upscale nickelodeons also had a singer, a piano player, and a doorman.) The nickel for admission was far lower than $1.20 for a Broadway play or sixty cents for a cheaper melodrama.[58] In the words of a 1907 description, "All you have to

do is to open the doors, start the phonograph and carry the money to the bank."[59]

The ADL was also hampered in its efforts to censor silent movies because of its own ambivalence about joining with other racial and ethnic groups to create a combined voice against offensive caricatures. This occurred because Jewish leaders were especially motivated to distinguish themselves from Black American groups. In January 1914, then, the ADL reported to its parent organization, B'nai B'rith, that its direct negotiations to remove harmful stereotypes of the Jew with the National Board of Censorship had failed.[60] (The National Board of Censorship had its own difficulties in deciding what should be removed from movies since the moviegoing audience was so diverse in age, educational level, and native and foreign status.)[61]

Jewish censoring groups also faced difficulties in removing caricatures of Jews from phonograph recordings. Joe Hayman's *Cohen on the Telephone* (1913) and Julian Rose's *Levinsky at the Wedding* series (1917 and 1918), for example, employed thick accents, twisted syntax, and linguistic confusion; in Ada Jones and Len Spencer's *Becky and Izzy* (1907), the couple's large noses make kissing difficult, and she gives him the nickname Fire Bug (arsonist).[62] These were hard to suppress since hundreds of thousands of 78 rpms featuring the comic Jew were produced by the major record companies following the initial success of *Cohen on the Telephone*. (It was, of course, not just recordings that made fun of Jewish immigrants that were successful; overall phonograph record sales rose from $27 million in 1914 to $158 million in 1919.)[63]

THE RESULTS OF PUSHBACK

Despite initial difficulties, by late 1913, the various campaigns and threatened boycotts began to have some effect on the depictions of the stage Jew. They were aided, in part, by major changes that had occurred in the theater industry—namely, the rise of syndicated groups and large booking offices that controlled many of the dramatic theaters across America and the schedules of the acts and actors who appeared on syndicated stages. Rather than threatening boycotts of individual theaters, which had shown little success before 1912, the ADL and other Jewish organizations could now pressure the National Theatre Owners Association, which represented 1,200 small-town theaters; the Shubert Organization, which owned and operated hundreds of theaters across the United States; or B. F. Keith's United Booking Office, with its enormous control over vaudeville circuits.[64] Moreover, vaudeville from its conception had presented itself to the public as a cleaned-up version of the variety show, suitable for women and children. Though this was not often the case, it had always operated with an eye to both satisfying the audience and "never falling seriously afoul of governmental bodies and/or many of the 'progressive' groups lobbying them."[65]

CENSORING ATTEMPTS 57

These censoring groups placed not only theater managers and owners on the defensive but also Jewish writers and comics. It now became their burden to prove that the caricature they presented on the stage was not demeaning. In reaction, author and playwright Montague Glass, whose works were explored in chapter 1, publicly carped that there were a lot of "professional Jews" in New York who were "continually on the alert looking for someone to say something that will reflect on their traditions . . . the genuine Jews . . . are never among those who rise in arms and declare that any representation of them that reflects a single imperfection is a gross libel."[66] Other performers who did not necessarily possess Glass's clout and stature, however, were now forced into more apologetic behavior. Some wrote their intentions into newspaper advertisements for their performances, taking advantage of the medium to defend their acts ahead of protests. The ads declared that the caricatures being presented were true to life or stated that their presentation of the Jew onstage avoided the low caricatures of vaudeville and was a respectable one, stressing the Jew's higher economic level and cultural advancement.[67] An ad announcing Julian Rose's one-man show playing Levinsky, a Jewish immigrant, for example, contained an encomium by a London rabbi who stated that though Jews had suffered from stage misrepresentation, Rose's performance was that "of a finished artist and a gentleman, and only represents a type that does exist."[68] Barney Bernard, the costar of Glass's Broadway show *Potash and Perlmutter*, proclaimed that in the show, "There is no clowning, and the Jew's love for money is shown in its proper light . . . the sole object is his home."[69]

When it came to silent films, the ADL and the New York Kehillah's Committee for the Protection of the Good Name of Immigrant Peoples, working closely with censoring boards, were able to achieve some measure of success by the fall of 1914. In 1915, the executive secretary of the National Board of Censorship of Motion Pictures wrote to the chair of the Kehillah committee, informing him that the National Board had contacted the Vitagraph Company to express concern about its recent film featuring a Jewish arsonist. He concluded, "We will see that the wishes of all concerned on the National Board and on your committee are adhered to."[70] In 1916, the ADL was able to pressure the producer and director D. W. Griffith to reshoot some objectionable scenes that appeared in his movie *Intolerance*. Carl Laemmle, the president of Universal, pledged that his studio would refrain from making movies with offensive Jewish caricatures. Censorship boards and citizen juries—largely composed of members of Chicago's well-established German Jewish community—either banned or removed frames from a number of films that portrayed Jews in a negative light between 1914 and 1918.[71]

Faced with a more organized community effort and increased negative publicity, the theater owners and managers, film companies, actors, and recording artists began to cooperate with the demands of these Jewish policing groups. Yet change was slow. Though, in 1916, the *Buffalo Courier* proclaimed that "the day of the burlesque Irishman, Dutchman and Jew has forever departed from the

enlightened state of modern time. No nationality, no matter what its individual characteristics may be, will tolerate an actor who makes their people look ridiculous," Ted Merwin noted that these efforts were not totally successful. In the years before World War I, for example, there were still hundreds of plays being produced that contained negative caricatures of the Jew.[72] It would take over a decade from the start of these efforts until an article in *B'nai B'rith Magazine* could proclaim that "the exaggerated Jew, the grotesque character, that used to supply comedy relief, is a thing of the past."[73]

However, it is not certain how much these censoring efforts, per se, achieved the end result. Other factors, such as changing audience tastes and the rise of musical theater replacing ethnic character comedy, played a role in reducing the presentation of the stage Jew. In addition, the changed economic status of Eastern European Jewish immigrants may have also been a factor in how the Jew was presented in silent film and on phonograph records as well as onstage. The Irish, for example, in the eyes of American society, went from "an inferior, animalistic, racial type" to "cultural scapegoat" to "laughable ethnic fool" and, finally, to "clever fool" and "heroic trickster."[74] Davies stated that ethnic jokes by others change "not in response to the popularity or unpopularity of the butt of the jokes but as a result of visible changes in the position and qualities of that group."[75] The increased assimilation of the Eastern European Jew by the end of the second decade of the twentieth century may have, thus, played a role in the gradual disappearance of the stage Jew's negative portrayal.

Pressuring the Smoothers

Some of the smoothing artists of this time were affected by the censoring attempts of the ADL and other Jewish organizations. David Warfield, for example, defensively declared to a Chicago journalist that his Jewish stage character in *The Auctioneer*, Simon Levi, was "a simple, amusing, earthy character study" and that Levi's sprinkling water on some of his goods and marking them "damaged by fire" was "merely an ingratiating exaggeration which no one takes seriously."[76] Bert Levy became the center of an ADL attack on his *Samuels and Sylenz* strip. They claimed that his presentation of Jewish characters was offensive despite the fact that of the two dozen extant strips, only one portrayed Jews in an unflattering light.

> SAMUELS. Vy did you give der check boy a dollar? You spoil him for others.
> A quarter vould do. Vy such extravagance?
> SY. Didn't you see der fine coat he gave me?[77]

However, since Levy had his characters use the vaudeville Jewish dialect, the ADL, determined to remove all Jewish stereotypical markers from the public's

CENSORING ATTEMPTS 59

gaze, found the strip "very objectionable to our coreligionists" and called for a boycott.[78]

Levy responded publicly to the campaign by using his comic strip to air his grievance, employing the unusual convention of breaking down the fourth wall—having his characters directly address the readers:[79]

> SAMUELS. Say! The feller who draws us is getting in trouble. The artist means us to be absolutely inoffensive. But some people think we are too true to life. [Both turn their backs away.] Let's turn round and disguise ourselves.
>
> SY. [now wearing a mask, directly facing and addressing the readers]: Well! How's this? (figure 2.1)

Here Levy appears to be sarcastically replying to his critics that if they thought his characters were "too Jewish," he would try to disguise them. It became clear, however, as the strip continued to unfold during the week that the disguise was of no avail. The second day's strip features Samuels wearing the mask and stating, "I tell you Sy dis disguise ting is a vunderful bizness. Our own mothers vouldn't know it vas us." Behind him, however, passing characters call out, "Hullo Samuels," "Paper Mr. Sylenz?" A few days later, as they continued to walk around with their masks, Levy had a passerby shout out behind them, "Take 'em off we know yer." When Samuels asks, "How did they know me?" Sy replies, "Keep your mouth shut and nobody will know you."[80] Levy's question to his critics, then, was that if all the visual markers were erased and the (true-to-life) Jewish dialect was silenced, how else could his characters be identified as Jews?

Despite his public protests, Levy quickly acquiesced to the pressure and announced that he would give up the strip, forfeit a payment of $12,000 for drawing it, and pay $2,200 to be released from his contract with a distributing syndicate. He concluded with a passive-aggressive statement that, unlike the ADL, the editors of the papers in which the strip appeared considered his characters to be "kindly and quite harmless." He insisted that he did not kill his strip due to pressure, stating that "twenty Anti-Defamation Leagues could not have suppressed the series (they did not succeed in suppressing 'Abie the Agent'). I alone voluntarily killed the drawings to please my fellow Jews."[81] While $12,000 in 1915 was not a small amount of money, it probably paled against the salary that Levy made as a vaudeville performer. In addition, his strip had been barely a two-month enterprise, and he immediately introduced a new comic strip a few weeks later. Levy may also have calculated that it was worth forfeiting this income to avoid bad press *and* to obtain good publicity from the ADL and other Jewish groups through this action. B'nai B'rith did, subsequently, provide such publicity, praising "such men as Mr. Bert Levy [who] are a pride and a glory to Israel." Four months later, no longer ostracized, Levy was invited to speak at a B'nai B'rith lodge, while another sought his services for a fundraising event.[82]

Figure 2.1. Bert Levy, *Silent Partner*, Buffalo Morning Express, July 22, 1914.

CENSORING ATTEMPTS 61

Samuel Zagat's (1887–1964) cartoon strip *Gimpel Bainish der Shadchan*, however, was not a target of the ADL, which, at first, seems surprising. It was featured in the Yiddish newspaper *die Warheit* beginning in 1912 and was drawn by Zagat and captioned in Yiddish by the *Warheit*'s editor, Louis E. Miller.[83] It presented the travails of Gimpel, clearly a recent immigrant, in his efforts to earn a living and master American culture. At a time when most cartoons in the Yiddish press depicted the (male) Jew as clean-shaven and dressed in contemporary clothing, Gimpel, with his short stature, large nose, untrimmed beard, splayed feet, and misfitting clothes, looked like the quintessential stage Jew character (figure 2.2).[84]

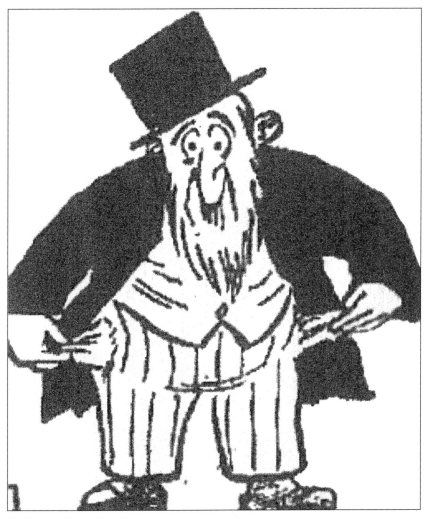

Figure 2.2. Gimpel Bainish. Excerpt from Samuel Zagat, *Gimpel Bainish*, *Warheit*, June 29, 1913.

Yet, because the strip appeared in a Yiddish paper not read by the leadership of the assimilated German Jewish community and, most certainly, not by American nativists, there was no pushback against it.

As with *Gimpel Bainish*, Hershfield's *Abie the Agent* also was not a target of censoring efforts by Jewish organizations. As noted previously, Levy stated that the ADL failed in suppressing *Abie the Agent*. Why this was so and what contributed to the popularity of Hershfield's strip will be explored next in a detailed examination of *Abie the Agent*.

CHAPTER 3

Smoothing Abie

There is a time to keep and a time to cast away . . .

—*Ecclesiastes 3:6*

THE ARTIST AND HIS CREATION

Harry Hershfield (1885–1974) was born in Cedar Rapids, Iowa, to Jewish immigrant parents shortly after their arrival from Odessa, Russia (today Ukraine) (figure 3.1). His father owned an unsuccessful grocery store in Omaha, Nebraska, and then, when the family moved to Chicago, he brought in income by working as a violin teacher, conductor, choir leader, and synagogue cantor.[1] Hershfield displayed an interest in cartoons from a young age, and at fourteen, he left school to work as an office boy, cameraman, and reporter for the *Chicago Daily News*. At the paper, he also did retouching, and soon he was drawing pictures of news and sports events. (According to Hershfield, the paper suspended him for two weeks when, in retouching an illustration, he straightened out the Leaning Tower of Pisa!)[2] From 1906 to 1909, he drew over a half-dozen short-lived comic strips and sports cartoons.[3]

Hershfield moved to New York and had his first real success in 1910, when he created the serial burlesque melodramatic strip *Desperate Desmond* (1910–1912) for Hearst's *New York Evening Journal*. The strip involved a fair maiden in distress, a noble rescuer, and, of course, the star: a dastardly villain, Desperate Desmond.[4] This strip, following Fredrick Opper's *Alphonse and Gaston* (1903), Winsor McCay's *Little Nemo in Slumberland* (1906), and Bud Fisher's *Mutt & Jeff* (1908), was one of the earliest cartoons to employ the serial form, in which the narrative was extended from one day to the next or one week to the next, versus the episodic form, in which each day's strip was a completed narrative. As a melodrama, it also left the reader with a cliffhanger at the end of each episode.[5] In addition, each panel of Hershfield's strip contained not only the dialogue, encased in "balloons"—a technique popularized by Richard Outcault in his 1896 *Hogan's Alley* comic—but also a few lines of text underneath the final panel, commenting on the action. The final, cliffhanger panel of a 1911 strip,

Figure 3.1. Harry Hershfield, circa 1914. Harry Hershfield Collection, SPEC.CGA.HH, Billy Ireland Cartoon Library & Museum (BICL), Ohio State University.

for example, has Desperate Desmond about to cut a rope, which would result in the hero, Claude Éclair, being impaled on sharp knives. The text, however, promises that "to-morrow's pictures may show unexpected developments" (figure 3.2). Additional text also appeared under the first panel of the next day's strip, summarizing the story up to that point. *Desperate Desmond* was thus a combination of illustrated fiction and comic strip.[6]

Figure 3.2. Excerpt from Hershfield, *Desperate Desmond*, *Omaha Daily Bee*, November 15, 1911.

Figure 3.3. Excerpt from Hershfield, *Desperate Desmond*, *Indianapolis Sun*, December 17, 1910.

In one of his early *Desperate Desmond* strips, Hershfield dropped the Yiddish word *varnitchkes* (bowtie noodles) into the gibberish of a jungle chief as a joke to entertain his Jewish friends (figure 3.3). In 1911, he introduced another chief, Gorgol, who, along with a fellow tribesman, Gomgotz, and other assorted members of the Wild Men of Borneo, employed Yiddish phrases totally out of context.[7] In a panel from a 1911 strip, for example, one tribesman proclaims in Yiddish: "*Foon Kovneh Goobernia*" (from Kaunas District) (figure 3.4). For a

Figure 3.4. Excerpt from Hershfield, *Desperate Desmond*, *Star Tribune*, August 12, 1911.

Jewish reader in the early twentieth century, the startling element of these strips would have been that Yiddish was being uttered and not the large eyes and exaggerated lips of the African tribesmen, which catches our attention (and dismay) today, since they would have been familiar with blackface presentations that appeared on the vaudeville stage.

Hershfield was not the first to introduce African "savages" uttering gibberish. His fellow cartoonist Winsor McCay had done so previously with his character the Imp. Nor was Hershfield the first to pair Jews and Native Americans. That had already happened in the 1895 Yiddish vaudeville playlet *Tsvishn Indianer* (Among Indians) and in the sheet music songs "I'm a Yiddish Cowboy" (1907) and "Big Chief Dynamite" (1909).[8] Hershfield, however, was the first

to slip Yiddish, incongruously, into the speech of Indigenous characters. In doing so, he launched what became a long-running comic tradition. A few years later, in 1918, for example, Fanny Brice presented herself onstage dressed in a Native American costume, singing, in a Yiddish accent, "Oy, oy, oy, oy, I'm a terrible squaw."[9] Many Jewish entertainers appeared on the vaudeville stage in blackface, and this use of Yiddish while in Native American costume was, in essence, "redface": an effort to proclaim that the Jews were part of a white racial group, as opposed to Native Americans who were not regarded as white.[10] In addition to the jungle tribesmen, Hershfield, in his 1912 strips, also inserted Yiddish words into a nonsensical jumble uttered by Russian speakers, ranging from a revolutionary to the czar.[11]

Hershfield appears to have had some of the passing anxiety experienced by his fellow artists when it came to introducing Yiddish into his strips. In explaining his comic use of Yiddish, he stated, "I had this African chief make use of certain colloquialisms affected by my Jewish friends." Note, here, his language: not "used by" or "spoken by" but "affected by" to underscore that his Jewish friends were English speakers who, occasionally, deliberately dropped Yiddish into their English conversation.[12]

According to Hershfield, these Yiddish insertions came to the attention of Arthur Brisbane, the editor of the *New York Evening Journal*, who, in 1913, with his eye on increasing Jewish readership, suggested that Hershfield create a comic strip with a Jewish protagonist.[13] An examination of Hershfield's *Dauntless Durham* strips near the end of 1913 confirms Blackbeard's observation that Hershfield "felt the strain of maintaining the suspenseful pace" of that serial.[14] For continuity strips, where a running story was maintained, the cartoonist encountered almost the same narrative difficulties as the playwright. Thus, Hershfield often abandoned the melodramatic format in *Dauntless Durham* for other graphic presentations such as *Life and Training of a Police Dog, How to Carve the Thanksgiving Turkey,* or *The Average Winners of Christmas Raffles.*[15] It is just as likely that it was Hershfield who pitched to Brisbane the idea of a new strip that would be popular with Jewish readers. Accordingly, in February 1914, Hershfield began drawing *Abie the Agent.* It appeared daily in black and white and, beginning in 1922, came out in color on Sundays.

Vaudeville's Influence

Hershfield, growing up in Chicago with a father who was a musician and a sister who worked as a cabaret singer, was certainly familiar with Chicago's vaudeville theaters.[16] Chicago was a hub of vaudeville booking offices, such as the Western Vaudeville Managers Association, which had agreements with the even larger B. F. Keith and Orpheum chains and owned, by 1910, twenty-two vaudeville theaters.[17] There were enough stages in Chicago "to keep a vaude-

SMOOTHING ABIE

villian acting for two seasons."[18] Moreover, Hershfield himself actually spent time in vaudeville. In 1912, he appeared on the New York stage as a monologist on the same bill with the later-well-known entertainers Georgie Jessel and Eddie Cantor and, he also presented at the Hippodrome in London. (In this, he was not unique among cartoonists: Windsor McCay and Bud Fisher, for example, had previously presented "cartoon acts" on the vaudeville stage.)[19]

As mentioned in chapter 1, vaudeville sketches were tightly structured: they were stripped down with little presentation of narrative, and there were no superfluous gestures or dialogue that might impede the eventual punch line. As Wickberg noted: "The joke aims at ultimate abstraction, condensation of detail, and exclusion of all elements not to the 'point,' so as to make it accessible as a product to an anonymous audience of consumers."[20] Hershfield strived for this in his comic-strip work as well, describing his process as one that "illustrated[ed] the picture just enough to show the idea. Any superfluous backgrounds will impede the balloons and hurt the comic."[21] He had little interest in detailed visual presentation, such as is found, for example, in the elaborately detailed comic-strip work of peer artist Winsor McCay's *Little Nemo*. Though he was a skilled cartoonist and artist, Hershfield saw his strip as a vehicle to deliver wit, puns, and jokes. "We of this school," he said, "are called 'idea men' and it matters little to us whether we employ men or clothes pins to illustrate the point."[22] Thus, Hershfield used *Abie the Agent* to present classic vaudeville humor quickly and without elaboration. In this, he was not alone. Many of the early comic-strip artists "kept in close touch with the comic weeklies, vaudeville shows and wisecrack centers . . . lifting the jokes and converting them into comic-strip fare."[23]

When a reward of ten dollars is offered for a lost handbag with fifty dollars in it, Abie quickly offers his own reward of fifteen. "Look at that wonderful view!" his friend calls out in a panel of one strip. "What view?" Abie complains in the next and final panel, "The mountains are in the way!"[24] In another strip, one fast-paced joke follows another as though Abie and his rival, Bennie Sparkbaum, are on the vaudeville stage: Abie believes that "pneumonia," the password to gain entry into his lodge, starts with the letter *n*. This would have been a perfectly good ending, but Hershfield went on to have Sparkbaum add to the gag and state, "Pneumonia usually starts with a bad cold." Abie then closes the strip with the quick retort, "You should have it!"[25] It should also be noted that Hershfield's incongruous insertion of Yiddish into his *Desperate Desmond* strips, noted earlier, was influenced by comic acts on the vaudeville stage that deliberately presented comedians dressed in the outfits of one ethnic group while speaking the dialect of another.

Ultimately, Hershfield was less concerned with illustration than he was with utilizing his strip for joke telling. In fact, looking at the arc of Hershfield's career, it is as if he consistently sought out better platforms to ply his wit. Between 1917 and 1920, Hershfield wrote a syndicated humorous advice column called

"Kabibble Kabaret" and voiced Abie on five humorous monologue phonograph discs.[26] He became known for his quick wit and endless supply of jokes, and, for decades, he was in great demand as a toastmaster and master of ceremonies at New York social events. One year he was said to have talked at 260 affairs in a six-month period. His ubiquitous presence at these events led Mayor Jimmy Walker to nickname him "Mr. New York."[27]

Although sequential strips like Smith's *The Gumps* (1917) and King's *Gasoline Alley* (1918) became especially popular with readers and though Hershfield had extensive experience creating sequential strips, he never deviated from keeping *Abie the Agent* in episodic form, since that was best for joke telling.[28] Though he subordinated the narrative (and illustrations) to the joke, this is not to say that he eschewed narrative altogether. In the same way that early Hollywood sound movies attempted to merge the vaudeville aesthetic ("performance, affective immediacy and atomistic spectacle") with the literary aesthetic ("character consistency, casual logic, narrative coherence"), so did Hershfield (and other cartoonists of that time) strive for that synthesis.[29]

LIMITATIONS OF THE EUROPEAN JEWISH EXPERIENCE

In addition to vaudeville, Hershfield's Jewish background and the fact that his protagonist was Jewish directly influenced the content of the strip, as will be further explored. However, the Jewish humor that Hershfield utilized was not essentialist. In creating *Abie the Agent*, Hershfield was not drawing on a particular kind of humor, supposedly unique to the Jewish people: a humor fashioned through centuries of oppression and opposition to it, which arose to express the anxiety of the Jews' relative powerlessness in their world; a humor forged "in failure rather than success, marginality rather than influence and puniness rather than power."[30] Humor historian Christie Davies has expressed doubt about speculative analysis of humor that involves the "mysterious collective consciousness of a nation, sub-nation, or ethnic minority of several million people."[31] In addition, Davies rejects Freud's oft-referenced assertion—treated as fact by scholars of Jewish humor who followed him—that Jews, as a consequence of their oppression, have a larger number of self-deprecating jokes. He holds that many regularly tell jokes that mock the ethnic group to which they belong.[32]

Life in America for Jewish immigrants was radically different from their experiences in Europe. Though life was hard for most newly arrived immigrants, their children—many of whom were born in the United States—did not encounter the persecution or the poverty experienced by their parents' generation. It is just as likely that the sheer number of Jews in New York, a city with the largest number of entertainment venues in the nation, at a time when daily working hours declined and leisure activities radically expanded, resulted in a higher percentage of Jews in comedy venues rather than some intrinsic Jewish movement

SMOOTHING ABIE 71

toward humor.[33] If there were any essentialist Jewish influences on Hershfield, perhaps the best that can be offered are Stephen Whitfield's cautious terms: "dispositions, susceptibilities, tendencies."[34]

Not only should the notion of essentialist Jewish humor be ruled out as an influence on *Abie the Agent*, but cultural productions from the Jewish past, such as biblical stories, rabbinic tales, and the often-obscene Purim *shpiels* (plays) from Western European lands during the Middle Ages, should be ruled out as well.[35] Though Joseph Boskin and Joseph Dorinson claim that "American Jews found the origins of their comic voice in medieval Europe," Elliott Oring, however, has stated that "arranging epochs, figures, and themes in chronological order and describing the humor associated with them is a far cry from demonstrating that the humor is developmentally related."[36] In addition, Davies notes that parodies, folktales, and jokes were (and are) performances and, as such, are dependent on audience reception. Given, then, the importance of their social contexts, they cannot simply be picked up from one historical period and dropped into another.[37] The existence of Jewish humor from previous historical periods is *not* proof of that humor influencing later generations.

Even more specifically, the Jewish experience in Europe from the seventeenth to the nineteenth century should also not be seen as a source of influence on *Abie the Agent*. Neither the *leytzanim* (jesters) and *marshalniks* (merrymakers) of Western Europe nor the later Eastern European *badchonim* (wedding masters of ceremony) who recited comic and sometimes risqué poetry often based on Jewish religious texts nor *Broder zingers* (itinerant performers) who sang and presented monologues in wine gardens and inns influenced American Jewish humor in general and Hershfield's creation in particular.[38] The memoirs of and interviews with Jewish vaudeville and stage performers do not mention Eastern European comic models. This should be of no surprise, since, with a few rare exceptions, the Eastern European Jewish masters of ceremony and jesters had vanished by the twentieth century. Reporter Hutchins Hapgood, for example, in describing Jewish life on New York's lower East Side in 1902, related the story of the famous Eastern European poet and former *badchan* Eliakum Zunser, who now ran a small print shop.[39] Those *badchonim* who remained performed only within insular Chasidic communities and, thus, were not an influence on American Jewish humor.[40]

It has been suggested that the humor of the *badchonim* influenced such Yiddish comedians as Benny Bell (Benjamin Zamberg) and Leo Fuchs. Zamberg, however, was American born, and his upbringing did not involve exposure to *badchonim*. His risqué lyrics did not appear until 1937, when he started writing off-color songs for the jukebox trade.[41] Fuchs was born in Warsaw to theater actors and appeared at an early age on the stage and, thus, may have some claim to be influenced by Eastern European *badchonim*, but his two comedic records, *Yiddisha Cowboy* (ca. 1947) and *Galitzianer Badchan* (Galician comic) (1948),

were only a very small part of his long career of well-mannered stage, TV, and comic movie roles. Again, it is hard to see the influence of the Eastern European *badchonim* on his work, especially given the late release date of his records.[42]

It is similarly unlikely that *Abie the Agent* was influenced by Yiddish theater and Yiddish vaudeville in the United States. As Harley Erdman notes in his examination of how the Jew was presented on the American stage, "twentieth-century Jewish performances in English represent a continuity with the nineteenth-century American theater not evident with the Yiddish stage of folk operettas, sentimental melodramas, and quasi-socialist problem plays." Then, too, for upwardly aspiring artists, the Yiddish theater was a lower-class enterprise. The vaudeville performer Joe Smith (Sultzer) quipped that "wanting to break into the Yiddish theater was like wanting to break into prison."[43] While, as noted in chapter 1, the Houston Hippodrome—a combination movie and vaudeville theater on New York's lower East Side—presented Yiddish dramatic sketches and songs along with dance numbers, this format was influenced by American vaudeville and not by Yiddish theater.[44]

Eastern European literary influences on Hershfield should be ruled out as well. At first glance, it may seem that Hershfield was inspired by the Jewish Eastern European literary character of the *schlemiel* (hapless one), who was unmanly, ineffective, and, when it came to business, an unsuccessful amateur.[45] Abie, as will be explored later, shared many of the same qualities as the *schlemiel* Menachem Mendl, who appeared between 1892 and 1913 in the stories of the Yiddish writer Sholem Aleichem (Solomon Rabinovitch, 1859–1916). Like Menachem Mendl, who attempted and failed at a great number of occupations (stockbroker, sugarbroker, journalist, insurance agent, etc.), Abie tried his hand at car sales, restaurant ownership, running a movie theater, and selling furs. Like Menachem Mendl's wife, Sheyne Sheyndl, Abie's wife, Reba—his practical, down-to-earth mate—treated her husband like a child. Like Menachem Mendl, Abie lacked the traditional male virtues of strength and courage, and, again like Menachem Mendl, Abie was primarily a talker; the humor in *Abie the Agent* primarily came from the characters' speech and *not* from their physical actions, in the same way that Sholem Aleichem wrote sentences that "are directed in the first place not to the eye, but to the ear."[46]

The Menachem Mendl stories, however, were not yet translated into English when *Abie the Agent* first appeared in 1914, and while Hershfield grew up hearing Yiddish at home, it does not appear that he was able to read it.[47] The Eastern European folktales of the *schlemiel* and *schlmazel* (luckless one) also do not seem to have been important influences on Hershfield. Though these characters were, no doubt, familiar to him, either through stories or, more likely—given his later success as a raconteur—through jokes, Abie's character simply did not reflect the Jewish *weltanschauung* of Eastern Europe. Furthermore, neither of Hershfield's two previous comic strips (*Desperate Desmond* and *Dauntless Durham*)

SMOOTHING ABIE 73

contained Yiddish words, except for a few incongruous instances, or reflected any Eastern European Jewish sensibilities.

This was also true of Zagat's *Gimpel Bainish*, the other Jewish comic strip that appeared during this time, albeit solely in the Yiddish press. Though born in Lithuania, Zagat came to America when he was three and so was exposed primarily to American culture for twenty-two years before creating *Gimpel Bainish* in 1912. Jane Peppler, who translated a number of these strips, suggests that the mischievous twins Hans and Fritz, from the *Katzenjammer Kids* comic strip created by Rudolph Dirks in 1897, directly influenced Zagat's use of Gimpel's twin boys, Notke and Motke. Their antics usually ended with a spanking by Gimpel and his wife, exactly as Dirks ended the shenanigans of Hans and Fritz.[48]

The sources, then, for the creation of *Abie the Agent* should not be sought in the ancient or the seventeenth- and eighteenth-century Jewish past. *Abie the Agent* was not influenced by the Jews' long, lachrymose history of oppression that supposedly manifested itself in self-deprecating humor. Rather, as Hershfield himself said: "My characters are drawn in this series to depict, really, the American humor, as seen through certain types of Jews."[49] It was American humor as presented on the vaudeville stage that was the primary influence on *Abie the Agent*.

It should also be noted that though Hershfield knew Bert Levy, worked with Bruno Lessing at Hearst's *Evening Journal*, reviewed Montague Glass's Broadway play in 1915, and, undoubtedly, was familiar with David Warfield, this is not to say that these men were direct influences on Hershfield in the development of *Abie the Agent* but, rather, that Hershfield's smoothing work on the image of the Jew took place during a time in which others were engaged in these endeavors as well.[50] On the other hand, the possibility that these artists were influences on the creation of *Abie the Agent* cannot be ruled out. In 1924, for example, Hershfield noted that Glass's characters Potash and Perlmutter had paved the way, "to some extent," for him to introduce a Jewish character as the central figure in a comic serial.[51]

Hershfield was certainly influenced by the censoring activities of the Jewish community at this time. Two years after he launched *Abie the Agent*, his explanation of the strip's birth indicates his awareness of these Jewish protests. "Previously," he stated, "there had been shown on the stage and in burlesque a type of alleged Jewish humor not at all complimentary to the Jewish people and not at all justified." Consequently, he decided to make Abe Kabibble "a clean-cut, well-dressed specimen of Jewish humor."[52] In subsequent years, Hershfield continued to make it clear that he was well aware of the Jewish community's sensitivities toward the stage Jew. In 1921, he proclaimed that in his strip, "you never see the stereotyped derby hat drawn over the ears, with a big beard, and the movement of the arms, as depicted by so-called Hebrew caricatures on the stage. There is never a mention of the slanderous 'fire' stories." Instead,

Hershfield declared that his purpose in creating this new comic strip was to present the Jew in the best possible light.[53] In 1924, he stated that he "wanted the Gentile to enjoy my pictures, but not at the Jew's expense."[54]

To protect himself against criticism from the anti–stage Jew watchdogs of the Jewish community, Hershfield went even further in his apologias. In addition to explaining his noble intentions in creating the strip, he also sought to make known that he had received the stamp of approval to do so from prominent individuals. First, as noted earlier, he stated that the idea for a Jewish comic strip did not come from him but from Arthur Brisbane, editor of Hearst's *New York Evening Journal*. Hershfield stated that Brisbane—in response to other Hearst editors who did not want the strip to appear as Gentile mocking of Jews— declared, "We will try to set a standard that will help to eliminate the bad type of humor that is used on the stage today."[55] In other words, there was no malice in Brisbane's project; in fact, it was aligned with the censoring efforts of the Jewish community. (The alleged sensitivity, here, of both Brisbane and the other editors toward an ethnic minority group seems surprising, as the strips *The Katzenjammer Kids*, which mocked the Germans, and *Bringing Up Father*, which made fun of the Irish, appeared regularly in Hearst's *New York Evening Journal* beginning in 1896 and 1913, respectively.) Finally, Hershfield recounted Brisbane's clear support and defense of him. "Mr. Hershfield," he recalled him stating, "I am sure, as a Jew, would be the last to offend his own people."[56]

Hershfield also stated that he sought the blessing of New York's prominent German Jewish communal leaders for *Abie the Agent* before proceeding to publish. He asserted that Abie's character was first submitted to his "advisor and mentor," philanthropist Nathan Straus, the owner of Macy's Department Store, for his approval of and advice about the portrayal of the Jewish character. He also noted that financier Jacob Schiff (head of the investment banking firm Kuhn, Loeb, and Company and a primary financial supporter of Jewish organizational activities) was a fan of the strip.[57]

However, Hershfield's ability to avoid the ire of the Jewish watchdogs—the sole exception being Weidenthal's *Jewish Independent* in Cleveland, which called *Abie the Agent* "atrocious"—was due less to his alliance with German Jewish leaders than to his work being syndicated in Hearst publications.[58] By 1913, the year before the strip debuted, Hearst's syndicated content had huge circulation: almost 700,000 in New York, over 500,000 in Chicago, and almost 250,000 in San Francisco. Further, Hearst was able to send syndicated content to small towns through the extensive telegraph service that was functioning throughout rural America. By 1913, Hearst owned over fifty publications across America that accounted for 66 percent of the comic-strip market.[59] In the same way, discussed in chapter 2, that taking on the phonograph and movie industries was, simply, too big a fight for the ADL to enter, so, too, was challenging Hearst. Ultimately, Hershfield's smoothed-over presentation of Abie together with his efforts to

SMOOTHING ABIE

minimize disapproval from the organized Jewish community, as well as being hitched to the enormous Hearst network, allowed *Abie the Agent* to go forward without censoring interference, in 1914 and in the years ahead.

NAMING ABIE

Even though, in later years, Hershfield would take full credit for deliberately fashioning a wholesome presentation of the Jew, it is difficult to know how deliberate and conscious he was in creating *Abie the Agent*. Even if his initial decisions were more self-serving—that is, how to draw a character who would be appealing to a wide, national audience—the fact is that he had a wide array of historical negative portrayals of the Jew that he could have used, but he did not. Instead, though he would retain a few of the negative features of the Jew that had appeared on the vaudeville stage and in print, he crafted a more smoothed portrayal for his protagonist's appearance, speech, and character, as did some of the other artists discussed earlier.

In creating his Jewish protagonist, Hershfield continued the long tradition in America of identifying a Jew in print or onstage by employing a recognizable Jewish name, such as Levi, Moses, Solomon, and Isaacs.[60] He chose the first name of "Abie," a common name that Jewish and non-Jewish vaudeville actors and songwriters used to signal a Jewish character. In the years before *Abie the Agent* was drawn, the lyrics to "Under the Matzos Tree" (1907) began, "Listen to your Abie, baby, Abie," and 78 rpm phonograph titles in 1909 included *Abie, Take an Example from Your Fader*, *Abie the Sporty Kid*, and *Abie Was a Fighting Guy*. Zagat, the cartoonist of *Gimpel Bainish*, also had a second strip published in 1912 titled *Abie's Moving Pictures*.[61] Though "Abie" identified a Jewish character, it was an American diminutive of the Old World name Abraham. Thus, "Abie," from the outset, signaled either an immigrant or, as indicated in the lyrics of comic dialect songs (e.g., "Abie, Take an Example from Your Fader"), the son of immigrants who had already started the process of acculturation by carrying an Americanized Jewish name.[62]

Hershfield took his character's last name, Kabibble, from the lyrics to a popular 1913 song, "Isch ga Bibble," written by Sam M. Lewis: "Isch ga Bibble I should worry? No, not me."[63] Soon after its appearance, he devoted eight of his *Dauntless Durham* strips to illustrating and punning on its supposed English meaning: "I should worry like a whale and blubber"; "I should worry like a lemon and be squeezed."[64] Though he stated in 1959 that Fanny Brice made the phrase popular when she was onstage for the Ziegfeld Follies (beginning in 1910), neither her discography nor any print review of her performances links her with that saying. (Perhaps he was thinking of her appearance in Montague Glass's 1918 melodramatic farce *Why Worry*.)[65] The literal meaning of *isch ga bibble* is unknown. Hershfield stated that it was a corruption of a well-known

76 SMOOTHING THE JEW

Yiddish phrase, *nisht geffidelt* ("don't fiddle with it"), but this seems unlikely since Sam Lewis (Levine), who grew up with Yiddish-speaking parents, would have used the correct words in his lyrics.[66]

SMOOTHING APPEARANCE

Hershfield eliminated the key facial markers of the stage Jew: the hook nose and beard. He drew Abie's face simply, which, according to graphic artist Scott McCloud's theory, made it easier for a reader to identify with him, as opposed to a detailed facial drawing that might result in the reader concluding, "This is not me," and rejecting identification with the character.[67] Richard Out-cault's Buster Brown (1902), James Swinnerton's Jimmy (1905), and George McManus's Jiggs (1913) provide other examples of a simple comics design attracting readers' identification (figures 3.5 and 3.6).[68]

Though Hershfield eliminated the well-known indicators that had previously been used in print and onstage to signify the Jew, he still retained other physical markers—after all, caricatures often continue to be linked to the stereotypes on which they are based just as stage characters are haunted by previous enactments. Cartoonist Clarence Rigby, for example, did this in *Little Ah Sid, the Chinese Kid* (1904) by eliminating the buck teeth and slanted eyes from his character but still retaining elements of the Chinese caricature, and George McManus, in *Bringing Up Father* (1913), though he softened the simian features of the Irishman, still utilized some previous caricatures of the Irish that had appeared in print and on the stage.[69]

Hershfield retained for Abie the flat feet of the stage Jew and grew them to even more outsized dimensions. When he added exaggerated large eyes and a roly-poly body, the total effect was that of a clown. Compare Abie, for example, with Flip, also short, with splayed feet and a protruding belly, who appeared in McCay's strip *Little Nemo in Slumberland* (1905) (figures 3.7 and 3.8). While, no doubt, Hershfield meant Abie to look comic, the depiction also, for the worried nativists reading the strip, would have made him seem a nonthreatening ethnic character.

Though Hershfield eliminated the baggy pants and derby hat pulled low over the ears that had been employed to identify the Jew on the vaudeville stage and instead had Abie sport more contemporaneous attire, with a tie, a vest, and fancy shoes, Abie still was not stylishly dressed (see figure 3.7). His jacket was short at a time when longer styles were in fashion; he looked ridiculous in Panama and straw hats; even when he wore a tux for a "fency" event, it was usually borrowed or rented.[70] Abie's slightly out-of-style clothes signal his difference from those around him, including his wife, business associates, and friends. They indicate that though he was trying, he was not yet fully assimilated into American society.[71]

Figure 3.5. Buster Brown. Excerpt from Richard F. Outcault, *Buster Brown*, September 1907. San Francisco Academy of Comic Art Collection (SFACA), SFS 83, BICL, Ohio State University.

Figure 3.6. Jiggs. Excerpt from George McManus, *Bringing Up Father*, December 3, 1913, SFACA, SFC59, BICL, Ohio State University.

Figure 3.7. Abie Kabibble. Excerpt from Hershfield, *Abie the Agent*, March 9, 1915, SFACA, Part 1, Newspaper Comic Strips, SPEC.CGA.SF, BICL, Ohio State University.

Hershfield also retained the vaudeville caricature of the short Jewish character. Both Abie's wife, Reba, and his business competitor, Bennie Sparkbaum, regularly call him a "shrimp," and they tower over him in the cartoon panels (figures 3.9 and 3.10).[72] In addition, the positioning of short Abie with two tall figures suggests another vaudeville influence on *Abie the Agent*, that of the longtime burlesque tradition of the two-act, which dates back to 1878. The two-act was a team consisting of a tall "straight man" and a short comic. The first was handsome, impeccably dressed, and street-smart, while the other was seemingly simpler, culturally naive, and disheveled—see, for example, teams such as Weber and Fields, Abbot and Costello, Laurel and Hardy, and Martin and Lewis.[73]

This tradition of the tall straight man and short comedian goes back long before burlesque and vaudeville. It is an old comic formula found in ancient Rome and then in the Italian *commedia dell'arte* (artistic comedy), which included the "scheming rogue" *zany* (comic) and his partner, the "stooge" *zany*.[74]

Figure 3.8. Flip. Excerpt from Winsor McCay, *Little Nemo*, *New York Herald*, August 1, 1909.

SMOOTHING ABIE 81

Figure 3.9. Reba and Abie. Excerpt from Hershfield, *Abie the Agent*, March 2, 1916, SFACA, BICL, Ohio State University.

Usually the two-act involved the tall man berating the short one or attempting to take advantage of him (the "put-down") or the short man ultimately triumphing over the tall one (the "reversal"). Sometimes the two engaged in slapstick or knockabout, in which the shorter one was, literally, pummeled by his partner. (Perhaps the most extreme example was the Three Keatons family act, in which Buster Keaton—later to be a silent movie star—was, at five years old, literally thrown around the stage and slammed into backdrops by his supposedly enraged father.)[75] Davies noted that "members of high-status groups have traditionally

Figure 3.10. Bennie and Abie. Excerpt from Hershfield, *Abie the Agent*, October 12, 1914, SFACA, BICL, Ohio State University.

been depicted as long and lean and those of low status as short, squat, and gross." Mintz also pointed out that the two-act allowed for oppositional qualities: "honesty versus dishonesty, of generosity versus thriftiness... in short just about all moral, ethical and social belief and behavior."[76] The dialogue form, usually just between two characters and free of unnecessary narrative background, was the simplest way to deliver jokes. Depending on the ethnic group being satirized, the two-acts were called "Double Dutch, Double Hebe, and Double Wop."[77]

The two-act translated readily into comics in the early twentieth century, such as in Bud Fisher's cartoon strip *Mutt & Jeff* (figure 3.11). Vaudeville also presented mixed two-acts, pairing the short, disheveled male comic with a tall, shapely,

Figure 3.11. Mutt and Jeff. Excerpt from Bud Fisher, *Mutt & Jeff*, 1911, SFACA, BICL, Ohio State University.

well-dressed woman who took the role of the prima donna (the smart one), inge-
nue (naive one), or soubrette (utilizing her sexual charms for advancement).[78]
The mixed two-act was also presented in comic strips. McManus, in *Bringing
Up Father*, used this convention with the tall wife, Maggie, and her short hus-
band, Jiggs (figure 3.12). Though the mixed two-act involving a Hebrew comic
was rarer on the vaudeville stage, since the stereotype of the stage Jew was that
he was too unsavory to be paired with a woman, Zagat nonetheless paired Gim-
pel with a tall, well-dressed female acquaintance (figure 3.13).[79] Hershfield, too,
did this, pairing Abie with his tall wife, Reba.[80]

SMOOTHING SPEECH

Reflecting the influence of the vaudeville stage, Hershfield had Abie speak with
Jewish dialect (e.g., "hendle" for "handle," "foist" for "first"). In addition, he also
used the vaudeville stage convention of using grammar-reversed constructions
and malapropisms (e.g., "we're disgusting" instead of "we're discussing"). Some-
times Abie's mistakes were based on homophones between Yiddish and English,
such as *mein* (my) and *mine*, which resulted in "mine everything." Though
Hershfield retained some aspects of the stage Jew's speech for his caricature, he
did not present Abie as speaking in thick Jewish dialect; rather, like Potash and
Perlmutter in Glass's short stories, Abie spoke with a dialect that was more
smoothed over, indicating some degree of assimilation. Compare, for example,
Abie's "Can you give me a couple of sample passes for this week for Romeo and
Julius?" with a Jewish dialect joke from the same time, in which one character
says, "Vot do you tink ohf dot new discovery?"[81]

Nonetheless, Abie's use of some dialect, of grammar-reversed constructions,
and of malapropisms signaled his incomplete assimilation as an American. In
contradistinction, both Abie's wife and his business competitor upheld correct
English standards. They did not speak in Jewish dialect and almost never used
inverted English word order. In one cartoon, Bennie Sparkbaum (identified as
Jewish only by his name), dressed fashionably and speaking flawless English,
stands over Abie in a superior position with a patronizing look on his face and
laughs at him for his English malapropism: "The poor feller is enjoying bad health
lately!" (figure 3.14). Another message conveyed by this is that the immigrant
community is perfectly capable of and will competently carry out the task of self-
policing to rid immigrants of their accents and to speed them along the process
of assimilation. Abraham Cahan's advice column, *Bintel Brief* (Bundle of
Letters), in the Yiddish newspaper *Forvertz* (Forward), which appeared in the
early twentieth century, was another example of Jews policing their own, as
Cahan dispensed advice to Jewish Eastern European immigrants on how to
shed their greenhorn ways and adopt all aspects of American culture.[82]

Figure 3.12. Maggie and Jiggs. Excerpt from McManus, *Bringing Up Father*, January 28, 1913, SFACA, BICL, Ohio State University.

86 SMOOTHING THE JEW

Figure 3.13. Excerpt from Zagat, *Gimpel Bainish*, *Warheit*, April 24, 1913.

Hershfield occasionally employed code-switching in the comic strip, inserting Yiddish words and phrases into Abie's English sentences. In one strip, for example, when Abie's relatives come to visit and consume his food, he exclaims, "*Faird fressen zay!*" (Like horses they eat!).[83] Sometimes Hershfield inserted Yiddish curses rendered into English (e.g., "Such pleasures my enemies should have!").[84] Here, however, unlike his earlier strip *Desperate Desmond*, the inser-

SMOOTHING ABIE 87

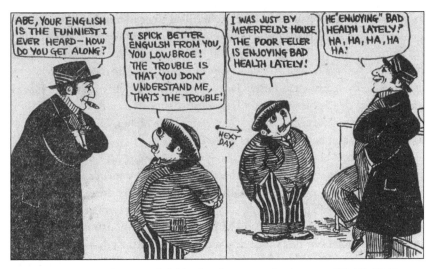

Figure 3.14. Excerpt from Hershfield, *Abie the Agent*, March 9, 1915, SFACA, BICL, Ohio State University.

tions were linguistically and grammatically coherent and were not being spoken by an incongruous character (i.e., an African tribesman). In fact, Hershfield had now replaced a Yiddish-speaking "savage" on the other side of the ocean with a more "civilized" English-speaking character in America.

In the same way that Abie's dialect and grammar reversals identified him as not yet assimilated, so, too, did the occasional appearance of Yiddish phrases in *Abie the Agent*. Yet the presence of Yiddish was double coded—that is, there was one message for the dominant culture (the non-Jewish readers) and a different one for the minority group (the Jewish community). Hershfield was not being deliberately subversive in doing this; rather, double coding is a natural consequence of belonging to an ethnic group that consists of a double boundary, "a boundary from within, maintained by the socialization process, and a boundary from without established by the process of intergroup relations."[85] The fact is that the bilingualism of first-generation immigrants reflects not only two languages but the pull of two worlds. The immigrants cannot master their new language completely and, most certainly, cannot forget their old one, though that linguistic tie may be viewed ambivalently. For his non-Jewish readership, Abie's use of Yiddish marked his differentness and his unfinished assimilation into American society; for his Jewish readership, it reinforced their identification with him as a Jewish American immigrant.[86]

Abie, though he sometimes used Yiddish, was, nonetheless, earnestly attempting to master English. In an early strip, in just three sentences, Abie's struggle with English is made clear as he talks with a passenger in his car. He renders the slang expression "soup to nuts" as "soup to meat" and "every few minutes"

as "every few more minutes." "Until we've filled the car" results in (the grammatically correct Yiddish construction) "till by us is full the car."[87] Yet, though he continues to wrestle with the English language, he is determined to master it. When writing a letter in a hotel lobby (so he can use its free stationery), he asks a passerby, "Excuse me, mister. Please—how do you spell, you know, 'sense'?" The stranger, clearly drawn as a well-established, upper-class American, replies, "C-e-n-t-s. You mean cents—money." To which Abie replies, "No, I want to write a feller that, 'I aint been in Yonkers sense Friday.'"[88]

In addition, Abie, in several strips, is found reading an English language newspaper on streetcars and in a barbershop. He scours want ads and reads articles about the war in Europe. In a time when the efforts of the Immigration Restriction League to promote a literacy test for incoming immigrants had gathered momentum, Abie's interaction with newspapers demonstrated that immigrants were literate or had the ability to become so. Abie's desire to learn and master English should also be contrasted with Zagat's comic-strip character Gimpel Bainish. The fact that Gimpel talked only in Yiddish conveyed the message that his assimilation into American society was woefully incomplete. His lack of English made him an outsider.

Despite the fact that Jewish Orthodox religious groups were, at best, ambivalent about learning English, that some Eastern European immigrants were wary that doing so was the first step in abandoning their identity as Jews, and that Jews in major urban centers living and working among their fellow immigrants could make do, quite well, with Yiddish, most of the immigrants, like Abie, began the process of adopting English as their primary language. Linguist Uriel Weinrich suggested that the social status conferred by a specific language is one of the stronger forces in deciding which language will be dominant. And Adina Cimet noted, "Acceptance of and submission to the dominant language is thus an attempt to attain levels of prestige, power, and control by abandoning one culture and exchanging it with another."[89]

Certainly, it was clear to the children of immigrants that financial success was contingent on not only mastering English but also speaking like "a regula Yankee." They could have American first names, dress like an American, eat like an American, and go to dance halls that featured mixed-dancing, concerts, and ball games like Americans, but it was the tongue that was the shibboleth in their journey toward full acceptance. The efforts of the Eastern European Jewish immigrants to learn English were supported by the already established German Jewish community of America. They viewed the Yiddish spoken by their newly arrived brethren as a lower-class language, and thus they immediately sought to establish institutions such as the Educational Alliance, which offered evening English classes.[90] As the years went by, Abie's mastery of English increased: he spoke with less dialect, his sentence structure featured correct English grammar, and the number of his Yiddish expressions was down to a

SMOOTHING ABIE 89

handful. The fact that English was now his dominant language and Yiddish was his supplementary language was a sign of his nascent assimilation.

SMOOTHING CHARACTER

The cartoon-strip structure aided in the smoothing of character. Unlike earlier, single-panel cartoons whose limited space could only convey a surface presentation of character, the multi-panel comic strips of the early 1900s allowed for character development. Rather than static ethnic caricatures—by definition exaggerations, and often grotesque ones, for the sake of humor—the sequential (panel-by-panel) interactions with other characters presented them as social creatures with distinct personalities. This created a certain degree of sympathy toward these characters on the part of the readers, even if the laughter directed toward them was sometimes derisive. In addition, the "gutters," or gaps between the panels, often demanded reader participation and involvement with the characters to imaginatively fill in the sequential links between one panel and the next, which also helped create some degree of sympathetic link between the reader and the character.

The newspapers' serial presentation of these strips also engendered, over time, comfortable familiarity with these ethnic characters, what Gardner called "the imaginative embrace."[91] Especially for residents of smaller towns and cities across America, whose encounter with Jews may have been nonexistent or infrequent, Abie became their introduction to a safe Jewish character. (On the other hand, serial repetition utilizing derogatory caricatures could also result in a familiar character who was menacing, such as cartoons in the American press of the German "Hun" during World War I.) Then, as newspapers (and the individual comic-strip artists) quickly realized that licensing comic characters for toys, phonograph records, clothing, plays, and endorsement of products could be enormously lucrative, this also had the effect, as the characters were attached to desirable consumer items and venues, of making the ethnic groups represented less of an alien Other.[92]

The need for money and the quest to obtain it formed a popular theme in vaudeville ethnic sketches that was also echoed in comic strips.[93] In a *Mutt & Jeff* strip (1911), for example, Mutt, unable to afford a fancy hat, complains that he was born handsome instead of rich; in Sidney Smith's *Old Doc Yak* (1917), Doc is threatened with eviction from the comic page, since "the advertising rates are too steep and the price of white paper is too high," unless he comes up with the rent.[94] Given that the preponderance of American cultural productions involving Jewish characters linked the Jew with money, it is not surprising that *Abie the Agent* was centered around Abie's commercial life.

It should be noted, however, that not all comic strips at the beginning of the twentieth century were centered around financial life. Some featured domestic

settings and involved marital life and children. Outcault, for example, turned from presenting the Yellow Kid, a street urchin of the slums, to, in 1902, drawing Buster Brown, the mischievous son of a genteel couple. Other comic strips (e.g., *The Katzenjammer Kids, Little Nemo, Little Jimmy*) also took place against the background of home life. This trend continued into the second decade of the twentieth century (when *Abie the Agent* arrived) with the appearance of two enormously popular strips, Sidney Smith's *The Gumps* (1917) and Frank King's *Gasoline Alley* (1918), which were also set in domestic spaces in the suburbs instead of on the city streets. This was because advertisers wanted newspaper content (including comic strips) that would appeal to middle-class readers or those with middle-class aspirations.[95]

Abie the Agent, however, focused on the challenges that Abie faced in dealing with merchandise, customers, business rivals, and employees in order to make a living. In fact, almost all of Abie's travails, such as navigating city life and interacting socially with others, were toward the goal of improving his economic standing.[96] After bidding a gracious farewell to a customer, Abie reminds Milton, his office boy, "The heppiness on mine face is for the customers—not employees!" When a potential customer treats him like a chauffeur, Abie, rather than complain, declares, "I got to keep mine tongue locked—a sale is a sale!"[97] Abie's profit margin is even calculated when it comes to his own personal injuries, as he informs a friend that, after purchasing accident insurance, he'll make a profit with his next accident![98] *Abie the Agent* also reflected the vaudeville characterization of the Jew as cheap. In one strip, Abie claims that he not only threw a silver dollar across the Hudson River, but he also dove in, trying to retrieve it.[99] In another, he declares: "A man should enjoy himself by a wedding, whether he's a guest or not!"[100] Abie frequently visits the writing room of the Hotel Astorbilt in order to use its free stationery.[101]

Yet, though the strip continued the dramatic and vaudeville traditions of linking the Jew with money, it did smooth over the ways in which this connection was made. First, Abie was held up as a model of industriousness. While Hershfield often utilized alliteration for the title of his strips (i.e., *Homeless Hector, Desperate Desmond, Dauntless Durham*), the title of *Abie the Agent* also indicated that Abie was truly an agent, an active force for his own economic advancement. During the first years of the strip, Abie engaged in a variety of business enterprises: first as a car salesman and then as an owner of a moving picture "teayter," a restaurant (Kabibble's Café), and a fur store. In later years, he owned a summer room-and-board home by the shore (Kabibble's Sea Front Pavilion) and operated an upscale cabaret with a soda fountain.

At the opening of the strip in 1914, Abie had already attained a modicum of white-collar respectability: he worked in an office, drove a car, went on vacation at a summer cottage, and attended social functions where he wore a (rented) tuxedo. He purchased hats, shopped for an overcoat, and owned a violin; Reba,

SMOOTHING ABIE 91

his wife, when Abie was courting her, had a piano in her parlor. (A parlor space, not an overcrowded tenement apartment jammed with family members and boarders, was also a sign of social respectability and wealth.)[102] In later years, unlike the classic Jewish *schlemiel* of Eastern Europe who rarely was able fulfill his goals, Abie began to achieve steady economic success. By 1919, Abie moved to a "swellish apartment house" with a doorman and joined a private club. That year he also exclaimed, "By golleh, this has been a profitable June, July and August for me—a beautiful profit I made."[103] In a 1920 strip, a friend asked him, since he was rich, why he drove his own car rather than have a chauffeur.[104] He attended the theater, visited museums, ate in fancy restaurants, and lived in a home surrounded by paintings, books, and objets d'art.[105]

Abie's economic success was in contradistinction to other comic strips of the time. Happy Hooligan, the eponymous character of the strip, for example, stayed hapless, hungry, and homeless; Mama and the Captain of *The Katzenjammer Kids* remained in ramshackle housing.[106] Unlike Jiggs in McManus's *Bringing Up Father*, who, though wealthy, still snuck out to the pub to drink and eat corned beef hash and cabbage, Abie had no desire to return to his lower-class roots. Moreover, Abie's efforts to seek great economic success, while presented humorously, were not represented as foolish, nor was Reba mocked for her higher-class aspirations, as McManus did, for example, with Jiggs's wife, Maggie.[107] Abie's economic success no doubt contributed to the strip's long-term popularity in national syndication. Both settled immigrants from all ethnic groups and long-settled Americans could identify with Abie's dreams, as they, too, harbored the desire of both economic and social improvement.

While one must be cautious in drawing connections between artists and their creations—the late Jewish American fiction writer Philip Roth, for example, stated, "Concocting a half-imaginary existence out of the actual drama of my life is my life"—nonetheless, there are elements of Hershfield's life, such as his personal economic accomplishments, that were a factor in influencing the positive manner in which Abie's upward economic path was presented.[108] Once *Abie the Agent* became a success, Hershfield was quick to capitalize on the popularity of his character. He was, no doubt, aware of the enormous income that his fellow cartoonists had made from licensing their products. By 1908, Buster Brown products—shoes, toys, and books—based on Richard Outcault's strip of the same name, were found in households throughout America. Outcault's royalties from a three-year Buster Brown stage show alone netted him $44,000. Bud Fisher, another fellow cartoonist working for Hearst's *New York American*, also made a fortune with his Mutt and Jeff characters, who were featured in stage productions and as merchandise items such as statuettes and postcards.[109] While Hershfield was unable to achieve their degree of marketing success, he did have some modest licensing accomplishments. *Abie the Agent* postcards were sold by 1916, and theater productions based on *Abie the Agent* appeared in the

1920s.[110] Hershfield wrote song lyrics ("At Abe Kabibble's Kabaret") and, as noted earlier, voiced a number of phonograph records featuring Abie.[111] He also wrote theater reviews in 1915 for the *New York Evening Journal*, using Abie as the critic.[112] Following the success of other cartoonists whose characters appeared in silent films, such as Opper's Happy Hooligan (1900) and McCay's Little Nemo (1909), Hershfield, with Hearst's funding, helped create two 1917 animated films, *Iskeh Worreh* and *Abie Kabibble Outwitted His Rival*.[113]

As a result of all these enterprises, Hershfield achieved great economic success. Coming from a family of, at best, modest means, he went on to live in an upper-class New York apartment, filled with old paintings and statuary from around the world, just as he depicted for Abie. Unlike his fellow cartoonist McManus, who wanted his personal life to appear to be like his character Jiggs's and so pretended to care little about money, Hershfield was quick to boast about his wealth. In one interview, he stated that his collection of antiques and paintings was valued at a million dollars, and his income from his various articles and vaudeville engagements netted him "not less than $100,000 a year."[114] Hershfield was probably not exaggerating his income. In the early 1930s, King Features was paying its more prominent cartoonists a yearly salary between $50,000 and $83,000. When royalties for the use of their characters in motion pictures, musical shows, advertisements, songs, and toys were added in, their income was between $150,000 and $250,000.[115]

Hershfield did, however, mock those who attempted to reach too far. In one 1914 strip, Abie runs into Jennie Grossman, a former acquaintance from the "old neighborhood." Jennie, an aspiring socialite, pretends that she doesn't know him, declaring that her name is now Jeanette Beverly Grossman. Abie indignantly responds by sarcastically reintroducing himself as Abram Buckingham Kabibble.[116] When one of his acquaintances, Mrs. Weinfliegel, dressed in fancy attire, brags that she summered in Baden-Baden and asks him where he "enjoyed the season," Abie, with an annoyed look on his face, counters that he vacationed in Yonkers-Yonkers (figure 3.15).[117]

Most significant to the process of smoothing Abie were the specific economic enterprises to which he was connected. Though he was involved in a number of occupations, he was not tied to the professions associated with Jews that had previously appeared on the vaudeville stage (and, even before that, on the dramatic stage, in literature, and in cartoons). Abie did not work as a peddler, a parasitic moneylender, a pawnbroker, or a cheap-garment shopkeeper. Unlike the vaudeville stage–Jew character who was scheming and dishonest in order to get ahead (and unlike the shirking of work attributed to Black Americans or the Irish attraction to drink and pub life that made for inefficient labor), Abie was a model of the Protestant work ethic, understanding the value of honest, steady toil with its concomitant traits of discipline and self-control that result in economic rewards.[118] The message this conveyed to both immigrant and nativist readers

SMOOTHING ABIE 93

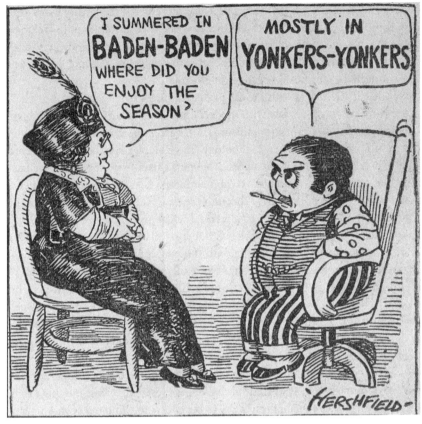

Figure 3.15. Excerpt from Hershfield, *Abie the Agent*, September 11, 1914, SFACA, BICL, Ohio State University.

was not only that the Jews would be able to become economically successful in America but that they would do so in an honest way.

Abie's first career was as an agent for the Complex Car Company. This position was emblematic of a new urban, bureaucratic social class of salespeople and clerks—people on salary rather than wages—who were striving for middle-class success.[119] Moreover, his job as a car salesman was significant. In 1914, the year this strip began, the affordable car, offering "the flexibility of the horse with the speed of the locomotive or electric trolley," was a popular item for a growing number of Americans. Manufacturing titan Henry Ford had just introduced the assembly-line technique the year before, a system that revolutionized the production industry. In 1910, Ford's annual production was 32,000, but by 1914, this number had increased by a factor of ten, when the company produced 308,000 cars. This resulted in the car becoming affordable for middle-class Americans.[120] The automobile also had iconographic meanings: not only did car ownership

94 SMOOTHING THE JEW

demonstrate one's social standing, but it also represented modernity itself—the new, frantic pace of urban society, with steam and then gasoline engines churning out goods and materials at ever faster speeds and everyone and everything seemingly in nonstop motion. In addition, the movement an automobile afforded was connected to the notion of freedom in America.[121]

While Abie's linkage with the car presented him as someone who was technologically savvy, up-to-date with modern industry, and striving to participate in the modern American world, this was, after all, a *comic* strip, so he was often not in full control of this new technology. The Complex cars he sold were constantly breaking down. In one panel, Abie puts earmuffs on a perspective customer he's taking for a ride so the customer doesn't hear the negative comments made about the car as they drive through the city.[122] Phonograph records of the time presented the immigrant as a technological greenhorn, as in *Goldberg's Automobile Troubles* (1916), in which Goldberg declares, "I think the gasarader and the sparkling plug are fighting with the magnesia."[123] Zagat's comic-strip character Gimpel Bainish had constant difficulty with the automobile as well.[124]

In addition to his difficulties with his merchandise, Abie also had run-ins with his savvy business competitor, Bennie Sparkbaum. The relationship between vaudeville's two-act characters certainly applies to the relationship between Abie and Bennie: "If on the one hand, they desire a dialogue and companionship, on the other they find themselves, by virtue of their urban predicament, in a state of unrelieved competition."[125] Despite the difficulties with his competitor and with his Complex cars, as well as the challenges presented by fast-moving urban life, Abie displayed amazing resiliency in his efforts to climb the economic ladder. Each day he would be (mildly) beaten down, only to bounce back, undiscouraged and undefeated, to try again the next day.[126] In this, his struggles were universal ones, shared and appreciated by American readers across the country.

ETHNIC AND RACIAL CARICATURES

Though Hershfield took deliberate steps to smooth the image of the stage Jew, he was not so careful when it came to demeaning stereotypes of other ethnic and racial groups, especially Black Americans, that had appeared on the vaudeville stage and in earlier comic strips, such as McCay's *Tales of the Jungle Imps* (figure 3.16).[127] As noted earlier, Hershfield had previously used elements of these Black American caricatures, such as "round, densely black heads, large white eyes and whitened oversized lips," in his *Desperate Desmond* strips; he later used them in *Abie the Agent* (figure 3.17).

The appearance of Black American caricatures in Hershfield's comic strip reflected the Jewish community's efforts during the early decades of the twentieth century to make it clear that Jews were a distinct race from Black Americans—namely, that they were white. During the nineteenth century, the German

Figure 3.16. Excerpt from McCay, *Tales of the Jungle Imps, Cincinnati Enquirer*, 1903.

Jewish community in America had felt no need to do this. Jewish community leaders in the North, in fact, had publicly expressed various degrees of sympathy toward Black Americans for the racism directed at them, while the strategy of the Southern Jewish leadership—feeling too insecure about their own position in the racially bifurcated states—was usually to refrain from public comment about Jews and Black Americans altogether. The Jews of the South were thus quiescent when it came to speaking out publicly against slavery and then, following Reconstruction, publicly challenging the continued economic and social discrimination experienced by Black Americans.

The positions of the German Jewish community in both the North and the South would change, however, as the flood of immigration that began at the close of the nineteenth century and continued into the twentieth caused American nativists, influenced by racial theories and a Black–white dichotomy that had been part of American society since the early seventeenth century, to now describe immigrants in racial terms. They declared that the "Mediterranean" races (especially Jews and Italians but Irish as well) were not white but were, in fact, Black.

This was unwelcome news for members of the established German Jewish community, since they (rightly) feared that nativists would make no distinction between the already assimilated German Jews and the Eastern European Jews coming off the boats. Having already faced some degree of social discrimination in being barred from hotels and social clubs, members of the German

Figure 3.17. Excerpt from Hershfield, *Abie the Agent*, May 18, 1914, SFACA, BICL, Ohio State University.

Jewish community certainly did not want to be linked with Black Americans, who were already socially segregated, and accordingly they concluded that "an unambiguous assertion of their whiteness was necessary to prevent the further erosion of the unapparelled acceptance they had long enjoyed."[128]

Some of the German Jewish leaders thus sought to remove Jews entirely from a racial definition, insisting publicly that the Jews were not a race but were linked to one another, instead, solely by religion.[129] A second strategy was to attempt to make the Jew invisible, to remove him (again, usually the male) from the gaze of nativists through print and stage censoring efforts, as noted in chapter 2. A third approach on the part of the German Jewish leaders was to publicly distance themselves from Black Americans despite being sympathetic to their plight.

SMOOTHING ABIE 97

Louis Marshall, for example, was not overtly associated with Black American causes even though he campaigned for civil rights laws that would ban all discrimination based on race or faith. Moreover, the Leo Frank trial in 1913 further created a gap between the leadership of the Jewish and Black American communities, as Marshall, serving as special counsel for Frank's defense, worked to shift the blame from Frank, now emphasized as a white man, to Jim Conley, a Black American janitor.[130]

The declaration on the part of some nativists that Jews should be racially categorized as Black affected the outlook of the Jewish immigrants from Eastern Europe. Though they had experienced discrimination, ostracism, and violence directed against them in Eastern Europe, they had no experience with the Black–white binary of racial designations in America and were initially more or less neutral in their attitudes toward Black Americans, especially since they were not in economic or housing competition with them. Moreover, many of the Eastern European immigrants were sympathetic to the plight of Black Americans, drawing parallels between American race riots and the pogroms in Russia against the Jews. In the opening decades of the twentieth century, the second generation of Jewish immigrants, however, understood that for them to be fully accepted as Americans, they needed to emphasize that they were not Black.[131]

Thus, Hershfield, in addition to posing Abie next to caricatures of Black Americans, also penned a few strips of Abie in blackface, which reinforced the idea, earlier made manifest in Jewish participation in blackface antics on the vaudeville stage, that the Jews were not Black: underneath their black makeup, it was to be understood, was a white person.[132] This is especially evident in the last panel of a 1914 strip in which both Abie and Bennie Sparkbaum remove their black makeup after a minstrel-like performance at their lodge (figure 3.18).

Figure 3.18. Excerpt from Hershfield, *Abie the Agent*, November 20, 1914, SFACA, BICL, Ohio State University.

Figure 3.19. Excerpt from Hershfield, *Abie the Agent*, November 16, 1914, SFACA, BICL, Ohio State University.

When it came to dialect, Hershfield was more evenhanded, utilizing the vaudeville Black American accent ("sho' thing, mistah") *together* with the stage accent of the Jew ("I'll bring yours beck") (see figure 3.17). In another strip, Hershfield used stock vaudeville dialects for both the "Chink" who owned the Chinese laundry ("come behind clounter") and for Abie, the Jewish customer ("gimme mine laundreh") (figure 3.19).

Yet, while the Jews would ultimately be successful in claiming a white ethnic identity for themselves (distinctive but assimilable), both the Chinese (barred from entering the United States in 1882) and Black Americans (who continued to be disenfranchised) were excluded as racial groups from joining the melting

SMOOTHING ABIE

99

pot of white American culture.[133] Though Black American caricatures appear less than thirty times in over two thousand *Abie the Agent* strips between 1914 and 1919—hardly "a persistent target of Hershfield's pen," as Richard Moss claimed—nonetheless, the appearance of these racist tropes highlights how deeply imbedded racial markers were within white American culture.[134]

Softening Reba

When Hershfield stated in 1921 that Abie was a cleaned-up representation of the Jew, he clearly meant the Jewish male, since he described the Jewish stereotype that he was rejecting as having "a derby hat drawn over the ears, with a big beard."[135] Though Abie's appearance stayed virtually the same through the first two decades of the twentieth century, Hershfield changed the appearance of Abie's wife, Reba, several times, as though she was merely in a supporting role, which was also in keeping with the secondary role assigned to women in early vaudeville skits.[136] Moreover, as the years went by, Reba appeared less frequently in the strip.[137] Nonetheless, Hershfield's rendering of Reba needs to be examined, since she, too, was a smoothed-over caricature.

Hershfield, just as he had done with Abie and the male Jewish caricature, eliminated some of the demeaning features of caricatures of the Jewish woman that had previously appeared. He avoided the depiction of Reba as the "masculinized hag," a type that had been presented in print and on the American stage, as noted earlier.[138] Her face was not grotesque, and she did not have an oversize nose. The only marker that Hershfield used to identify her as a Jew was her first name. (Her last name, Perlman, which also identified her as a Jew, was only found in a few strips at the outset of the series when Abie referred to her father as Mr. Perlman.) Hershfield seems to have modeled Reba on the Gibson Girl (1894), a character drawn by Charles Dana Gibson, who appeared regularly in newspapers and journals; she was youthful, beautiful, tall, thin, and graceful—and clearly meant to be an Anglo-Saxon (figures 3.20 and 3.21).[139]

At the same time, Hershfield had an alternate model on which to base Reba, one that was coming from the drawing board of Nell Brinkley, a fellow cartoonist at the *New York Evening Journal*. Perhaps even more popular at the time than the Gibson Girl, her Brinkley Girl (1913) was an independent young woman. Brinkley clothed her in exotic, colorful fabrics without restrictive corsets and showed more of her body than previous fashion allowed (figure 3.22).[140] Hershfield, however, dressed Reba far more conservatively than the Brinkley Girl, and more conservatively than some other women who appeared in *Abie the Agent*. In one panel from 1914, for example, Abie is at a dance hall attempting to do the "tengle" (tango). Hershfield drew his dance partner as having bare arms and wearing an outfit that clearly showed her legs (figure 3.23).[141] McManus, in *Bringing Up Father*, dressed Jiggs's and Maggie's fully assimilated

Figure 3.20. Gibson Girl. Library of Congress, Prints and Photographs Division, Excerpt from Charles Dana Gibson, *Picturesque America: Anywhere in the Mountains, Life*, May 24, 1900.

Figure 3.21. Reba. Excerpt from Hershfield, *Abie the Agent*, July 15, 1915, SCAFA, BICL, Ohio State University.

Figure 3.22. Brinkley Girl. Library of Congress, Prints and Photographs Division, Excerpt from Nell Brinkley, *Uncle Sam's Girl Shower,* 1918.

Figure 3.23. Excerpt from Hershfield, *Abie the Agent,* July 8, 1914, SFACA, BICL, Ohio State University.

daughter, Nora, in Brinkley Girl clothing, and Hershfield, who presented Reba as a successfully assimilated immigrant, could have done the same.[142] Instead, he covered her up, even when, at the outset of the strip, Reba was single and not yet married to Abie. Reba's appearance renders her as part of conservative, middle-class white society.

Reba's appearance was based on an American model, and it seems that the Gibson Girl also had a model for her character: the white, Anglo-Saxon, Protestant women of the time. Though Abie's pet name for Reba, "Reba mine gold," seemed to be a paternalistic twentieth-century echo of both Shylock in Shakespeare's *The Merchant of Venice* and Barabas in Marlowe's *The Jew of Malta*—both conflating their daughters and their possessions ("My daughter! O my ducats! O my daughter!" and "Oh my girl, my gold, my fortune")—Reba was, in fact, a force to be reckoned with.[143] She dressed in fashionable clothes and worked in an office. She was the opposite of both Rosalind and Katrina, the perpetual damsels in distress in Hershfield's earlier burlesque melodramatic comic strips, *Desperate Desmond* and *Dauntless Durham of the U.S.A.* Reba reflected the changing role of women during this time: they were increasingly visible as they entered what had been men's exclusive spheres of work, consumption, social activities, and politics.[144]

Despite Reba's work outside the home, *Abie the Agent* reflects the predominant male attitude toward women that was found in the late nineteenth and early twentieth century. Women were to be, in Banta's description, "Daughters of Eternity" (versus men, who were "Sons of History"): they were to remain unchanged and were not to be actors on the historical stage. The male was "the center of the universe of human events, the sole maker of history, and the guardian of correct female conduct."[145] Thus, though Reba was presented in *Abie the Agent* as a modern woman, she did not have the characteristics of the more radical "new woman" of the time, who smoked, drank, drove a car, campaigned for suffrage, and, in the eyes of conservative commentators, abandoned home, eschewed having children, and, in general, undermined masculinity.[146] While Hearst's *New York Evening Journal* supported the new woman's consumption and leisure-time pursuits, Hershfield never put Reba behind the wheel of a car or showed her enjoying leisure activities.[147] Though Abie and Reba did not have children, this was not because of Reba's denunciation of child-rearing. At a time when popular silent serial films like *The Perils of Pauline* or *The Hazards of Helen* featured heroines who were powerful, resourceful, and athletic and the Brinkley Girl had all sorts of adventures outside the home, Reba was restricted to fulfilling traditional gender roles.[148] Though she was firm and outspoken and reflected some of the new social changes involving women, Reba's rather conservative role would have assured American nativist readers of the strip that the Jew was not going to break radically with the conventional roles assigned to women at that time.

Abie the Agent, by maintaining many of the derogatory features of vaude-ville caricatures of Jewish appearance, speech, and character, underscores how prevalent and powerful were the negative presentations of the Jew that were circulating during this time on both the dramatic and comic stages, as well as in muckraking and pseudo-scientific articles and in books by reporters, public officials, and academicians, all of which were fueled by nativist fears of immi-grants in general and of the Jew in particular. Some of those caricatures, how-ever, if they could not be dropped, could at least be smoothed. This process, though it may not have always been a conscious decision on Hershfield's part, nonetheless resulted in the presentation of a less derogatory caricature of the Jew than had previously appeared in print and onstage. His nose was no longer prominent, and his countenance was not hidden by facial hair. His grammati-cal constructions still indicated his immigrant status, but his enunciation was now close to standard English. His female counterpart was not grotesque but resembled the ideal of white, Anglo-Saxon womanhood. In short, Abie and the other Jewish characters in the strip were accessible, nonthreatening, and less Other than the stage Jew caricatures had been.

CHAPTER 4

Becoming American

Germans, Frenchmen, Irishmen and Englishmen, Jews and Russians—into the Crucible with you all! God is making the American.
—Israel Zangwill, The Melting Pot

As discussed earlier, the opening decades of the twentieth century were filled with growing nativist fears: paradoxically, both that the Jews would not be able to assimilate into American culture *and* that they would all too readily do so, economically displacing settled Americans and threatening to take white Protestant women as their wives, thus weakening the Anglo-Saxon stock. The onset of the Great War raised the nativist question of whether a hyphenated identity, such as Jewish-American, was a disloyal one. In a variety of ways, *Abie the Agent* demonstrated that the Jew was not a sexual threat and not only would be able to become integrated into American society but also would be a loyal and staunch defender of the nation. At the same time, especially among second-generation Jews whose identity was "selectively American on one side and selectively ethnic on the other," there was the question of just what a Jewish-American identity meant.[1] *Abie the Agent* suggested one model that skewed the equation on the side of American identity.

The Effeminate Man

By carrying over the stage stereotype of the male Jew as unmanly, *Abie the Agent* sent the message that the Jew would not be a sexual threat. The melodramatic stage Jew typically displayed moral and physical cowardice, weakness, and effeminacy (e.g., Dickens's Jewish villain, Fagin, addresses other male characters as "my dear").[2] In one strip, after struggling unsuccessfully to wrestle a convertible "one man top" into place, Abie exclaims: "It's a 'one man top,' all right but I guess I ain't the man!"[3] Abie most certainly did not engage in idealized American male pursuits of that time: fighting, hunting, and drinking. When he did so, he was presented as being way out of his league (figure 4.1). President

Figure 4.1. Excerpt from Hershfield, *Abie the Agent*, March 21, 1914. SFACA, BICL, Ohio State University.

Theodore Roosevelt, big-game hunter, Rough Rider during the 1898 Spanish-American War, and self-identified rancher, wrote in 1902 of the American heroic type, the cowboy: "A cowboy will not submit tamely to an insult and is ever ready to avenge his own wrongs; nor has he an overwrought fear of shedding blood.... He does possess, to a very high degree, the stern manly qualities that are invaluable to a nation."[4]

Despite this national glorification of "stern manly qualities," Abie was simply not one to stand up to others. In one cartoon, when Reba demands to know why Abie doesn't step in to stop a "brutish crook" from beating up a "little feller," he replies that he is helping by giving the victim his moral support.[5] Several strips, in their last panel, reflecting vaudeville knockabout routines, show him in bed at home or in the hospital after being attacked by thugs.[6] In a 1915 strip, he replies to an insult directed at him by his business competitor, "I know you're joking, Sparkbaum, but if I thought you mean it I'd give you a punch on your

nose!" Sparkbaum responds: "Yes, I mean it!" Abie, reluctant to fight, states to the group surrounding him, "Look—first he was joking and now he's lying!"[7] When Reba spots "that big, fresh, Mister Fishmeyer" sitting near them at the theater, Abie exclaims: "I feel like smashing him in the face again!" "Again?" asks Reba. "Yeh," replies Abie, "once before I felt like smashing him in the face!"[8]

Abie did not drink alcohol, though he might socialize with others in a saloon and drink a "gless lemonade." In a 1920 cartoon he declares: "Never was I *shicker*" (drunk).[9] In another cartoon, after he orders a cup of coffee at the bar, his companion demands to know what's wrong with a stiff drink of whiskey. Abie replies, "Whiskey gives a feller too much courage!"[10] The sheet-music cover for one of Hershfield's songs shows Abie with a bottle of celery tonic on the table.[11]

Moreover, Abie's appearance as a short, roly-poly clown, as noted in chapter 3, emphasized that he was no sexual threat to anyone. This characterization stood in physical contrast to the stereotypes appearing in novels and on the stage that overtly portrayed the Jew as a lecher and sexual predator or, more subtly, made the point through the marker of the large nose. (As historian Sander Gilman has detailed, the nose can have phallic associations.)[12] Rather, Abie can be read as a de-phallicized male.[13] In fact, given that Abie and Reba have no children, his virility was not even intimated. He stood in stark contrast with Bennie Sparkbaum, his handsome, tall business rival. If Abie, physically, is a shrimp, a clown, anything but a man, Sparkbaum is "all man": tall, debonoir, and handsome.[14] It may not be too far-fetched to suggest that Abie, who does not procreate or demonstrate any erotic passion and who, as noted previously, displays none of the traditional masculine qualities of strength and courage, may be an early example of the American Jewish male who later appears in twentieth-century novels and movies as a sexual *schlemiel*.[15]

Learning Self-Control

One of the steps needed for acculturation and, later, for assimilation is mastery of a given society's social behaviors. This mastery marks the assimilated from the unassimilated (and, in more judgmental terms, the civilized from the uncivilized). Thus, in 1911, faced with "the advent of millions of immigrants of non-Teutonic stocks," Charles Eliot, president emeritus of Harvard University, called on schools to renew their efforts to teach manners to students.[16] While he snobbishly noted that there was still a difference between the good breeding of the nativists, achieved over time, and the proper manners recently acquired by the immigrants, nonetheless the latter were still necessary in a democracy. Among the qualities he listed for immigrants to learn were punctuality, order, thoughtfulness, and quietness. Since, as John Cuddihy noted, civility required the bifurcation of private affect from public demeanor, careful self-control was necessary.[17] The relaxed behaviors exhibited indoors with family and close friends

were to be regulated outside the home, and the manners exhibited in formal settings were to be more restrained than conduct in the neighborhood.

This notion of self-control in order to navigate society was at the heart of Freud's early concepts of id and superego. The very meaning of "self" was understood during the early twentieth century as the integration between inner character and public-presenting personality.[18] Consequently, the Progressive reformers who sought Americanization for the immigrants believed that for them to competently function (and to get ahead) in American society, these new arrivals would need to learn instrumental culture: basic skills and social behaviors. More specifically, they believed that to look like, dress like, sound like, and act like an American meant following the manners of white Anglo-Saxon Protestant, middle-class urban dwellers. Since men were viewed as the primary agents and actors in the world of politics and economics, it was their character that was most in need of attention. Women, however, though secondary in importance, were consumers as well as rearers of children; thus, they were not ignored when it came to expectations for their proper behavior.

The need for immigrants, and specifically Jewish immigrants, to learn middle-class American manners was an issue of serious concern for nativists. If there were those who feared that the Jew was unassimilable, there were others who had anxiety about the Jews' success. From the point of view of the old-moneyed American gentry and business elite, wealth had destroyed the social distinctions that had formerly prevailed.[19] They were greatly alarmed that, now, members of an "inferior" racial group could reach high economic status alongside their own. Accordingly, they proclaimed that Jewish wealth had been achieved too fast and that the speed at which it occurred indicated dishonest business practices. Even with wealth, these nativists asserted, the Jews undermined proper social decorum, proving themselves, in the end, not capable of becoming fully assimilable into upper-class American society. Thus, in the same way that illegal social restrictions had been erected against German Jews in the late 1870s, such as in the Seligman and Corbin affairs, so, too, were restrictions now placed against the Eastern European arrivistes in hotels, resorts, clubs, and private schools.[20] In this way, these old-money elites would be shielded from the Jews' "odious ways and manners."[21] An 1897 editorial in *Life*, for example, declared that "many Jews are refined and delightful, and are welcomed in the best society" but also stated that "a remarkable large proportion of even the more successful Jews are not altogether nice. Their manners and ways make their company unacceptable . . . many of them are somewhat noisy and somewhat greedy . . . they lack distinction and ease of manner."[22]

At first sight, Abie's clown-like physical appearance suggested that he would have difficulty self-regulating: his large eyes and potbelly were indications of enormous desire. American film historian Henry Jenkins noted that the clown represents an anarchic child in an adult's body who threatens to become unre-

BECOMING AMERICAN

strained, to burst out in disorder, thus disrupting the naysaying, restrictive elements of society.[23] Indeed, Abie's shortness was not just a carryover from the vaudeville caricature of the short Jew, nor was it just a continuation of vaudeville's two-act model, with one short actor and one tall one; it also enforced his status as anarchic child. In addition, as Lara Saguisag has noted, the child was a "useful shorthand for communicating the perceived inferiority and physical, mental, and emotional underdevelopment of the nation's new arrivals."[24] Members of immigrant ethnic groups were often represented as mischievous children whose anarchic ways needed to be brought under control by adult authority figures. Richard Outcault's Black American character Mose, in his *Pore Lil Mose* strip (1900–1902), is one example, as are the German Katzenjammer twins.[25]

While both Abie's wife, Reba, and his business competitor, Bennie Sparkbaum, navigate easily as adults through American society, Abie struggles to do so. He is often clueless or frustrated by the cultural demands put upon him, trying to decipher what is required or what he should refrain from doing. As such, Abie's challenges mimic the social training and frustrations of children as they are guided by parents through an often-overwhelming world. In one 1915 strip, Abie exclaims, concerning Reba, that she "waits on me like by a child."[26] It should be mentioned that the positions could have been reversed: in other words, Abie, as the skillful child, would be able to adroitly navigate society, while his immigrant "parents" (Reba and Bennie) would be lost and bewildered by the new world in which they find themselves. George McManus did this with the Irish immigrant Jiggs and his highly assimilated daughter, Nora. Note the title of his strip: *Bringing Up Father*.

A child he may have been, but Abie was not an unruly force like the "boy-man" US president, Teddy (not Theodore) Roosevelt, who was pictured in *Life* magazine as a boy of raw energy, fond of roughhousing and brawls and who would ultimately lead the country into war. Even though his inner child was clearly present, Abie was able to self-regulate. His life was far less chaotic than those of the Irish immigrants in Outcault's *Hogan's Alley* who battered one another in their attempts to play golf on the street or than those of the Feitelbaum family in Milt Gross's *Dunt Esk!*, who found it impossible to keep their feet on the ground.[27] Abie was not naughty or disruptive like the Katzenjammer twins. While his faux pas provided much humor as he struggled to master the correct social behaviors of the middle class, the message to nativist readers was that the Jewish immigrant, unassimilated as he might be, was, at the same time, a malleable child, willing to try to restrain himself, who ultimately would be able to be assimilated into white Protestant American society. Moreover, Abie's childish qualities of energy and vitality also suggested that the Jewish immigrant would be able to make contributions to American society.[28]

The physical construction of the *Abie the Agent* strip also echoed this self-regulation, making it clear that Abie was firmly under control. Unlike Winsor

McCay, who sometimes, in his *Nemo in Slumberland* strip, literally had his characters break through a cartoon panel, Hershfield stated that he was careful to keep his characters within the rigid frames of the comic strip. If a character needed to fall backward to show shock or amazement or needed to leave the panel, Hershfield drew the character falling or exiting to the next panel on the right. If a character fell in the last strip, the final line of the panel obscured most of their body. In his Abie strips, throughout the first two decades of the twentieth century, Hershfield did not breach this border, keeping Abie's body and movement tightly bound within the confines of the panel.[29]

Abie was not always successful in his attempts to master self-control. For example, there was his struggle with voice modulation. In one strip, Abie, shouting out from his apartment window to sell a car, is commanded by a police officer to "cut out that noise."[30] In another strip, Abie is chastised by a waiter in the fashionable Rectmonico's (a takeoff on Delmonico's restaurant) for his loud talking.[31] In another example, when a flower box falls on his head, an officer tells him that he must "stop yelling" because he is on upscale, refined Fifth Avenue. Abie asks if he should instead "holler on Canal Street" (on New York's lower East Side), where residents would not mind the volume. When Abie takes his nephew, Sidney, to a "nice place" for a meal, the upscale couple at the next table are appalled by Sidney's loud voice and coarse language as he demands of Abie, "Say, you, don't be a piker [cheapskate]—how about some dessert?" Abie, not at all embarrassed by his nephew's behavior, proudly responds to them, "Did you listen something—there ain't no 'sissy' about that kid!"[32]

Abie's table manners were also in need of improvement. In one instance, his wife, Reba, is exasperated that he eats with a knife rather than with a fork. In another, he confesses that he tried to drink hot chocolate through a straw.[33] In a third, Abie takes a "refineded" gentleman to lunch at "one of those bohemish places where everybody ects like in his own house." At the meal, confusing the public space with his private one, Abie acts as if he is at home, polishing off a plank steak meant for two to share.[34] In the fashionable Ritzmore Café, he is completely befuddled when presented with multiple cutlery on the table. When a customer calls for a knife, Abie leans over and says: "Here—I think I have yours."[35]

Though a number of ethnic comic strips at the time suggested that so-called civilized behavior had to, at times, be literally beaten into the protaganist— Maggie, Jiggs's wife in *Bringing Up Father*, hit him with a rolling pin in the last panel of many strips to bring him into line, and the unruly German twins, Hans and Fritz, were spanked at the end of each episode of *The Katzenjammer Kids*— Abie complied with the civilizing that Reba deemed to be necessary. He needed but mild chiding from her to bring him into line. In one cartoon, Reba declares, "I don't care what your ideas are, you'll tip your hat [to women] when you're out with me, Abe," and though Abie, passive-aggressively, subsequently tips his hat to a *man* they meet in the street, it is clear that he has received her lesson.[36]

Politics

While Hershfield had not shied away from political and social issues in his previous strip, *Desperate Desmond*—presenting, for example, a long-winded suffragette and the presidential candidates of 1912 (Roosevelt, Taft, and Wilson, albeit not the socialist candidate, Eugene Debs)—*Abie the Agent* contained no such material.[37] There were no references, for example, to the conflicts centered around union organizing, which was a core concern on the lower East Side. By 1910, when Hershfield came to New York, the Jewish Working Man's Association, the United Hebrew Trades, and the International Ladies Garment Workers Union (formed, respectively, in 1883, 1888, and 1900) were already well-established trade unions, and the shirtwaist workers' strike, which involved twenty to thirty thousand participants, had just concluded. In 1911, news of the Triangle Shirtwaist Company's tragic fire, in which 146 women workers perished, was splashed across city papers.[38] One simply could not be living in New York City and be unaware of labor issues and unionizing activities. Hershfield, however, was not about to have Abie take sides between the factory owners and the unions. Similarly, although the National American Woman Suffrage Association was almost twenty-five years old by the time *Abie the Agent* was created and although thousands of women had gathered the year before (1913) for the Washington Suffrage Parade, Hershfield kept Reba away from suffrage events and conversations.

On the one hand, this was not unusual for syndicated comic strips at the time. Most syndicated comics stayed clear of political topics for two principal reasons. First, the lead time needed to pen cartoons (an average of three weeks) meant that the events described or parodied would have already been old news by the time the strips reached the readers.[39] Second, because the strips were syndicated across the nation, they appeared in papers with diverse political positions. Thus, they needed to avoid any references "that might cause the slightest offense to any nationality, race, religion, political or trade organization."[40] In refraining from political references that might cause offense, these strips were following the vaudeville model of excluding from the presentation any acts that expressed overt political messages, which would have alienated some of the paying customers.[41]

Yet the *New York Evening Journal*, which published *Abie the Agent*, had no difficulty in espousing various political causes. William Randolph Hearst, given his wealth and his ability to sustain the newspaper through increased circulation and advertising, was not beholden to any political party to help subsidize his paper and thus was free to fully express his own political views. While the paper's sensationalist exposés, which presented it as a champion of the underdog and a foe of the powerful wealthy, were, no doubt, brought forth with an eye toward increasing circulation, nonetheless, the paper did champion many liberal political causes, calling for public ownership of public franchises such as coal mines, railroads, and telegraphs and for direct election of US senators. At

other times, the paper was fiercely nationalist, printing sensationalist stories to feed support for what became the Spanish-American War and to denounce hyphenated Americans on the eve of World War I.[42]

Hershfield's refusal to include political issues in *Abie the Agent* was also in contrast with Samuel Zagat's *Gimpel Bainish*. Zagat had no hesitation in taking sides, especially when it came to labor issues and supporting the workers.[43] In one strip, Gimpel, during a labor strike, has his hair cut by a barber who is a "scab" (strikebreaker). The two men are subsequently attacked by strikers (figure 4.2). It seems that when it came to the presentation of a Jewish character, Hershfield wanted to avoid all controversy. Other Jewish creators after Hershfield would

Figure 4.2. "Pull out his guts, the scab. He'll know better next time." Excerpt from Zagat, *Gimpel Bainish*, *Warheit*, May 21, 1913 (author's translation).

BECOMING AMERICAN

explicitly follow this strategy of staying clear of politics in their own portrayals of American Judaism. For example, Gertrude Berg, the writer, producer, and star of *The Goldbergs* radio (1929–1946) and then TV (1949–1956) shows, said of her work, "I don't bring up anything that will bother people. Unions, politics, fund-raising, Zionism, socialism, inter-group-relations, I don't stress them."[44] The absence of all politically charged issues from *Abie the Agent* helped convey that Abie, as a stand-in for the Jewish immigrant, was capable of self-regulation and was not going to disturb the social order.

WORLD WAR I

When it came, however, to the Great War, Hershfield could not avoid bringing political events into *Abie the Agent*. At first, Hershfield had Abie echo most Americans' isolationist position when war broke out in Europe. In one strip in 1914, Abie stated that the outbreak of war in Europe was of no interest to him. In a 1915 strip, while reading the news, he declared, "I'm gled they're going to put something else in the papers besides bettles"; in another, he proclaims, "I'm sick and tired reading in the papers about this war business."[45] (Zagat's *Gimpel Bainish* echoed similar sentiments in the *Warheit*: in a 1914 strip, Gimpel steps away from a fight, stating, "I'll just follow President Wilson's example and stay neutral.")[46] Hershfield, however, soon came to have Abie support the war effort, demonstrating that the larger Jewish community was supporting this American cause. What Hershfield did not express was that the Jewish community was divided on the issue of which side to support—Russia or Germany—and was further divided concerning the entry of America into the war.

From the outset of hostilities in Europe in 1914 until America's official entry into the war in 1917, the Eastern European Jewish immigrant community, given its antipathy toward Russia as a result of oppressive czarist policies toward the Jews, wished to see Russia's defeat at the hands of Germany.[47] This, however, was in direct opposition to US policy, which viewed Russia as an ally. With the czar's abdication in March 1917 and a revolutionary government in place by October, pro-Russian sentiment waxed in the Jewish community, especially among Jewish socialists, Progressives, and labor unionists. They now supported attempts to defeat Germany so that the revolutionary Russian government could be preserved. The draft in the United States, however, which was necessary to supply an army of several million for the war effort, was another matter entirely.[48] Many of the Jewish groups that wanted Germany defeated also protested conscription. The Jewish Eastern European immigrant community had memories of czarist draft practices that wrenched Jewish conscripts, often young boys, from their families and communities for long periods and sought to eradicate all Jewish practice from their lives. It was precisely to avoid conscription that a number of them had immigrated to America.

Not all in the Jewish community, however, were opposed to the draft or to America's entry into the Great War. In 1917, for example, the Yiddish poet Morris Rosenfeld, champion of the Jewish worker and of unionizing efforts, wrote Yiddish lyrics to what became a popular song on the East Side of New York, *Mein America* (My America). In the song, the narrator expresses his love and devotion to America and his willingness to lay down his life in war: "America: thou hast my love. / And if my valor thou wouldst prove / and ask my life as sacrifice, / it shall be yielded in a trice. / No wherefore and no why I ask, / I shall obey, whate'er the task."[49]

German Jewish American leaders, in particular, supported the draft for several reasons. First, they worried that opposition to conscription represented a symbolic refusal by Jews to be integrated into American society, since military service was seen by those who favored Americanization efforts for the immigrants as an opportunity for assimilation and the further forging of a national identity. War would bring the nation together. In the words of former US president Theodore Roosevelt: "The military tent where they all sleep side by side . . . will rank next to the public school among the great agents of democratization."[50] The German Jewish leaders did not want to turn down this opportunity offered to the Jews to participate fully in the American community.

Second, and more worrisome, was the issue of dual loyalty that now reared its head. While hyphenated Americans signified, at best, incomplete assimilation, now, in wartime, they represented a fifth column, "the nation's enemies who had squandered their right to be part of God's crucible."[51] Roosevelt proclaimed, "We must have one flag, and only one flag; and we must tolerate no divided loyalty."[52] A growing number of organizations (such as the Young Men's Christian Association, American Legion, and US Chamber of Commerce) joined the already established anti-immigration groups to question not only whether immigrants could be assimilated into American society but also where their loyalties lay. German Jewish Americans were especially worried about loyalty questions, which were often posed directly toward them, as America's declaration of war against Germany in April 1917 was followed by nativist xenophobia against German Americans: "The German preeminence in music, philosophy, and science gave way to a harsh picture of unyielding efficiency and strength, of arrogant militarism and imperialism."[53] Thus, the German Jewish leadership in America was quick to respond that German Jewish Americans were Americans first. War and conscription efforts were supported by leading German Jewish philanthropists and communal leaders, like Jacob Schiff and Louis Marshall, as well as by the German-led American Jewish Committee and the Educational Alliance. New York Jewish communal leaders, such as Cyrus Adler and Rabbi Stephen S. Wise, proclaimed that it was Jewish immigrants' obligation to register for the draft and that doing so would end nativist concern about their hyphenated identity (namely, Jewish-American).[54]

BECOMING AMERICAN

Hershfield, like the US German Jewish leadership, was determined to show that the Jewish community supported the war effort. In his 1917 phonograph recording, *Abe Kabibble "Does His Bit,"* he had Abie state: "Join the army and don't be a slacker! This ain't the slack season. It's very busy by the government."[55] Hershfield had Abie hawk Liberty bonds and support the returning soldiers by treating them to meals and free tickets to his movie theater.[56] He also had Abie enlist in the army, after declaring: "I'll hendle a gun for Uncle Sam."[57] (Throughout the war, however, he was not stationed "over there" but, rather, at an army camp in New York). Hershfield proudly stated that after the end of the conflict, he received a letter from the US Secretary of War, thanking *Abie the Agent* for its support.[58]

But whether those in the American Jewish community supported the draft and America's entry into the war or were opposed to them, all were united in their concern for the suffering of the Jewish population in Russia's Pale of Settlement during the Russian and German battles. Jewish refugees, as well as those Jews forcibly resettled by the retreating Russians, faced starvation and death by typhoid and cholera. Beginning in 1914, the Jewish community reacted by sending funds to these victims of war. At the end of 1917, when America had entered the war, a campaign was started to raise funds, both for the Jewish Welfare Board to provide additional support for those Jews serving in the military and for the Jewish Joint Distribution Committee to aid Jewish war victims in Europe.[59]

Thus, an *Abie the Agent* cartoon panel of 1917 conveys two different messages to the readers. For his non-Jewish audience, Abie, and, by implication, the Jewish immigrant community, supports the Great War. He declares, "I'll spick and talk for this great cause." The poster depicted in the panel makes it clear that the funds he seeks to raise will go to the army and navy. For Jewish readers, it is implied that the other recipients of the funds Abie raises are Jews suffering in the war zone, a group that would have meant little to most non-Jewish readers but carried enormous emotional significance for the members of the Jewish community (figure 4.3).[60]

Hershfield also kept the political issue of Zionism out of his strip. The concerns expressed at the outset of World War I by nativists about potential dual loyalties of recent immigrants continued to play out at the end of the war concerning Zionism, an issue on which the Jewish community was also divided. Though the notion of a Jewish homeland as a haven for Jews was popular among Eastern European Jewish immigrants, many of the German Jewish community leaders spoke out against it, since the Zionist movement tended to emphasize issues of Jewish race and separate nationhood—concepts that were opposed to nativist declarations that there were no longer to be hyphenated Americans. The German Jewish leadership did not want charges brought against the Jewish community that they had loyalties elsewhere, outside the United States. Hence,

Figure 4.3. Excerpt from Hershfield, *Abie the Agent*, December 7, 1917. SCAFA, BICL, Ohio State University.

Hershfield, clearly with his eye toward his German Jewish patrons, made no mention of Zionism in *Abie the Agent*.[61]

Acquiring Culture

In addition to self-regulation—such as learning voice modulation, displaying correct eating manners, and avoiding social disruption—another step needed for assimilation into a society is familiarity with its cultural history. In this, Abie clearly had some work to do. Many of the strips illustrate his inability to recognize items that were known to well-established Americans. One strip depicts Abie's unfamiliarity with the basics of baseball. When the umpire calls him out, Abie declares, "Gimme one more chance and you can take it off from the next inning!"[62] In another, Abie views Archibald Willard's painting *The Spirit of '76* but has no clue about its Revolutionary War context; he says that it was about "a oldish man and a boy playing each on a drum, and another man with a headache!"[63] In a strip from circa 1919, Abie decides to buy an American flag, but the salesman sells him one that has not only the frayed ends cut off but most of the stripes as well. In the comic's punch line, Abie can recognize that it's "the American fleg" but cannot quite tell why it looks strange (figure 4.4).

Figure 4.4. Excerpt from Hershfield, *Abie the Agent*, July 14, 1916. SFACA, BICL, Ohio State University.

Abie is also clueless when it comes to the culture of the higher-class society he is seeking to enter. For example, he assumes that someone in the museum has carelessly broken off the arms of an antique statue, and at a fancy dinner he is ignorant as to the meaning of *demitasse* (figures 4.5 and 4.6). In another strip, he proudly shows off to a friend his latest purchase: a 1915 Stradivarius violin.[64]

Some of the cultural artifacts that Abie encountered and the activities he sought to master were only accessible for those living in large urban areas rather than in rural areas. This not only reflected that the comic strip itself was "a child of the city streets," originating in urban centers, but echoed, as well, Hershfield's personal city experiences in Chicago and New York.[65] Moreover, Abie's efforts to become more cultured also seem to mirror Hershfield's personal attempts. Though he had dropped out of high school when he was fourteen, Hershfield proclaimed that when spending evenings at home, he read the dense and complicated works of seventeenth- and eighteenth-century philosophers Spinoza and Kant. He filled his

Figure 4.5. Excerpt from Hershfield, *Abie the Agent*, February 1, 1914. SFACA, BICL, Ohio State University.

New York apartment with first editions of modern authors, which he delighted in showing off to visitors. A photo of his home library shows several rows of identically bound classics, suggesting that Hershfield had simply bought them for conspicuous display.[66]

Yet, amid Abie's struggle to learn American culture, there was a subtle message that was being delivered to both Jewish readers and American nativist readers. The fact that Abie was interacting, although imperfectly, with these American elements assured non-Jewish readers that they had nothing to fear: the Eastern European Jews would eventually be able to assimilate and, in fact, were desirous of doing so. The message for the more settled Jewish immigrants and their children was an assurance that acculturation, one day, would be possible for them.

Figure 4.6. Hershfield, *Abie the Agent*, November 7, 1916. SFACA, BICL, Ohio State University.

Smoothing the Past

At a time when the hyphenated identity of the immigrant was viewed with disfavor, since it represented, at best, incomplete integration into American society and, at worst, divided loyalty, *Abie the Agent* is a model of smoothing over the ethnic past. In doing so, it reinforced the Americanization movement's goal that immigrants should quickly, and totally, shed their Old World ways. Only in the beginning of the strip, when he is required to identify himself in a court of law, do we discover Abie's full Jewish name: Abram Mendel Kabibble. When, in one strip, his rival, Bennie Sparkbaum, asks, "Have you no patriotism for your fatherland? Where do you come from?" Abie refuses to answer, declaring that it was none of Bennie's business.[67] The town or country he came from, with one exception among hundreds of strips, is never named. (A 1916 strip stated that he was from Odessa, the original home of Hershfield's family.) In fact, in only a handful of strips does Abie make any general reference to coming from a land outside the United States.[68] He was not a member of a *landsmanschaft*, a Jewish fraternal organization that linked members to their village or town of origin. Instead, he had a lodge that functioned like a chamber of commerce. Abie never publicly expresses or even intimates feeling nostalgia for or having memory of his homeland. What matters are only his efforts to become an American.[69]

Even Abie's early years (and struggles) in America are rarely mentioned, and when those memories are brought forth, it is a painful experience. In one strip, an old friend visits his summer rental cottage and recalls Abie's years of poverty (sleeping on the tenement roof, eating nothing but herring), and Abie orders him out, declaring, "What was—was! What is—is!"[70] In another strip, at a gala event that he is leading, Abie encounters an old employer who gave him his first job soon after Abie arrived from Europe. Though Abie, dressed in a tux, presents himself as a successful man, the employer, much to Abie's embarrassment, recalls how Abie used to sweep out his store (figure 4.7).

Most of Abie's religious background is also smoothed over. He observes no Jewish holidays, and though he eats food associated with Eastern European Jewry—corned beef, *zoar* [sour] pickles, herring, rye bread, horse "redish," and salmon sandwiches—none of that food had specific religious connections. In one strip, Abie and Reba discuss using a city alderman (not a rabbi) to officiate at their wedding ceremony.[71] Abie did not go to services at a synagogue, and when he attended weddings or a bar mitzvah, only the reception was shown. Contrast this with Zagat's *Gimpel Bainish* strip, mentioned earlier. Gimpel's world was filled with religious references: he did not eat meat during the nine days preceding the Jewish observance of the Tisha B'Av fast day; the *lulav*, *etrog*, and *sukkah* (ritual objects used during the Jewish festival of Sukkot) made an appearance in the strip; he held a Torah scroll for the holiday of Simchat Torah as he attended services in the synagogue; and he peddled matzo during Passover.[72] In the same

Figure 4.7. Hershfield, *Abie the Agent*, January 5, 1916. SFACA, BICL, Ohio State University.

way he had slyly slipped Yiddish words into his earlier strip, *Desperate Desmond*, to amuse his Jewish readership, so, too, Hershfield occasionally did so in *Abie the Agent* or made subtle allusions to Jewish ritual. Abie's phone number at the Complex Company, for example, was Yontif 872, *yontif* being the Yiddish word for "holiday." On the cover of his sheet music, "At Abe Kabibble's Kabaret" (1915), Hershfield drew Abie dancing on a table, holding in his hand a *grogger*, a noise-maker used for the Jewish holiday of Purim (figure 4.8). The strip's non-Jewish readers would not, however, have recognized it as a ritual object.

While it is possible that Hershfield may have left out other Jewish ritual objects and religious observances because *Abie the Agent* was a nationally syndicated comic strip and these references would have been incomprehensible to the non-Jewish readership, he did sometimes have Abie use Yiddish expressions that were unknown to his non-Jewish readership: "*A klog ahf mineh sonem!*" (a plague on my enemies); "*Oy, kop shmertzen!*" (what a headache).[73] When these terms appeared, they were not translated, leaving English-reading audiences to figure out the joke from context clues alone. Rather than using Jewish religious and ritual references sparingly because of concern with comprehension for the non-Jewish readership, it is more likely that Hershfield was worried about making Abie "too Jewish." (In a 1919 strip, he has Reba buying Abie a Christmas present.)[74] In a 1921 interview, Hershfield stated that he wanted the strip "to be read by all Americans without regard to religious belief."[75]

Abie's neighborhood was also smoothed over. The teeming crowds of people from all walks of life who crowded the city streets together with horse-drawn wagons, rushing autos, streetcars, and elevated trains—all often flecked with soot from coal—were scaled back or eliminated. While the *New York Evening Journal* splashed pictures, sketches, and reports of automobile crashes, train wrecks, pedestrian accidents, and lurid accounts of tenement fires across its front pages, *Abie the Agent* presented a cityscape far removed from such disturbing events. It was not alone in this presentation. Other strips did so as well, especially since the comics were touted as entertainment for the whole family.[76] Furthermore, it is notable that though *Abie the Agent* was an ethnic comic strip, there was nothing in it that reflected a Jewish neighborhood, in general, or New York's lower East Side, in particular.

Unlike Outcault's *Hogan's Alley*, which was, in effect, comic "slumming"—a chance for the reader to view and laugh at Irish slums from afar—or Jacob Riis's *How the Other Half Lives*, which offered a voyeuristic opportunity to view photographs of impoverished Jewish immigrants in squalid quarters, *Abie the Agent* functioned as a site for the presentation of the model (totally whitewashed) Jewish immigrant neighborhood.[77] While, understandably, the darker elements of lower East Side life—alcohol, gambling, prostitution, and gangs—were eliminated, so, too, were the slightly more benign aspects. The population of the lower East Side was overflowing—more than 700 inhabitants per acre, compared

BECOMING AMERICAN 123

Figure 4.8. Hershfield, "At Abe Kabibble's Kabaret" (New York: Leo. Feist, 1915).

to an average of 161 in the rest of Manhattan—yet there was no crowding in the panels of *Abie the Agent*; there were no throngs filling the narrow, congested streets. There were no pushcarts, no boarders in the crowded tenement apartments, no laundry on lines, no workers in sweatshops, no garment piecework piled on the kitchen table, and no children hanging out on the roofs, the stoops,

124 SMOOTHING THE JEW

and the streets. It was possible to present sympathetic cartoon realism of lower East Side life—Bert Levy, for example, regularly drew a number of such illustrations—but Abie's neighborhood is pictured, instead, without any blemishes and without any ethnic markers, with the rare exception of a delicatessen (figure 4.9).[78]

ASSIMILATION

Abie was, truly, the ideal model of the melting pot at work. While some of his ethnic markers remained, such as his name and his inverted English grammatical syntax, overall, he had jettisoned most of his original language and all his religious practices, and he held no Old World nostalgia. Instead, he embraced America's language, dress, manners, and culture. He was not just attempting to acculturate—to speak English, dress, eat, and behave *like* an American—he was seeking to fully assimilate, that is, to *be* an American. In this, he was not different than many other immigrants of the time. As Mark Winokur noted, official culture "trusts only immigrants who can repress the visible characteristics of ethnicity. . . . Denial of ethnicity becomes a piece of the fabric of success, of how one achieves status and recognition in American culture."[79] Especially before reaching a modicum of economic security, many Eastern European Jewish immigrants who arrived in the United States faced a stark choice: they could be identifiably Jewish or they could be American. For example, store employees and peddlers who chose to refrain from work on Saturday, the Jewish Sabbath, lost two days of wages, since the stores were closed on Sundays, and peddlers who appeared on the streets with their merchandise on Sundays risked fines for violating the blue laws.

On the other hand, not all of the immigrants' ethnic origins necessarily needed to be erased. Many in the American Jewish immigrant community embraced "behavioral assimilation": adopting American clothing, learning English, and joining in American cultural activities while maintaining their ethnic identities through in-group marriage, religious practice, and general Jewish affiliation.[80] Others, who were even more assimilated, would maintain Jewish food, humor, and socializing with other Jews as markers of their Jewish identity. Abie, as noted previously, eschewed all religious practice, evinced no interest in Jewish social and political concerns, and did not appear to reside in a Jewish neighborhood. He did, however, consume Jewish food, and all his business associates, competitors, and friends were Jews, the only exception being customers and thugs who assaulted him. His friends Meyer, Jake, and Max made regular appearances in the strip, and, in one strip, Abie refers to "Benneh the butcher, Boolvon the baker, Old Feivel, Doovid the doctor, Leon the lawyer, and Sidney *der Shatchen* [the matchmaker]."[81] The Jewish identity that Hershfield created for Abie certainly reflected his own. He, too, enjoyed all the

Figure 4.9. Levy, *Passover Eve on the East Side, New York Times*, April 16, 1904.

material benefits of being an American while maintaining social ties to the Jewish community. There was one difference, however, and that was Hershfield's decision to have Abie married to a Jewish woman.

Abie's endogamous marriage took place against a backdrop of Jewish communal concern over the issue of assimilation. The subject of interfaith romance and marriage was a popular one in both song and theater during the early decades of the twentieth century, as the Jewish community wrestled with the dialectic of acculturation and assimilation. Israel Zangwill's *The Melting Pot* (1908), for example, ended with the promise of an interfaith marriage between David Quixano and Vera Revendal, and Montague Glass's *Potash and Perlmutter* (1913) had a romance between Perlmutter and Ruth Snyder, a Gentile.[82] Some of the American Jewish community's leaders supported interfaith marriage, wanting to battle claims made from some nativists that the Jews were clannish and were not capable of being assimilated. Thus, a 1910 advertisement for a production of *The Melting Pot* in Philadelphia was subtitled "A Story of the Amalgamation of the Races," carrying the endorsement of such German Jewish leaders (and Hershfield supporters) as Nathan Straus and Jacob Schiff.[83] On the other hand, there were others in the Jewish community who worried that intermarriage could lead to the end of the Jewish people. When, for example, in 1908, Rabbi Emil Hirsch of Chicago Sinai Congregation delivered a seemingly positive sermon on the subject of interfaith marriage, Mollie Osherman (the future chair of the Anti Stage-Jew Ridicule Committee, discussed in chapter 2) wrote of his efforts: "With our deep, impassioned love for our bible and our heritage, we will never grasp the sword of intermarriage and maim our religion beyond recognition, even though Dr. Hirsch covers the keen blade with rose-wreathed phraseology."[84]

Abie's endogamous marriage to Reba, however, was not based on Hershfield's concerns about intermarriage per se. He himself was married to a non-Jew, Jane Dellis (Sarah Jane Isdell, 1879–1960), whose family came from Ireland (figure 4.10).[85] It is likely that Reba being a Jew was due to Hershfield's assignment to create an ethnic comic strip, which would, by definition, call for ethnic characters to fill the panels. *Bringing Up Father* and *The Katzenjammer Kids*, for example, both depicted endogamous marriages as well. Especially since there were no children in Hershfield's strip, a Jewish wife was needed for Abie. Regardless of Hershfield's intent, there were two messages that Abie's marriage to Reba sent to the readers. First, it offered reassurance to those nativists who worried that the "inferior" races increasingly arriving on America's shores would intermarry with and pollute their Anglo-Saxon stock; rather, the Jews would only marry their own kind (and would not wildly reproduce). At the same time, Jewish readers were assured that their identity would not be lost due to assimilation.

Abie's quest to become fully American and, simultaneously, to hold on to some aspects of ethnic identity was not unusual; what does make *Abie the Agent* distinct from other ethnic comic strips of the time is that there was no ambiva-

BECOMING AMERICAN 127

Figure 4.10. Jane Dellis Hershfield, ca. 1909. Harry Hershfield Collection, T-Mss 1979–004, Billy Rose Theatre Division, The New York Public Library for the Performing Arts.

lence expressed in it about his attempts to totally assimilate. While *Abie the Agent* is double coded—one message for Jewish immigrants and another for American nativist readers—the strip is not open to ambivalent readings about Abie's desire to jump headfirst into the American melting pot. For example, though both McManus's *Bringing Up Father* and *Abie the Agent* presented the *bildung* (education) of their respective protagonists, Jiggs and Abie, in American ways, the key difference between them was that Abie did not push back against this educational process. Unlike Jiggs, whose escape from his upper-class surroundings to join his lower-class buddies in the pub signaled a resistance to assimilation into American society, Abie eagerly embraced all aspects of American life.

If the cost of assimilation is the erosion of and general loss of the immigrant's old pattern of life, such as the replacement of *gemeinschaft* (close-knit community) with *gesellschaft* (impersonal society), Abie had no hesitations, displayed no indication of such a loss, and had no regrets. He sought to leave his past life completely behind him.

Abie's desire to assimilate, moreover, was not an expression of the tension between the generations, as Old World parents sought to hold back their children's assimilation into American society, nor was it an expression of the shame that some second-generation Jews felt toward their immigrant parents. *Abie the Agent* did not present a subtle critique, parody, or sly subversion of American culture, nor did it depict an invasion of high society by lower elements (as did the Marx Brothers). While Saguisag noted that "newspaper comics were often disassembling the hegemonic white, middle-class values that they were buttressing," such was not the case with *Abie the Agent*.[86] Rather, Abie, with his rival, Bennie Sparkbaum, pointing the way before him, wholeheartedly embarked on the path to become an American while leaving behind most of his ethnic origins. Abie's competition with Bennie, in fact, had as much to do with his seeking assimilation as it did with economic success. Their arguments were not only about competing for customers but also over English usage, proper dress, and knowledge of American material culture. In one strip, for example, Abie and Bennie argue whether Samuel Clemens or Mark Twain was the author of *Huckleberry Finn*.[87] Though Abie may resent Bennie, he doesn't accuse him of "putting on airs" or criticize his attempts to socially improve himself. Bennie's clear success in becoming an American is exactly what Abie is trying to reach.

Reba also played a more important role in the strip than merely providing Abie with a Jewish partner. Like Bennie Sparkbaum, she represents the successful transformation of the Jewish immigrant into a fully assimilated American. That is why Reba had no verbal markers to identify her as a Jew and why her visage and general appearance (like Bennie's) was that of an ideal American (that is, white Anglo-Saxon Protestant). Portraying Reba in this way signaled to the readership that the melting pot would be succesful in eliminating the perceived distinctive Jewish physiognomy that labeled them as different than "real Americans."

As the successfully assimilated Jew, Reba also served as the foil to Abie, the yet unassimilated immigrant. Reba, representing the successful Americanization process, reassured readers that she was in control and could tame and transform Abie's uncivilized immigrant behavior, guiding him through the steps of refinement. She was also a partner in Abie's aspirations to better himself economically. She introduced him to polite society and constantly warned him to conduct himself correctly (figure 4.11). In one strip, when Abie tells her he's been invited over to the house of a new acquaintance, she tells him: "They are very fine people, Abe. If you join them in a game of cards and lose, don't cry about it."

BECOMING AMERICAN 129

Figure 4.11. Excerpt from Hershfield, *Abie the Agent*, June 6, 1914. SFACA, BICL, Ohio State University.

Don't be a piker. They're a high class family."[88] Abie might have been the "agent," a male who made his way in the world, but, in reality, it was Reba who served as parent and tutor to the short, childlike Abie, guiding him along the correct paths toward American assimilation. Hershfield's strip could just as easily been called *Bringing Up Abie*.[89]

Abie's success in assimilating into American society can best be appreciated when he is compared with the other Jewish comic-strip character of the time, Gimpel Bainish. Both struggle to learn American culture, such as baseball, for example (figures 4.12 and 4.13). Gimpel, however, throughout his appearances in *Wahrheit* strips in the first two decades of the twentieth century, does not change during his time in America. All his conversations with others are in the familiar Yiddish language of the Eastern European Jewish immigrants; he never seeks to learn English. Gimpel's struggles, though humorous, do not lead to his social or economic success. Not only do his clothes, appearance, and profession (matchmaker) remain unchanged from his previous Eastern European world, but so do the ways in which he organizes his experience. In one episode, when he is chased by an ox on a farm, he recalls the persecution of Jews in Eastern Europe as he calls out: "Help me, Jews! Antisemitism! A *goyish* [non-Jewish] ox will take out my Jewish guts."[90] In contrast, Abie works hard at mastering English, his professions are American, and he wears American clothes. In a number of strips, dressed in full golfing attire, he works hard at hitting the ball, though is unsuccessful in avoiding being hit by others.[91]

Abie was, in essence, the poster child for assimilation into white Protestant, middle-class American society. His efforts to learn English, learn self-control,

Figure 4.12. "Now they're shouting. They're celebrating! I guess I should also do it. They should not think that I am a 'green' one." Excerpt from Zagat, *Gimpel Bainish*, *Warheit*, October 14, 1913 (author's translation).

and master the particulars of American culture communicated to nativists that the Jew, indeed, would be able to fit in, be successful (but not too successful), and begin to absorb American language, dress, and manners. *Abie the Agent* also sent a similar, reassuring message to its Jewish readers: they, too, would one day be able to fit in.

Abie's marriage to Reba may also have had symbolic weight for both nativists and immigrants. Following Riv-Ellen Prell's suggestion that stereotypes of Jewish women produced by Jewish men, along with other gender issues of "family, romance, sexuality, desire, and marriage," may be a projection of Jewish male anxiety about their place in America, it is possible to view Abie and

Figure 4.13. "All I see here is balls throwed in the air and fellers chasing it—I'm afraid to esk anybody questions, it looks ignorant on mine part!" Excerpt from Hershfield, *Abie the Agent*, 1916. SFACA, BICL, Ohio State University.

Reba's relationship as reflecting the liaison of Jews with America.[92] There were clear differences between them: Abie was short, ill-dressed, and in constant (horizontal) motion, while Reba was elegantly dressed, relatively immobile, and erect (vertical).[93] Her appearance was not just like the Gibson Girl, the tall, thin, and graceful character who appeared in newspapers and journals, but was also similar to caricatures of Columbia, the symbol of America, who appeared in *Puck*, *Judge*, and *Life* cartoons in the late nineteenth and early twentieth centuries, with short immigrants crowded around her. They made an odd couple: he was unruly, uncivilized, a "shrimp," more child than man; she was an elevated, elegant, and cultured adult. Abie loved her unabashedly, though she was somewhat cool to him, but a couple they were, all the same. Together, Jews and America would wed one another.

Conclusion

What do the smoothing efforts of Jewish artists reveal to us about America and about the American Jewish community in the opening decades of the twentieth century? First is the centrality of the issue of immigration, and the concomitant worries on the part of nativists, that forms the foreground and background against which cultural productions of that time should be viewed. Seen on the dramatic and comedy stages, heard on phonograph records, appearing in newspapers and journals, and published in books, questions and concerns about immigrants were ubiquitous. In addition, this was a time in which Jewish immigrants had their own worries and struggles about their ability to assimilate or, at a minimum, acculturate into American society. The topics that appeared in *Abie the Agent* reflect these concerns. The professions that Abie chose; his persistent efforts and travails to learn English, master American manners, and gain knowledge of American culture; the appearance of highly assimilated guides— his wife, Reba, and his business competitor, Bennie Sparkbaum—to help in his efforts to become an American; and his endogamous marriage are all evidence, whether conscious or unconscious on Hershfield's part, of an answer to nativist questions and fears about the ability of the immigrant, in general, and the Jew, in particular, to assimilate into American society. Concerns about massive immigration occurring at this time in America clearly shaped and influenced the content of *Abie the Agent*.

At the same time, to return to the analogy from the introduction, of hands drawing hands, these smoothing creations, in turn, influenced the culture whence they came. Determining the strength of that influence, however, is not easy. While caricatures are helpful in understanding the zeitgeist of a period, in that they are a reflection of the culture (with the understanding that some may contain archaic tropes), care must be taken not to exaggerate their power. As with jokes, caricatures in print and on the stage are only social barometers, not forces

CONCLUSION 133

of social change. At best, the claims for their influence must remain speculative. However, a few reasonable assumptions can be made. *Abie the Agent* appeared in national syndication, and, especially for those Americans in rural areas, the strip may have been their only source for positive representations of the Jew. For those in small towns that vaudeville reached through its network of circuits, *Abie the Agent* would have presented more favorable images of the Jew than the ones that appeared as part of vaudeville derogatory caricature. In addition, at a time when Hearst and Pulitzer were competing for subscriptions, stealing cartoon artists from one another, and yanking those strips they decided were failing to draw readers, the run of *Abie the Agent* from 1914 to 1931 (and then continuing from 1935 to 1940) is testimony to the popularity of the strip. In the same way, though confined to New York City, the long run of Glass's play *Potash and Perlmutter* resulted in thousands of theatergoers attending the performances and watching the story of the upwardly mobile, increasingly Americanized, smoothed-over Jewish characters. *Abie the Agent*, despite its national syndication and Hearst's patronage, along with Glass's Broadway show and the other smoothing productions of their fellow artists, would not be powerful enough to halt the increased voices for immigration restriction, which resulted, ultimately, in the closing of America's gates in 1924; however, it is certain that these works exposed Americans from all walks of life to a more positive image of the Jew.

The messages that these smoothing artists proclaimed was that the newly arrived Eastern European Jews would be able to assimilate into white Anglo-Saxon American society—holding the same cultural values and engaging in acceptable social behaviors. They provided assurance that the Jewish immigrants were a model of sobriety, hard work, and honesty and that they aspired to engage in the same consumer behaviors as long-settled Americans. They would not disrupt or threaten white middle-class American society by challenging the traditional roles assigned to women, to laborers, or to Black Americans. These artists demonstrated to nativist readers that Jewish immigrants were capable of becoming "real" Americans.

When it came to the physical appearance, manner of speaking, and personal qualities of the Jewish characters presented by the smoothing artists, it is clear that the caricatures that had previously appeared of the male Jew on the American dramatic stage and in print in the eighteenth and early nineteenth centuries and, before that, in anti-Jewish and anti-Semitic imagery from Western Europe—hooknose, beard, heavy dialect, and unscrupulous business behavior—influenced how these characters were now shaped. This resulted in plainer facial features, lack of beards, less thick accents, and honest business pursuits. At the same time, some of the older tropes—such as the association of the Jew with money, the Jew as untrustworthy schemer, and the Jew with some accent—continued to haunt how the Jew was represented by others in print and onstage in the opening decades of the twentieth century.

Whether the continued use of aspects of derogatory caricatures was anti-Semitic in intent and reflected clear hostility toward Jews, however, is less certain. While some historians have amassed detailed collections of these caricatures and reached that conclusion, when compared with the caricatures of other ethnic and racial groups, it appears that the Jews received no more special attention than did other visible ethnic groups found in urban settings during this period. In vaudeville, for example, each ethnic or racial group had its comic turn on the stage, where they received equally scathing presentations. Though these presentations were offensive, they operated merely as a visual shorthand, and were not necessarily antagonistic in intent. Hershfield's presentation of both Chinese and Black American caricatures taken from the vaudeville stage is a case in point: while thoughtless and offensive, they were not hostile.

Though these stage and print caricatures contained elements that were simply and reflexively continued from past representations, they also contained some new aspects that reflect how the Jew was viewed at that time. First, the caricature of the Jew as German gave way to the Jew as Eastern European, as evidenced through the use of different names and a slight change in dialect, reflecting the changed composition of Jewish immigration during this period (see figure 4.7, above, where Abie reconnects with his first Jewish American employer, bearing the German last name of Holzman.) Second, if the close connection of the Jew with money was still prevalent, his profession had changed with the times. Rather than moneylender or pawnbroker, the Jew was now most often presented as petty merchant, reflecting the dominance and visibility of the Jews in this profession, which first emerged in the postbellum era of the nineteenth century. Warfield's Simon Levy, Glass's Potash and Perlmutter, and Levy's Samuels and Sylenz characters are examples of this.

These more modern caricatures suggested that even though the Jews' methods were viewed as scheming and underhanded, they did not shirk hard work—it was clear that they were diligent and successful in their business endeavors. This success was seen in the caricatures of Jewish parvenus: i.e., their wives wore gaudy jewelry, and both husbands and wives dressed in ostentatious clothing (only Jews, and not the Irish or Italians, for example, were portrayed as nouveau riche). While clearly reflecting nativist fears that "new money," especially the money of not yet fully assimilated Jews, was invading old-money class territory, these depictions also conveyed that the Jews were seen as economically rising in America. It should also be noted what was missing from these caricatures: Jews were not associated with drink, low levels of intelligence—*au contraire*, their keen intelligence was used for moneymaking schemes—or assaults on others, as were other ethnic groups. Thus, in the midst of these negative caricatures focusing on the Jews' business deviousness was also a grudging regard for their intelligence, work ethic, and economic improvement.

CONCLUSION

Whether the Jew was being singled out or was an equal part of offensive immigrant caricatures, whether some elements of the caricature consisted of older tropes serving as shorthand or newer tropes reflecting the changed social standing of some Jews, these caricatures were viewed by some Jewish artists and by the leadership of the American Jewish community as being widespread and damaging. This view led to efforts to craft a smoother image of the Jew, as well as to censorship campaigns to eliminate derogatory representations. These efforts were possible due to growing Jewish power at the time. Jews in America, after centuries in which negative caricatures of them had appeared, in both Western and Eastern Europe, and, to a lesser extent, in nineteenth-century America, now began to exercise some control over the production and dissemination of their representation.

The works of the Jewish smoothing artists demonstrate that the Jews were now able to introduce new self-images; and the slow but steady progress of the ADL and the Anti Stage-Jew Committee illustrates that derogatory images could be reduced through economic pressure. It took real power to accomplish this: the close connection of the German Jewish leadership with politicians and social reform leaders in Chicago, for example, and the star status of certain artists such as David Warfield, Montague Glass, and Harry Hershfield (who also had Randolph Hearst's publishing empire behind him). *The Auctioneer*, *Potash and Perlmutter*, and *Abie the Agent* were among examples from the time, of playwrights, stage-producers, actors, and comic-strip artists having increased control in the production of images of Jews. That is not to say, however, that the past images were eliminated entirely. While a more smoothed image of the Jew was now being presented with plainer facial features, lack of beards, and honest business pursuits, at the same time, some of the older tropes—the association of the Jew with money, and the Jew as untrustworthy schemer—continued to haunt the representations of the Jew presented in print and onstage in the opening decades of the twentieth century.

Though these smoothing artists presented a positive image of the Jew to more-settled Americans, assuring them that the Jew could assimilate into American society, their work also reveals the passing anxiety of immigrants and their children regarding their perceived ability, or inability, to "pass" as full Americans. It was one thing for one's ignorance to be exposed to a fellow Jew, like Abie with his rival, Bennie Sparkbaum. It was another to be exposed in the midst of Gentile society, as were Levy's cartoon-strip characters, Samuels and Sylenz. While in strip after strip of *Abie the Agent*, long-settled Americans would have laughed at Abie's social faux pas as he struggled to learn American manners and not expose his ignorance of American culture, these slips would also reflect, for Jewish readers, their worries that they, too, may not have mastered it all and that they, too, risked exposure as still being "green" immigrants or as coming from

recently arrived immigrant families. Sometimes it was the tongue that gave Abie away. In other strips, it was the clothes he wore or his cluelessness about some new facet of American culture. Hidden in the midst of the humor provided by Abie, Potash and Perlmutter, and Samuels and Sylenz were the insecurities of the immigrants and their children as they sought full acceptance into American society.

These insecurities were also shared by the artists who were involved in smoothing the caricature of the Jew. Second-generation immigrants they might be, with full facility in English, middle- to upper-class status, and even non-Jewish wives, yet they still were not entirely, in Dash Moore's phrase, "at home in America."[1] Despite their self-proclaimed identity as fully assimilated Americans, their Old World parents were not far away, and their poor, foreign fellow Jews were still pouring off the ships into an America increasingly looking with disfavor on these new arrivals. Despite their success, they were anxious about their hyphenated status as Jewish-Americans. The goal of becoming "full" Americans would take yet another generation to be accomplished.

While Dash Moore's work on second-generation Jews—that is, the children of immigrants—lauds their contributions to Jewish and American history through their ability to create new Jewish institutions on American soil, it also notes that these community builders were a minority.[2] Not only were most Jews not community leaders, but some of them opted out of affiliation with Jewish institutions altogether. *Abie the Agent*, along with other works by smoothing artists, reflected the desire of some in the second-generation Jewish community to wholeheartedly embrace American society while leaving behind much of Jewish praxis and formal Jewish affiliation. Membership in Jewish organizations was to be eschewed, religious practices curtailed, the speaking of Yiddish replaced, and connections to the Old World severed. Abie, most certainly, did not cling to his immigrant appearance and ways, as did other immigrant comic characters such as Happy Hooligan, the Katzenjammer twins, and Jiggs. Consuming Jewish food, socializing with other Jews, and, in Abie's case (though not in Morris Perlmutter's), marrying a Jew would now constitute Jewish identity in America. If there was to be, in Horace Kallen's words, a "symphony of America," where a Jewish-American identity would be forged, this did not necessarily mean that it would have to be a balanced synthesis.[3] Between the Jewish community on the one side and the allure of American culture and economic success on the other, the weight could be primarily on the American side.[4]

The American side of the hyphen was a powerful one. *Abie the Agent* and *Gimpel Bainish* present clear examples of how influential American culture was on the Jewish community. In the same way that cream cheese and lox, for example, which are viewed today as quintessential markers of Jewish identity, were not from Eastern Europe but, rather, were American products, so, too, the comic sources for Hershfield's and Zagat's strips were not Eastern European but

CONCLUSION 137

American, coming from the vaudeville stage.[5] The impact of American culture on the Jewish community began immediately after the arrival of Eastern European immigrants and influenced not only their language, religious practices, foodways, and clothing but, in the case of these Jewish comic strips, their artistic productions as well.

Yet not everything was left behind, even for those Jews who embraced American life. The Jewish identity of Abie, Potash and Perlmutter, and Samuel and Sylenz did not entirely disappear into America's melting pot. They were part of a "dominant minority"—wholeheartedly embracing American identity while maintaining inner selves that were still quintessentially Jewish.[6] Full Americans these new immigrants might become, but their names, their foods, and, yes, their jokes remained Jewish. Skewed though the balance might be, the works of the smoothing artists modeled that one could be Jewish *and* be an American. Though Glass's Morris Perlmutter married a Gentile, Levy's Samuels and Sylenz put on their masks, and Hershfield's Abie Kabibble wore a tuxedo and presented his calling card to those in high society, nevertheless, Jews they all remained. Their presentation was an important contributor to the formation of what, today, is called cultural or ethnic Judaism.

At the same time as they indicated the possibility of assimilation, the characters created by these smoothing artists, who retained Jewish names, consumed ethnic foods, occasionally used Yiddish, and socialized primarily with other Jews, also subtly suggested to their non-Jewish audience that certain identifying elements of Jews would *not* disappear into the melting pot. The Jew would remain a hyphenated American, and, given the clear desire of the Jewish immigrant to learn American ways, the hyphen should be understood as representing a dual identity, not divided loyalty. Jews could engage in certain behaviors (namely, being "Jewish") in ways that were not threatening (such as ethnic food consumption) while also embracing the white, middle-class values and behaviors of America. Moreover, since the hyphen is not an essentialist link between two cultures but rather represents the interaction between them, not only did the Jewish immigrant audience became Americanized with every performance watched, every story read, and each daily comic strip followed but America, in turn, through learning about these Jewish characters, became, as it were, a little bit Jewish.

While these smoothing artists presented a more positive image of the Jew to Americans, they also marked the beginning of that image becoming more invisible with each passing year: first, on the stage, and later, on the radio, in movies, and on TV up through the 1950s.[7] The process of smoothing, begun at this time, would result over the years in all the markers of the Jew being erased. In movies and on television, Jewish dialect was softened further and replaced by a New York accent. Quick verbal punning took the place of Yiddish dialect and English malapropisms. Residence in any urban environment now stood in for

the Lower East Side, and neurotic behavior was presented instead of seemingly nervous gesticulation. A few markers remained, such as shortness and unmanliness for the Jewish male, while the still seldom-identified Jewish woman was transformed from the caricature of wearing ostentatious jewelry into the character of the spoiled, materialistic "Jewish princess."

The smoothing process did not always move in a linear fashion. Sometimes, for purposes of nostalgia or to identify a character more clearly as a Jew, there would be a return to some of the earlier stereotypes. Thus, the entertainers Fanny Brice and Eddie Cantor brought back Jewish dialect on the vaudeville and musical stage in the 1920s, while Milt Gross, in his 1925 newspaper column "Gross Exaggerations in the Dumbwaiter," and Mac Liebman, in his 1927 book *Vot Is Kemp Life?*, also returned to the "thick" Jewish dialect of the past decades.[8] In addition, since the visual cues employed in print or on the stage to signal a Jewish character, such as physiognomy, costume, and gesture, did not translate to later radio broadcasts, performers needed to adopt aural indicators along with names and professions. Gertrude Berg's successful radio show about a contemporary Jewish family, *The Rise of the Goldbergs*, for example, employed both Yiddish dialect and syntax. Berg spoke perfect English, yet she had Mollie's husband, Jake, in 1929, speaking lines in dialect: "Dat's why, Molly, I'm begging you, look out for de company he goes, please."[9]

The attempts to remove the Jew from the gaze of nativists through print and stage censoring efforts and, when he was visible, to smooth his distinguishing markers resulted, over the following decades, with less remaining of him than even the smile of Lewis Carroll's Cheshire Cat or, in this case, the nose of the Jew, but this trend would be reversed, as third- and then fourth-generation Jewish American cartoonists made the Jew visible again. Today, hundreds of graphic novels and comics feature Jews and use diverse caricatures of them.[10] In the 1960s, for example, Robert Crumb returned to caricatures of the short, lecherous Jew with a large nose, precisely to reclaim and destabilize that older image.[11] In 1975, Howard Chaykin, as noted in chapter 4, produced the Americanized version of Israel's "new Jew"—the gun-shooting, brawling, womanizing Dominic Fortune. Art Spiegelman would create, between 1980 and 1991, a radically different caricature—the Jew as mouse—and Trina Robbins introduced the blond, Jewish superheroine Lindsay Goldman in *GoGirl!* in 2000.[12] They, together with scores of other Jewish cartoonists, continue to explore the question, as did *Abie the Agent* over one hundred years ago, of how the Jew is to be visually represented and what constitutes Jewish identity in America.

Acknowledgments

First, my deep debt to my teachers: Leon Jick (1924–2005) of Brandeis University, whose love of American Jewish history made even the distinctions between the AJ Congress and the AJ Committee seem exciting, and Norman Mirsky (1937–1998) of Hebrew Union College-Jewish Institute of Religion, who taught me the importance of the quotidian.

My thanks to Wendy Pflug, Susan Liberator, and the other staff at the Billy Ireland Cartoon Museum and Library in Columbus for their helpful and always gracious research assistance during my visits there, and prompt response to my endless long-distance duplicating requests; to Adam Rosenthal and his staff at Hebrew Union College-Jewish Institute of Religion in Los Angeles for their help in arranging for interlibrary loans and locating obscure articles in arcane databases; and to Charles Niren, my "Kentucky buddy," the world's undisputed expert on Hershfield's later comic strip and radio show, *Meyer the Buyer*, who joined me in hunting for documents.

My thanks also to Stuart Charmé, Howard Chaykin, Alan Holtz, Josh Lambert, and Ted Merwin for sharing their wisdom with me in phone calls and emails; to Andy "Doc" Davis who, over breakfast, explained the influence of minstrelsy, the circus, and concert saloons on vaudeville; and to Leah Hochman and Nancy Green for their encouragement of my research efforts.

If it "takes a village" to raise a child, it most certainly has taken a small community of editors at Rutgers University Press to help transform my manuscript into this book. My thanks for this to Elizabeth Maselli and Christopher Rios-Sueverkruebbe for their critical comments and ability to see both forest and trees, to Carah Naseem who helped see it through the final steps, and to Daryl Brower and Sherry Gerstein for heading up the production efforts. A special thank-you also to Colin MacDonald, whose copy-editing skills finely honed what

I had written. I am also indebted to the anonymous reviewers whose comments, criticisms, and suggestions have resulted in not a perfect but a better book.

I would also like to express my gratefulness to Phil Cohen, Doug Cotler, Richard Fliegel, David Frank, Richard Gilbert, Jeff Kirshner, Alan Lenhoff, Rhoda Michaelynn, Rob Philipson, and my very special interfaith Martini Unity group for their friendship, love, and support as I engaged in research and writing. My gratitude also to Rick Burke, my close friend of over fifty years who, when I told him of my new research, surprisingly revealed to me that his grandfather, Max Sax, had been a childhood friend of Harry Hershfield (!) and then brought down from his attic *Abie the Agent* memorabilia that he had inherited.

Finally, and most importantly, I couldn't have done this without my wife, Susan, whose encouragement lifted me up as I labored for long hours on this book, and whose endless patience in sitting through, for the hundredth time, my explanation to others about this project, was remarkable. In Abie's words, she is "mine everything," whose love and support mean the world to me.

Notes

INTRODUCTION

1. See Bloom, *The Anxiety of Influence*. There is no consensus, however (especially when it comes to Marxian economic determinism), as to the *degree* of influence that culture has upon the artist and artistic works, nor is it easy to exactly measure the direct or indirect influence of an artistic work on a society. See Barry, *Beginning Theory*, 165–166.

2. Lipsitz, *Time Passages*, 20; see also 36.

3. See Cole, *How the Other Half Laughs*, 95; Lambert, "'Wait for the Next Pictures,'" 13–20; Robinson, "Introduction," xx; Stein, Meyer, and Edlich, "Introduction: American Comic Books and Graphic Novels."

4. Discussed in Cole, *How the Other Half Laughs*, 70–71. Lara Saguisag argues that single-frame cartoons in which interaction takes place between the caricatures, as in Outcault's *Hogan's Alley*, should also be categorized as comics. Saguisag, *Incorrigibles and Innocents*, 191n1. See also Kunzle, *The Early Comic Strip* and *The History of the Comic Strip*.

5. Campbell, *Yellow Journalism*, 9–10; Gordon, *Comic Strips and Consumer Culture*, 38–41.

6. These characters are discussed in Goulart, *The Funnies*, 13, 18, 22; Perry and Aldridge, *The Penguin Book of Comics*, 118.

7. As noted by Soper, "From Swarthy Ape," 270, 272.

8. Goldstein, *The Price of Whiteness*, 36. See also Daniels, *Coming to America*, 226.

9. Gordon, *Comic Strips and Consumer Culture*, 86–87.

10. Conolly-Smith, *Translating America*, 83. See also Campbell, *Yellow Journalism*, 53.

11. See Conolly-Smith, "Transforming an Ethnic Readership," 72–74, and *Translating America*, 84, 282. For an examination of the first Jewish cartoons and cartoon strips in the American Yiddish press, see Buhle, *Jews and American Comics*, 29–41; Portnoy, "A Brief History of Yiddish Cartooning"; and Rubenstein, "Devils & Pranksters," 17–20.

12. Campbell, *Yellow Journalism*, 55–60.

13. While there was no lack of Jewish caricature in cartoons of this time, Jewish characters with prominent roles were totally absent in comic strips. It was not until 1948 that Jerry Siegel and Joe Shuster of *Superman* fame created *Funnyman*, which featured an identified Jewish protagonist. Their character, however, in comic-book form, had a more limited

142 NOTES TO PAGES 4–10

circulation than *Abie the Agent* did through national newspaper syndication. Even Jewish characters with bit parts did not appear in the comics until later, such as Mr. Guggenheim in Sol Hess and Wallace Carlson's *The Nebbs* (1923) and Sam Catchem in Chester Gould's *Dick Tracy* (1931). On Jewish characters in comics, see Andrae and Gordon, *Siegel and Shuster's Funnyman*, 86–105; Gordon, "The Farblondjet Superhero," 1–2; Morris, *The League of Regrettable Superheroes*, 55; Stromberg, *Jewish Images in the Comics*, 381.

14. Appel, "Abie the Agent, Gimpl the Matchmaker"; Holtz, "Obscurity of the Day: Potash and Perlmutter"; Marx, "A Stranger among His People," 156n30.

15. See Bernard and Burkhardt, "My Yiddish Matinee Girl"; Coniam, *The Annotated Marx Brothers*, 43; Farrell, *Young Lonigan*, 103, and *Judgement Day*, 217; "Abe Kabibble," Vance's Fantastic Tap Dictionary; Swerling, "Abie! (Stop Saying Maybe)," notated music. There was also a "Tijuana Bible" (pornographic comic book) that featured him. Jeff Marx Collection on Harry Hershfield and Bert Levy, Billy Ireland Cartoon Library & Museum, *Abie the Agent* ("Tijuana Bible"), no. 5, n.d., Box 1, Folder 3.

16. Lazarus, "The New Colossus."

17. Aldrich, "The Unguarded Gates."

18. Daniels, *Coming to America*, 274–275; Flanagan, *America Reformed*, 13; Gerstle, *American Crucible*, 97.

19. James, *The American Scene*, 134. Here and throughout most of this study, the primary Jewish neighborhood of New York during this time will be referred to as "the lower East Side" rather than its later mythic title, "the Lower East Side." On the neighborhood's name, see Rischin, "Toward the Onomastics of the Great New York Ghetto."

20. Grant, *The Passing of the Great Race*, 8. See also Jacobson, *Whiteness of a Different Color*, 81–82; Simons, "The Origin and Condition of the Peoples Who Make Up the Bulk of Our Immigrants," 433.

21. See Brodkin, *How Jews Became White Folks*, 55–56.

22. On efforts to restrict immigration during the early twentieth century, see Daniels, *Coming to America*, 279; Jacobson, *Whiteness of a Different Color*, 78–80; Marinari, *Unwanted*, 19–20, 26–27, 31, 35.

23. The term *Progressive Era*, rather than the *Progressive Movement*, is used here, since there was no one coherent movement but rather an "explosion of scores of aggressive, politically active pressure groups" during this time. See Rodgers, "In Search of Progressivism," 114.

24. For a detailed examination of the melting pot concept, see Gleason, "The Melting Pot."

25. On the "symphony of America," see Kallen, "Democracy versus the Melting-Pot," 220. On the "orchestration of mankind," see Magnes, "A Republic of Nationalities," 392. See also Bourne, "Trans-National America"; Kun, *Audiotopia*, 41–46.

26. My use of "smoothing" here, and in the book's title, draws on Josh Kun's phrase "smoothing over of foreign blemishes" of pop voices on 1950s music records. Kun, *Audiotopia*, 67.

27. Singer, *Melodrama and Modernity*, 59–90.

28. On efforts to restrict immigration during the nineteenth century, see Altschuler, *Race, Ethnicity, and Class in American Social Thought*, 49; Marinari, *Unwanted*, 9–12.

29. Jacobson suggests that the roots of early nineteenth-century nativist reactions against immigration can be traced back even further, to the 1790 naturalization law that created "the over-inclusivity of the category 'white persons.'" Jacobson, *Whiteness of a*

NOTES TO PAGES 10–17

Different Color, 68; see also Daniels, *Coming to America,* 276–283; Kraut, *The Huddled Masses,* 209–211.

30. Bill Blackbeard published a collection of 1914 *Abie the Agent* strips, although it contains little analysis; Richard Moss, in an article, focused on one aspect of the strip: Hershfield's depiction of Black Americans; and Ted Merwin devoted a few pages to *Abie the Agent* in his book on Jews in the 1920s. Blackbeard, *Abie the Agent*; Merwin, *In Their Own Image,* 74–79; Moss, "Racial Anxiety," 90–108.

31. Some of the details of Hershfield's life brought together in this book had been, literally, ripped asunder, with one half of his family scrapbook and memorabilia archived in Columbus, Ohio, and the other half in New York—perhaps a fitting reflection of his upbringing in the Midwest before becoming a permanent and well-known citizen of New York City.

32. See Allen, *Horrible Prettiness,* 30–35; Bergquist, "The Concept of Nativism"; Boelhower, *Through a Glass Darkly,* 17–36; Charmé, "Varieties of Authenticity in Contemporary Jewish Identity."

33. Goldstein, *The Price of Whiteness,* 86–98, 108–115; Jacobson, *Whiteness of a Different Color,* 57. Bial moves even further from essentialist categories such as race and argues that what constitutes Jewish identity is performance. Bial, *Acting Jewish,* 17–22.

34. Bodnar, *The Transplanted,* 207–210; Kraut, *The Huddled Masses,* 5–7; Sarna, *American Judaism,* 158–159, 169–171.

35. Riesman, "The Found Generation," 421. See also Mannheim, "The Problem of Generations"; Sollors, *Beyond Ethnicity,* 208–236.

36. James, *The American Scene,* 124.

37. Ribak, *Gentile New York,* 80–81, 126–127, 133–136.

38. See Greene, *A Singing Ambivalence,* 68–69.

39. Mayo, *The Ambivalent Image,* 17–18.

40. Soper, "From Swarthy Ape," 162.

41. Du Bois, *The Souls of Black Folks,* 9; Mullaney, "Brothers and Others," 71–72. While there is a difference between the crushing racism experienced by Black Americans and the negative reactions by nativists experienced by Italian, German, Irish, and Jewish immigrants upon their arrival in America, nonetheless, Du Bois's conception of "double consciousness" is a useful one in describing not only the awareness of the gaze upon oneself as an Other but also the integration of that awareness as a part (slight or large) of one's self-identity. For an exploration of Jewish double consciousness, see Sartre, *Anti-Semite and Jew,* 96–101.

42. See Banta, *Barbaric Intercourse,* 56–58; Soper, "From Swarthy Ape," 268.

43. See Carlson, *The Haunted Stage,* 2–7, 15, 47; Erdman, *Staging the Jew,* 105; Nathans, *Hideous Characters and Beautiful Pagans,* 5–6.

44. Mayo, *The Ambivalent Image,* 17–18.

45. Allen, *Horrible Prettiness,* 28.

CHAPTER 1 — CARICATURES AND SMOOTHING EFFORTS

Epigraph: "*Life* and the Jews."

1. Wanzo, *The Content of Our Caricature,* 5.

2. See Goulart, *The Funnies,* 8; Winokur, *American Laughter,* 90–106.

3. Other ethnic groups, such as Slavs and Poles, who were not settled in well-defined, ethnic urban neighborhoods on the East Coast or in the Midwest, did not receive as

144 NOTES TO PAGES 17–22

much attention since they were not as "distinctive, visible, and audible." Dormon, "American Popular Culture," 190.

4. Banta, *Barbaric Intercourse*, 4 (quotation), 25. See also Lowe, "Theories of Ethnic Humor," 448.

5. See, for example, Handlin, *The Uprooted*, 164–165; Mooney, *Irish Stereotypes*, 16–17.

6. Jones, *Strange Talk*, 139–141, 174–177.

7. Distler, "The Rise and Fall of the Racial Comics," 95; Mintz, "Humor and Ethnic Stereotypes," 25.

8. Wickberg, *The Senses of Humor*, 66, 68; Cole, *How the Other Half Laughs*, 7. See also Appel and Appel, *Jews in American Graphic Satire and Humor*, 16, 18, 21–22.

9. Appel, "Jews in American Caricature," 108–109. For examples of the caricature of Jews in the Middle Ages, see Cassen, "From Iconic O to Yellow Hat," and Lipton, *Dark Mirror*.

10. See Erdman, *Staging the Jew*, 20–22, 32–37; Harap, *The Image of the Jew in American Literature*, 216, 227–229; Merwin, "Jew-Face," 215–221.

11. Erdman, *Staging the Jew*, 40–43, 58–60; Schiff, "Shylock's *Mishpocheh*," 93–94.

12. Kraut, *Silent Travelers*, 52 (quotation), 143. See also Daniels, *Coming to America*, 223.

13. See, for example, *Business Educational Diet*, drawing, *Judge's Library*, April 1900.

14. Handlin, "American Views of the Jew at the Opening of the Twentieth Century," 323–324, 327; Higham, *Send These to Me*, 146–147.

15. Dinnerstein, *Antisemitism in America*; Dobkowski, *The Tarnished Dream*; Baigell, *The Implacable Urge to Defame*.

16. Diner, *A Time for Gathering*, 170–172; Varat, "'Their New Jerusalem.'"

17. Mayo, *The Ambivalent Image*, 18, 88–91; Davies, *Ethnic Humor*, 315, 323.

18. Fischer, *Them Damned Pictures*, 71–72, 78–80.

19. Though the speech of ethnic characters was referred to as "dialect," that is not technically correct. Dialects are "regional or social variants of a given language." What was being spoken was, technically, a contact language: the immigrants' new language spoken with an accent and often in the syntax of their native language. Nonetheless, given its ubiquitous use, the term *dialect* is employed in this book to refer to immigrants' speech presented in novels and cartoons, on the stage, and on the air. See Wardhaugh, *An Introduction to Sociolinguistics*, 28, 40.

20. Baigell, *The Implacable Urge to Defame*, 18; Dormon, "Ethnic Stereotyping," 490; Wickberg, *The Senses of Humor*, 128. See also Appel, "Jews in American Caricature," 116–117; Hess and Kaplan, *The Ungentlemanly Art*, 104.

21. Gordon, *Comic Strips and Consumer Culture*, 161–162, 164; Yaszek, "Them Damn Pictures," 27.

22. Varat, "'Their New Jerusalem,'" 284. My examination of *Puck* cartoons from 1880 to 1920, however, does not show this to be the case.

23. Davies, *Ethnic Humor*, 9.

24. See Diner, *A Time for Gathering*, 169–173, and "The Encounter between Jews and America," 12–14.

25. Tevis, "'Jews Not Admitted.'"

26. On vaudeville, urbanization, and mass culture, see Gebhardt, *Vaudeville Melodies*, 26; Peiss, *Cheap Amusements*, 41–45; Springhall, *The Genesis of Mass Culture*, 131–133.

27. Like both burlesque and variety shows, the circus in the early twentieth century used ethnic caricatures, presenting clowns who were dressed like Chinese, Germans, and Jews. Towsen, *Clowns*, 271–72.

NOTES TO PAGES 22–26

28. See Erdman, *Blue Vaudeville*, 8, 17, 19, 163; Lewis, *From Traveling Show to Vaudeville*, 7–8, 315–318; Winokur, *American Laughter*, 67–68.

29. Gebhardt, *Vaudeville Melodies*, 24–26; Nesteroff, *The Comedians*, 2–3; Snyder, *The Voice of the City*, 64–70.

30. On theater owners, see Green and Laurie, *Show Biz*, 4; McLean, *American Vaudeville*, 44–47; McNamara, *The Shuberts of Broadway*, 12, 14, 42, 43, 63; Mooney, *Irish Stereotypes*, 13–16.

31. Jenkins, "Anarchistic Comedy," 92; Jenkins, *What Made Pistachio Nuts?*, 59, 81, 85–86; Laurie, *Vaudeville*, 211.

32. LaDelle, *How to Enter Vaudeville*.

33. McLean, *American Vaudeville*, 24; Slide, *New York City Vaudeville*, 9–11.

34. Corenthal, *Cohen on the Telephone*, 6–7; Green and Laurie, *Show Biz*, 51, 72–73; Kenney, *Recorded Music in American Life*, 31–32, 37; Stewart, *No Applause*, 249–251.

35. DiMeglio, *Vaudeville U.S.A.*, 21.

36. Cross and Proctor, *Packaged Pleasures*, 146; Stewart, *No Applause*, 242–243.

37. Gottlieb, *Funny, It Doesn't Sound Jewish*, 110–111.

38. DiMeglio, *Vaudeville U.S.A.*, 85–86.

39. Yochelson and Czitrom, *Rediscovering Jacob Riis*, 86–92.

40. See Gordon, *Comic Strips and Consumer Culture*, 9; Soper, "From Swarthy Ape," 171.

41. Jenkins, *What Made Pistachio Nuts*, 33–37, 78–79; Stewart, *No Applause*, 87–88, 91.

42. Herman and Herman, *Foreign Dialects*, 357. See also Winokur, *American Laughter*, 49.

43. McLean, *American Vaudeville*, 3. See also Jones, *Strange Talk*, 171–174; Snyder, *The Voice of the City*, 12.

44. On laughter and ridicule, see Cole, *How the Other Half Laughs*, 12; Wickberg, *The Senses of Humor*, 8, 47, 56–57, 64.

45. Jones, *Strange Talk*, 177.

46. Ben-Amos, "The 'Myth' of Jewish Humor," 124–125.

47. Wickberg stated that from the 1890s on, the definition of having a good sense of humor was viewed as the ability not only to laugh at others but to laugh at oneself. This calls into question whether the immigrants were *actually* laughing at themselves or whether this was a retrojection on the part of later writers. Wickberg, *The Senses of Humor*, 102.

48. Thissen, "Beyond the Nickelodeon," 63.

49. For an example of Jewish dialect on the stage, see Newton, "Abie Cohen's Wedding Day," 41–46. For examples of Black American and other ethnic dialects, see Byron, "Crank Up the Phonograph," 75–77, 155, and Jones's and Spencer's 78 rpm records: *Fritz and Louisa*, *Maggie Clancy's Grand Piano*, and *Mammy Chloe and Her Joe*.

50. For a discussion of dialect in American society at this time, see Jones, *Strange Talk*, 163–164, 174.

51. Jones, *Strange Talk*, 172–174.

52. Jones, *Strange Talk*, 175–176.

53. See Conolly-Smith, *Translating America*, 152–153; Cole, *How the Other Half Laughs*, 24; Jones, *Strange Talk*, 171.

54. As discussed in Jones, *Strange Talk*, 162.

55. Brandes, "Jewish-American Dialect Jokes," 236.

56. Jones, *Strange Talk*, 171.

57. Lipsitz, *Time Passages*, 7–8.

146 NOTES TO PAGES 26-30

58. See McLean, *American Vaudeville*, 68–71.

59. On the new humor of vaudeville, see Cohan and Nathan, "The Mechanics of Emotion," 75–76; Erdman, *Staging the Jew*, 151–152; Jenkins, *What Made Pistachio Nuts*, 38–48; Levine, *Highbrow/Lowbrow*, 198–199, 234.

60. For examples of immigrant caricature on the stage and in humor journals, see Appel, "Jews in American Caricature," 107; Dell, "The Representation of the Immigrant"; Dormon, "American Popular Culture," 187–189, and "Ethnic Stereotyping," 500–502, 504–507; Romeyn, *Street Scenes*, 133–137; Wallace, *Greater Gotham*, 448–449.

61. See Distler, "The Rise and Fall of the Racial Comics," 78; Oldstone-Moore, *Of Beards and Men*, 217–20.

62. On the stage Jew, see "Ben Welch," *Buffalo Morning Express*, January 5, 1915; Distler, "The Rise and Fall of the Racial Comics," 78–80; Erdman, *Staging the Jew*, 104; Gilman, *The Jew's Body*, 38–49.

63. Byron, "Crank Up the Phonograph," 72–74; Cooper, *Yankee, Hebrew and Italian Dialect*, 17, 82–83; Erdman, *Staging the Jew*, 33–34; Harap, *The Image of the Jew in American Literature*, 227–229. Over one hundred years earlier, Jews in Germany were caricatured by their use of *mauscheln* and *judeln* (corrupted speech). See Gilman, *Jewish Self-Hatred*, 139–148.

64. Distler, "The Rise and Fall of the Racial Comics," 83–84.

65. Herman and Herman, *Foreign Dialects*, 357.

66. For an exploration of code-switching, see Wardhaugh, *An Introduction to Sociolinguistics*, 104–110.

67. Davies, *Ethnic Humor*, 3. See also Gottlieb, *Funny, It Doesn't Sound Jewish*, 25, 106.

68. Baigell, *The Implacable Urge to Defame*, 27–30.

69. On these negative qualities, see Appel, "Jews in American Caricature," 108–109; Diner, *A Time for Gathering*, 190; Erdman, *Staging the Jew*, 34–37; Harap, *The Image of the Jew in American Literature*, 216, 227–229, 309–341; Mayo, *The Ambivalent Image*, 44–66, 71–82; Rosenberg, *From Shylock to Svengali*.

70. See Lifson, "Yiddish Theatre," 553–554; Romeyn and Kugelmass, *Let There Be Laughter*, 23.

71. On such articles, see Weingarten, "The Image of the Jew," 39–41, 55; Yochelson and Czitrom, *Rediscovering Jacob Riis*, 20–23, 68–76.

72. Kraut, *Silent Travelers*, 144–147, 155–156; Luthi, "Germs of Anarchy, Crime, Disease, and Degeneracy," 33–35.

73. Bingham, "Foreign Criminals in New York," 383–384; Turner, "The Daughters of the Poor." See also Wallace, *Greater Gotham*, 608–615, 626–630.

74. On Jews and crime, see "Izzy the Painter on Trial for Arson," *Evening World*, November 20, 1912; Joselit, *Our Gang*, 46–52, 75–81; Kraut, *The Huddled Masses*, 183–185.

75. Goldstein, *The Price of Whiteness*, 35–38; "*Life* and the Jews," 147.

76. See Diner, *The Jews of the United States*, 108–111; Erdman, *Staging the Jew*, 96; Sorin, *A Time for Building*, 105–107.

77. Hendrick, "The Jewish Invasion of America," 127. See also Hendrick, "The Great Jewish Invasion."

78. Ross, *The Old World in the New*, 144, 148, 150. The Jews were not the only racial group who were seen as a sexual threat—the Chinese were as well. See Saguisag, *Incorrigibles and Innocents*, 33.

NOTES TO PAGES 31–38

79. Appel, "Jews in American Caricature," 120; "Themes of the Theatres," *Sun* (New York), April 1, 1903. Mayo, however, has stated that Jews, in *Puck*, were not treated as badly as Irish Catholics. See Mayo, *The Ambivalent Image*, 85.

80. Erdman, *Staging the Jew*, 160.

81. Erdman, *Staging the Jew*, 83–89; 145–149; Harap, *The Image of the Jew in American Literature*, 230–233, 235–237.

82. Erdman, *Staging the Jew*, 105–107.

83. Warfield also wrote short stories about New York's Jewish East Side, involving sympathetic Jewish characters. For examples, see Warfield and Hamm, *Ghetto Silhouettes*.

84. Distler, "The Rise and Fall of the Racial Comics," 173–176; Erdman, *Staging the Jew*, 106–113.

85. Marx, "A Stranger among His People," 142.

86. Marx, "A Stranger among His People," 143–144, 147 (quotation).

87. Baigell, *The Implacable Urge to Defame*, 102, 104–107.

88. Rochelson, "Language, Gender, and Ethnic Anxiety," 401. See also Marx, "A Stranger among His People," 147–148.

89. Levy, "Oh, Jew! Suppress Thyself!" 13, 19.

90. See, e.g., Erdman, *Staging the Jew*, 25–26.

91. Jeff Marx Collection, Billy Ireland Cartoon Library & Museum, Box 1, Folder 4. See also Marx, "A Stranger among His People," 145–146, 149–150.

92. Lessing, "Bimberg's Night Off," 139.

93. Lessing, "Ingratitude of Mister Rosenfeld," 387–391. See also Cole, *How the Other Half Laughs*, 67.

94. On Glass, see "Here's the Answer to the Oft Asked: Who Is Montague Glass?" *New York Times*, January 22, 1911; Masson, *Our American Humorists*, 136; "Montague Israel Glass," *1837–1915 England and Wales Civil Registration Birth Index*; "Montague Glass, Writer, Dies At 56," *New York Times*, February 4, 1934.

95. On Glass's short stories, see Harap, *Dramatic Encounters*," 72, 74–75; Joshi, *Potash & Perlmutter*, 9; "Montague Glass, Writer."

96. Mencken, "The Burden of Humor," 155.

97. Cather, "New Types of Acting," 47. See also Mintz, "Humor and Ethnic Stereotypes," 22; Springhall, *The Genesis of Mass Culture*, 148.

98. See Glass's stories "Keeping Expenses Down," 10–12, 70–71; "Sympathy," 11; and "Taking It Easy," 12–13, 55.

99. Glass, "The Early Bird."

100. See Diner, *Hungering for America*, 194; and the Glass stories "Celestine and Coralie," 104; "Dead Men's Shoes," 5–6; and "Keeping Expenses Down," 70.

101. Glass, "A Cloak and Suit Comedy," 240; "A Present for Mr. Geigermann," 16; "Firing Miss Cohen," 285, 287. See also Matras, *Language Contact*, 101, 106.

102. For example, Gross, *Nize Baby*; Liebman, *Vot Is Kemp Life?*; Ross (Rosten), "The Rather Difficult Case of Mr. K*A*P*L*A*N."

103. Kilmer, *Literature in the Making*, 47. See also "Abe and Mawrus," *Bookman*, 15–16. For Glass's use of phonetic spelling, see Glass, "An Up-to-Date Feller," 6 and "Firing Miss Cohen," 285.

104. Hayman, *Cohen on the Telephone*. See also Jones, *Strange Talk*, 168–171.

105. Glass, "Business and Pleasure," 9.

106. Glass, *Abe and Mawruss*, frontispiece; "Celestine and Coralie," 104–105; *Potash and Perlmutter*, frontispiece; "Taking It Easy," 12; "The Fly in the Ointment," 5; "The Striped Tourists," 475, 477.

107. Though neither Glass nor Klein was credited on the playbill as a writer, they were soon identified as such. Klein, in fact, once the play proved to be lucrative, filed suit against Glass to be named as coauthor but—having missed the maiden voyage of the *Titanic* in 1912 due to a last-minute business appointment—perished in 1915 during the sinking of the *Lusitania*, and his case became moot. See "Charles Klein: An Inventory of His Plays"; Harap, *Dramatic Encounters*, 80–81; Tavares, "Mr. Charles Klein."

108. As described in Romeyn, *Street Scenes*, 179, 182.

109. Cather, "New Types of Acting," 46, and "The Sweated Drama," 18. See also Erdman, *Staging the Jew*, 154.

110. Romeyn, *Street Scenes*, 177; Erdman, *Staging the Jew*, 153.

111. See Erdman, *Staging the Jew*, 101; Soper, "From Swarthy Ape," 170–171. Just as the issue of "double consciousness" experienced by various ethnic groups was different in degree from the Black American experience of such, so, too, the passing anxiety of these second-generation Jewish artists was different in degree than it was for those Black Americans attempting to pass. At worst, discovery for these Jews might result in social difficulties, while discovery for Black Americans, especially given that miscegenation was still illegal in twenty-nine states in 1924, could result in violent death. Then, too, Black American passing often meant loss of one's birth family and community. See Facing History and Ourselves, *Race and Membership in American History*, 188; Hobbs, *A Chosen Exile*, 15.

112. Dash Moore, *At Home in America*, 9.

113. For example, Warfield and Hamm, *Ghetto Silhouettes*, v. See also Erdman, *Staging the Jew*, 3, 111–113.

114. "Benjamin Barnett," *1870 US Census, New York, New York*; Cullen, *Vaudeville Old & New* 100–101; Jones, *Strange Talk*, 163–164, 168, 176.

115. Merwin, *In Their Own Image*, 91.

116. On this attitude of some Jewish artists and writers, see Cole, *How the Other Half Laughs*, 12–17.

117. Cole, *How the Other Half Laughs*, 68–70. See also "Bruno Lessing," *Bookman*; Merwin, *In Their Own Image*, 91.

118. Marx, "A Stranger among His People," 148–149; James, *The American Scene*, 193.

119. See Erdman, *Staging the Jew*, 106–107, 153; Glass, "Keeping Expenses Down," 11, and "Sympathy," 4–5.

120. Kilmer, *Literature in the Making*, 50–51.

121. On Montague Glass's family, see Glass, "The Truth about Potash and Perlmutter," 55–56; "James David Glass," *1879 United Kingdom Naturalisation Certificates and Declarations*; Masson, *Our American Humorists*, 136–137.

122. Dash Moore, *At Home in America*.

CHAPTER 2 — CENSORING ATTEMPTS

Epigraph: "Resents Jewish Caricatures," *New York Times*, April 4, 1910.

1. See also, Glanz, *The Jew in Early American Wit*, 135; Harap, *The Image of the Jew in American Literature*, 222; Mayo, *The Ambivalent Image*, 80–81.

NOTES TO PAGES 46–51

2. "The Jew on the Stage," *Buffalo Courier*, October 1, 1899; "The Case Is Different," *New York Dramatic Mirror*, December 14, 1889.

3. On Rabbi Schanfarber's endorsement, see Romeyn, *Street Scenes*, 170.

4. *Indianapolis News*, 1901, quoted in Harap, *Dramatic Encounters*, 30; "Some Foolish Irishmen," *Rochester Democrat and Chronicle*, April 1, 1903.

5. Marx, "Moral Hazard: The 'Jew Risks' Affair of 1867."

6. "Resents Lampooning the Jew," *New York Press*, June 24, 1907.

7. See, e.g., Dauber, *Jewish Comedy*, 207–208; Romeyn, "My Other/My Self," 237–240; Schiff, "Shylock's *Mishpocheh*," 84–85.

8. See, e.g., Brandes, "Jewish-American Dialect Jokes," 233–239; Davies, *Ethnic Humor*, 309–310; Jones, *Strange Talk*, 170–171.

9. Jones, *Strange Talk*, 166–167, 171–175.

10. See Kun, "Strangers among Sounds," 12–13; Leveen, "Only When I Laugh," 49–51; Wanzo, *The Content of Our Caricature*, 2, 28.

11. Sarna, *American Judaism*, 44–47, 161.

12. On these socioeconomic divides, see Kibler, *Censoring Racial Ridicule*, 34–37; Romeyn, *Street Scenes*, 167, 175; Winokur, *American Laughter*, 71–72.

13. Erdman, *Staging the Jew*, 66–70.

14. Cohen, "Antisemitism in the Gilded Age," 188. For a detailed definition of surplus visibility, see Zurawik, *The Jews of Prime Time*, 5–6.

15. Quoted in Marx, "A Stranger among His People," 148–149.

16. Jacobs, "The Damascus Affair of 1840," 271–280; Korn, *The American Reaction to the Mortara Case*, 23–77.

17. See Marinari, *Unwanted*, 24–25, 38–40.

18. See Abel, *Menus for Movieland*, 7–10; Zurier, *Picturing the City*, 70–71.

19. On Jewish sensitivity to the gaze of others, see Distler, "The Rise and Fall of the Racial Comics," 186–187, 191–192; Erdman, *Staging the Jew*, 145; Staples, *Male-Female Comedy Teams*, 85–86, 118–120.

20. Quoted in "Stage Jew to Be Driven from Boston Theatres," *Jewish Independent*, May 30, 1907.

21. "To Boycott the Stage Jew," *New York Times*, April 25, 1913.

22. On these class issues, see Erdman, *Staging the Jew*, 151–152; Wickberg, *The Senses of Humor*, 184–190.

23. Marble, "The Reign of the Spectacular"; Zurier, *Picturing the City*, 80–84.

24. On these organizations and censorship, see Cross and Proctor, *Packaged Pleasures*, 201; DiMeglio, *Vaudeville U.S.A.*, 146–147; Friedman, *Prurient Interests*, 25–57; Keire, "The Committee of Fourteen," 573.

25. "Comic Supplements Publicly Denounced," *New York Times*, April 7, 1911; Nystrom, "A Rejection of Order," 159–191.

26. "Films Ridiculing Jews," *Emanu-El* (San Francisco), February 27, 1914; Kibler, *Censoring Racial Ridicule*, 147–162.

27. On these organizations, see Friedman, *Prurient Interests*, 136–137; Kibler, *Censoring Racial Ridicule*, 44, 51–62; Erdman, *Blue Vaudeville*, 23–24, 27–30.

28. "Merchant of Venice Crusade Still Growing," *Jewish Independent*, March 20, 1907.

29. For example, from *Jewish Independent*, "Crusade Sweeps the Nation Like a Cyclone," July 19, 1907; "Notice to Managers Stage Jew Must Go!" July 12, 1907; "Stage Jew to Be Driven from Boston Theatres."

150 NOTES TO PAGES 51–54

30. "Battle against the Stage Jew Nearly Won," *Jewish Independent*, August 2, 1907.

31. Quoted in "To Suppress 'Stage Jew,'" *Rome Daily Sentinel* (New York), July 10, 1907. See also "Here Is the Letter to Local Managers," *Jewish Independent*, July 26, 1907.

32. See, from *Jewish Independent*, "Crusade Is Sweeping through the Southland," November 28, 1907; "Jews of Cincinnati Busy with Stage Jew," November 1, 1907; "Youngstown Jews' Victory," April 26, 1907.

33. "Battle against the Stage Jew Nearly Won."

34. "Charles M. Stern Is at the Head," *Albany Evening Journal*, February 5, 1912; "Condemn Stage Jew," *Billboard*, May 21, 1910; "The Order Has Also Taken Up," *B'nai B'rith Messenger*, September 10, 1908.

35. Nahshon, "The Pulpit and the Stage," 15, 21, 27; "Resents Caricaturing Jews," *New York Press*, April 4, 1910.

36. Central Conference of American Rabbis (CCAR), *Yearbook* 19, p. 88; "Embargo on Acts," *Billboard*, April 16, 1910.

37. "The Jew on the Stage," *Variety*, December 10, 1910.

38. "Abolish Jewish Caricature," *New York Times*, March 26, 1912. See also CCAR, *Yearbook* 20, 109; *Yearbook* 21, 76–80; *Yearbook* 22, 101–103.

39. "Offensive Caricature," *Judge*.

40. See Montefiore Bienenstok, "The Hebrew Comedian," *Reform Advocate* (Chicago), September 7, 1912; CCAR, *Yearbook* 21, 76–80; *Yearbook* 22, 101–103; *Yearbook* 23, 122; *Yearbook* 24, 132–33. Distler, quoting from an article in the *New York Star*, mentions another rabbinic group, the Associated Rabbis of America, meeting in Detroit in 1914, which announced steps to force Jewish comics from the stage. I suspect this may have been a mix-up with the CCAR, which met in Detroit that year. *New York Star*, July 25, 1914, in Distler, "The Rise and Fall of the Racial Comics," 190.

41. *Chicago Record-Herald*, March 23, 1913, quoted in Distler, "The Rise and Fall of the Racial Comics," 188–189; *Chicago Record-Herald*, April 5, 1913, quoted in Romeyn, *Street Scenes*, 172.

42. As described in "How about the Negro?" *New York Age*, July 3, 1913; "Jews to Boycott Theaters Where Race Is Ridiculed," *Chicago Tribune*, April 25, 1913.

43. From the *Chicago Tribune*, see "Jews Push Fight on Stage Ridicule," April 23, 1913; "Jews to Boycott Theaters," April 25, 1913; "To Protest Stage Caricature of Jews," June 12, 1913.

44. See Cutler, *The Jews of Chicago*, 104–107, 164–166; "Jews Wage Battle on Stage Caricature," *Chicago Tribune*, September 3, 1913; "To Protest Stage Caricature of Jews."

45. On Osherman, see "Mollie Osherman," *1900 U.S. Census, New York*; "Mollie Osherman Dies," *Chicago Hyde Park Herald*, January 10, 1973.

46. Erdman suggested that Chicago's distance from the influence of the show-business industry in New York also encouraged this campaign, but I do not think this is correct given how closely the vaudeville circuits were linked by rail and telegraph and given the large number of vaudeville theatres found in Chicago. Erdman, *Staging the Jew*, 152.

47. See "Ban on Hebrew Comedians," *New York Dramatic Mirror*, August 20, 1913; *Chicago Record Herald*, May 3, 1913, quoted in Romeyn, *Street Scenes*, 173; "Eva Bars Caricature of Jews," *New York Clipper*, May 31, 1913; "Protest against Race Caricature," *Chicago Tribune*, May 22, 1913.

48. *Chicago Record Herald*, August 14, 1913, quoted in Distler, "The Rise and Fall of the Racial Comics," 189; Romeyn, *Street Scenes*, 172–173.

NOTES TO PAGES 54–58 151

49. "Hebrew Protest Meeting," *New York Dramatic Mirror*, August 20, 1913; "Jews Fight Stage Caricature," *Chicago Tribune*, August 24, 1913.

50. The Jewish Community (Kehillah) of New York City, *Proceedings of the Fifth Annual Convention of the Jewish Community Kehillah*, 20. See also "Against Motion Picture Libels on Races," *Moving Picture World*, April 18, 1914.

51. "Correspondence," *Reform Advocate*, October 31, 1914.

52. See "Jews Are Organizing to Stop Defamation," *Constitution* (Atlanta), September 18, 1913; Marcus, *United States Jewry*, 187–188.

53. For details of the ADL's censoring attempts, see "Act Is Not Objectionable: Local B'nai B'rith Lodge Takes Action Regarding Forthcoming Act at the Empress," *Fort Wayne Daily News*, January 31, 1914; Anti-Defamation League, *Report of the Anti-Defamation League*; Belth, *A Promise to Keep*, 37–43; Sable, "Some American Jewish Organizational Efforts," 245, 249–250, 253–254.

54. Sable, "Some American Jewish Organizational Efforts," 245–248.

55. Friedman, *The Jewish Image in American Film*, 21.

56. Erens, *The Jew in American Cinema*, 30–31, 33–37.

57. Belth, *A Promise to Keep*, 49–50.

58. On nickelodeons, see May, *Screening Out the Past*, 35–36; Painter, *Standing at Armageddon*, 172; "The Nickelodeon as a Business Proposition," *Moving Picture World*, July 25, 1908; Thissen, "Beyond the Nickelodeon," 54.

59. "The Nickelodeon," *Moving Picture World*, May 4, 1907.

60. See Kibler, *Censoring Racial Ridicule*, 137–39; "Report of the Anti-Defamation League to the Grand Lodge B'nai B'rith, January 28, 1914," quoted in Sable, "Some American Jewish Organizational Efforts," 246.

61. Waller, "Locating Early Non-Theatrical Audiences," 81–82.

62. Though *Levinsky at the Wedding* does not seem to have been recorded until 1917, Rose was doing the routine as early as 1908. "Julian Rose: Levinsky at the Wedding," advertisement, *Brooklyn Daily Eagle*, October 18, 1908. See the following 78 rpms: Hayman, *Cohen on the Telephone*; Jones and Spencer, *Becky and Izzy*; Rose, *Levinsky at the Wedding*.

63. As noted in Cross and Proctor, *Packaged Pleasures*, 164.

64. See DiMeglio, *Vaudeville U.S.A.*, 21–27; McNamara, *The Shuberts of Broadway*, 13–14, 42–43; Snyder, *The Voice of the City*, 35–37.

65. Erdman, *Blue Vaudeville*, 21. See also Snyder, *The Voice of the City*, 17–21.

66. Della Macleod, "Don't Keep a Barrel, but Burn Every Bad Story and Write Better One, Says Montague Glass," *New York Times*, August 17, 1913.

67. On these ads, see Harley Erdman, *Staging the Jew*, 152; "Julian Rose Heads New Empress Show for Week Starting This Afternoon; Six Real Acts," *Fort Wayne Journal-Gazette*, February 1, 1914; Romeyn, *Street Scenes*, 174–76.

68. "Distinguished Rabbi Writes Julian Rose: A Finished Artist," *Fort Wayne Journal-Gazette*, February 1, 1914.

69. Quoted in Romeyn, *Street Scenes*, 180–181.

70. "Objectionable Films," *Jewish Charities*.

71. See Belth, *A Promise to Keep*, 50; Erens, *The Jew in American Cinema*, 71–72; Kibler, *Censoring Racial Ridicule*, 155–161.

72. Merwin, *In Their Own Image*, 72–73; "Majestic-Joe Welch in 'The Peddler,'" *Buffalo Courier*, October 15, 1916.

NOTES TO PAGES 58–64

73. Sophie Mayers, "The Jew on the Screen," *B'nai B'rith Magazine*, 41, no. 12, 1927, 506–507. Quoted in Sable, "Some American Jewish Organizational Efforts," 248.

74. Soper, "From Swarthy Ape," 258.

75. Davies, *Ethnic Humor*, 318–19. See also Distler, "The Rise and Fall of the Racial Comics," 183–85.

76. Percy Hammond, "News Notes of the Plays and Players," *Chicago Sunday Tribune*, January 18, 1914.

77. Levy, *Samuels and Sylenz, Lowell Sun*, July 15, 1915.

78. Marx, "A Stranger among His People," 150.

79. Though unusual, this convention was not uncommon. Bud Fisher, for example, utilized it in his *Mutt & Jeff* comic strip, as did Winsor McCay in *Little Nemo in Slumberland* and Sidney Smith in *Old Doc Yak*. See Lindenblatt, *The Early Years of Mutt & Jeff*, 161; Marschall, *The Complete Little Nemo in Slumberland*, 26–27; Smith, *Old Doc Yak*, 1917.

80. Levy, *The Silent Partner, Buffalo Morning Express*, July 23 and 27, 1915.

81. "An Artist's Sacrifice," *Sentinel* (Chicago), October 8, 1915.

82. "A Loyal Jewish Artist," *B'nai B'rith News* 8, no. 2, October 1915 (quote); Marx, "A Stranger among His People," 152.

83. On *Gimpel Bainish Der Shadchan*, see Tamiment Library & Robert F. Wagner Labor Archive, "Guide to Samuel Zagat Drawings and Photographs"; "Louis Miller, Pioneer of Jewish Press in America, Dies at Age of Sixty-One," *Jewish Telegraphic Agency*, May 24, 1927; Peppler, *Gimpel Beynish the Matchmaker*, 3.

84. On Gimpel, see Buhle, *Jews and American Comics*, 29–40.

CHAPTER 3 — SMOOTHING ABIE

1. On Hershfield's early childhood, see "Harry Hershfield," *Iowa Delayed Birth Records*; "Henry Hershfield," *1885 Iowa State Census*; Hershfield, *Laugh Louder Live Longer*, 11–13; Michael Kaufman, "Harry Hershfield Dead; Humorist and Raconteur," *New York Times*, December 16, 1974.

2. Hershfield, *Laugh Louder*, 12–13.

3. Hershfield's strips included *Homeless Hector*; *War's Ebb and Flow*; *Bill Slowguy*, *Adventures of a Fly*; *Christopher's Luck*; *Tiny Tinkles*; *The Luck of Christopher*; *The Fortune Teller*; *Raffles*; and *Rubber, the Canine Cop*. He also illustrated W. O. McGeehan's humorous verses on horseracing, "The Piker's Rubaiyat." See Biographical Files, Billy Ireland Cartoon Library & Museum (hereafter, BICL), "Hershfield, Harry"; Holtz, "Harry Hershfield," *American Newspaper Comics*, 502–503; Jay, "Ink-Slinger Profiles"; Jeff Marx Collection, BICL, Box 1, Folder 2.

4. Hershfield based *Desperate Desmond* on Charles W. Kahles's melodramatic comic strip *Hairbreadth Harry* (1906), though Kahles was not the first to use the trope of a villainous character seeking to win the hand of a fair maiden against a rival. Sidney Smith's *Signor de Pluro*, for example, appeared in episodic form in 1903. See Blackbeard, "Desperate Measures," v–ix; Holtz, "Obscurity of the Day: Signor de Pluro."

5. For an examination of the serial form and melodramatic parody in comics, see Gardner, *Projections*, 40–43; Holtz, "Mutt, Jeff and Bud," 12; Lambert, "'Wait for the Next Pictures,'" 4–10; Williams, "Visual Continuity in Winsor McCay's Slumberland," 17–18.

6. Blackbeard and Williams, *The Smithsonian Collection of Newspaper Comics*, 53. For the history of speech balloons in cartoons and comic strips, see Dauber, *American Comics*, 5–6, and Gravett, *Comics Art*, 22–26.

NOTES TO PAGES 66–69 153

7. Harry Hershfield, *Desperate Desmond*, in *Indianapolis Sun*, December 17, 1910; *Boston American*, July 6 or 7 and July 17, 1911; *Tennessean* (Nashville), July 5, 1911. For Hershfield's accounts of his Yiddish insertions, see "An Exclusive Interview for The Jewish Monitor from Harry Hershfield, Creator of Abie the Agent," *Jewish Monitor* (Fort Worth-Dallas), June 3, 1921; Clarence Freed, "The Creator of Abie the Agent," *Sentinel*, September 5, 1924.

8. Branen, *Big Chief Dynamite*, notated music; Leslie, *I'm a Yiddish Cowboy*, notated music. For a detailed examination of Khanan-Yakov Minikes's playlet *Tsvishn Indianer*, see Slobin, *Tenement Songs*, 108–114. For later theatrical presentations pairing Jews and Native Americans, see Most, "Big Chief Izzy Horowitz." For actual interactions between Jews and Native Americans in the West, see Marks, *Jews among the Indians*.

9. Brice, *I'm an Indian*, 78 rpm. Decades later an early version of *Mad Magazine* (1953) had the Lone Stranger ask his sidekick, Pronto, "*Vas ist los?*" ("What's up?"), and comedian Mel Brooks, portraying a Native American chief, shouted out in the film *Blazing Saddles* (1974), "No, no, *zayt nisht meshuge*" ("don't be crazy!"). Brooks, *Blazing Saddles*, 35 mm; Kurtzman, "Lone Stranger!"

10. On blackface and impersonations of Native Americans, see Dormon, "Ethnic Stereotyping," 492–494; Koffman, *The Jews' Indians*, 112. Rogin, *Blackface, White Noise*, 26, 150–154; Rubinstein, *Members of the Tribe*, 43–55.

11. Harry Hershfield, *Desperate Desmond, Buffalo Enquirer*, March 14 and 16, 1912; *St. Louis Star and Times*, August 9, 1912; San Francisco Academy of Comic Art Collection (hereafter, SFACA), BICL, Hershfield, *Desperate Desmond*, 1912. See also Romeyn and Kugelmass, *Let There Be Laughter*, 24–25.

12. Freed, "The Creator of Abie the Agent." In his 1913 comic strip *Dauntless Durham*, which followed *Desperate Desmond*, Hershfield stated in the first episode that the dashing hero, "the ideal of the young American," descended from ancestors who came over on the Mayflower and was born on October 13, 1885, in Cedar Rapids, Iowa, which was Hershfield's birthday and birthplace. Blackbeard, *Dauntless Durham*, 3.

13. See "An Exclusive Interview"; Freed, "The Creator of Abie the Agent." It is curious that Hershfield never made mention, during the decades-long run of the strip or in the years following, of Rudolph Block, who was his comic-strip editor for the first thirteen years of *Abie the Agent*. Block, unlike Brisbane, had direct day-to-day involvement with the comics that appeared in the *New York Evening Journal*. On Block, see Cole, *How the Other Half Laughs*, 67–71.

14. Blackbeard, "Desperate Measures," xv.

15. Blackbeard, *Dauntless Durham*, 88, 90–91. For the pressures of the comic-strip schedule, see Schoenfeld, "The Laugh Industry," *Saturday Evening Post*, 47.

16. On Hershfield's father and sister, see "Cartoonist's Sister Entertains," *New York Clipper*, May 16, 1917; "Michael Hershfield," *New York Times*, August 4, 1931; "Rose Alberti," *New York Clipper*, February 15, 1913.

17. On these booking offices, see DiMeglio, *Vaudeville U.S.A.*, 141–146; Stewart, *No Applause*, 117, 219–220.

18. DiMeglio, *Vaudeville U.S.A.*, 142.

19. See Alfred E. Clark, "Friends Turn the Dais on Harry Hershfield at 80; Famed Toastmaster Honored at a Waldorf Dinner," *New York Times*, December 5, 1965; Hershfield, *Laugh Louder*, 14; Laurie, *Vaudeville*, 211.

20. Wickberg, *The Senses of Humor*, 122 (quotation), 158–159.

21. Nadel, *Art out of Time*, 312.

22. "Paintings Are His Hobby—As for Comics Here's What Harry Hershfield Has to Say," *Cornell Daily Sun* (Ithaca, NY), May 21, 1932. See also "Personalities," *Hebrew Standard*, October 7, 1921.

23. Schoenfeld, "The Laugh Industry," *Saturday Evening Post*, 47.

24. SFACA, BICL, Hershfield, *Abie the Agent*, November 25, 1915, and January 1915.

25. SFACA, BICL, Hershfield, *Abie the Agent*, May 1, 1914.

26. Harry Hershfield, "Kabibble Kabaret," *Los Angeles Herald*, December 14, 1917; *Catalog of Copyright Entries*, s.v. *Abe Kabibble at the Races*, 78 rpm and *Abe Kabibble Goes to a Wedding*, 78 rpm; Hershfield, *Abe Kabibble "Does His Bit,"* 78 rpm, *Abe Kabibble at the Ballgame*, 78 rpm, *Abe Kabibble Dictates a Letter*, 78 rpm.

27. See Clark, "Friends Turn the Dais on Harry Hershfield"; Harry Hershfield Collection, Billy Rose Theatre Division, newspaper clippings; Hurd, *Cartoon Success Secrets*, 66.

28. See Gardner, *Projections*, 27, 46.

29. Jenkins, *What Made Pistachio Nuts?*, 24–25.

30. Whitfield, "Towards an Appreciation of American Jewish Humor," 41 (quotation), 43.

31. Davies, *Ethnic Humor around the World*, 8.

32. Davies, "Exploring the Thesis of the Self-Deprecating Jewish Sense of Humor," 29–32. See also Ben-Amos, "The 'Myth' of Jewish Humor," 112–117, 121; Oring, *The First Book of Jewish Jokes*, 4–10; Saper, "Since When Is Jewish Humor Not Anti-Semitic?" 82.

33. Bial, *Acting Jewish*, 8, 22.

34. Whitfield, *In Search of American Jewish Culture*, 22.

35. On Purim plays, see Belkin, "The 'Low' Culture of the Purimshpil," 33–42.

36. Boskin and Dorinson, "Ethnic Humor: Subversion and Survival," 86; Oring, *Jokes and Their Relations*, 113. See also Dorinson, *Kvetching and Shpritzing*, 8–10, 15.

37. Davies, *Ethnic Humor*, 3–4.

38. See Idelsohn, *Jewish Music in Its Historical Development*, 435–444; Krasney, "The Badkn," 7–20; Lifschutz, "Merrymakers and Jesters among Jews," 45–49, 52–53; Sandrow, *Vagabond Stars*, 9–11, 36–39.

39. Hapgood, *The Spirit of the Ghetto*, 91–92.

40. For the history of *badchonim*, see Baumgarten, "Yiddish Oral Traditions," 100–101; Slobin, *Tenement Songs*, 15–16; Sapoznik, *Klezmer!*, 15–18, 43.

41. On Zamberg, see Romeyn and Kugelmass, *Let There Be Laughter*, 6; Samberg, *Grandpa Had a Long One*, 33–34, 45–46.

42. Fuchs, *Der Galitzianer Badchen*, 78 rpm; Fuchs, *Yiddisha Cowboy*, 78 rpm. On Fuchs, see "Leo Fuchs," SaveTheMusic.com.

43. Erdman, *Staging the Jew*, 11; Sapoznik, *Klezmer!*, 38.

44. On Yiddish vaudeville, see Nahshon, "Entertaining the Crowd"; Thissen, "Early Yiddish Vaudeville in New York City."

45. Pinsker, *The Schlemiel as Metaphor*, 17–19; Wisse, *The Schlemiel as Modern Hero*, 38.

46. Wiener, "On Sholom Aleichem's Humor," 43. See also Wisse, *The Schlemiel as Modern Hero*, 49–51.

47. For a history of Sholem Aleichem's publications, see Dauber, *The Worlds of Sholem Aleichem*, 308, 325–326; Sholem Aleichem, *The Letters of Menakhem-Mendl*, xi; Wisse, *The Schlemiel as Modern Hero*, 49.

48. Peppler, *Gimpel Beynish the Matchmaker*, 3; Peppler, *Gimpel Beynish, Volume 2*, 3. For examples of the Katzenjammer Kids' spankings, see *The Katzenjammer Kids*, 15–17, 23, 25. A detailed examination of the Jew's caricature in the Yiddish press has yet to be written.

NOTES TO PAGES 73–79

49. "An Exclusive Interview."

50. Hershfield Collection, Billy Rose Theatre Division, Hershfield, "Abie Laughs at This Abe and Mauruss," *New York Evening Journal*, October 15, 1915.

51. Freed, "The Creator of Abie the Agent."

52. "Abe Kabibble Breaks In," *Cartoons Magazine*.

53. "An Exclusive Interview."

54. Freed, "The Creator of Abie the Agent."

55. "An Exclusive Interview."

56. "An Exclusive Interview."

57. "An Exclusive Interview"; Freed, "The Creator of Abie the Agent"; Martin Golde, "Gossip and News of Jewish Personalities," *Sentinel*, October 17, 1930. Hershfield dropped both their names into a panel in a 1919 cartoon. SFACA, BICL, Hershfield, *Abie the Agent*, August 16, 1919.

58. "They are having a dreadful time." *Jewish Independent*, August 21, 1914. Alone among all the Jewish newspapers, the *Jewish Independent* continued its attacks on the strip for the next twelve years, until 1926. See "Blasts from The Shofar," *Jewish Independent*, October 1, 1926.

59. On Hearst's circulation, see Abel, *Menus for Movieland*, 7–10; Gordon, *Comic Strips and Consumer Culture*, 37, 161–168.

60. Erdman, *Staging the Jew*, 33.

61. On the name Abie, see Buhle, *Jews and American Comics*, 38; Byron, "Crank Up the Phonograph," 75; Gottlieb, *Funny, It Doesn't Sound Jewish*, 246–247.

62. There are several assertions that a character named "Abie" first appeared in Hershfield's earlier strip, *Desperate Desmond* (1910–12), as a "melting pot dialectician and philanthropist," but I have been unable to locate it. See Blackbeard, "Desperate Measures," xv; Hershfield, *Laugh Louder*, 13–14.

63. Lewis, *Isch Ga-Bibble*, notated music. See also Lewis's and Morton's 78 rpm record, *Isch ka Bibble*. Lewis also wrote the hit that Al Jolson made famous: "Where Did Robinson Crusoe Go with Friday on Saturday Night." Romeyn, *Street Scenes*, 211.

64. Blackbeard, *Dauntless Durham of the U.S.A.*, 43, 45–47. While "isch kabibble" can be definitely dated to 1913, the English phrase "I should worry?" appeared in print a few years earlier. See Brown, "What? Me Worry?"

65. See Hershfield, *Laugh Louder*, 13–14; "Fanny Brice Dies at the Age of 59," *New York Times*, May 30, 1951; Goldman, *Fanny Brice*, 84–85.

66. Harry Hershfield, "It's a Funny World," *Sentinel*, March 4, 1937; "Sam M Lewis," *U.S. Passport Applications*; "Samuel Lavine," *1900 U.S. Census, New York*. For details into the meaning and history of the phrase "Isch kabibble," see Gottlieb, *Funny, It Doesn't Sound Jewish*, 7; Mencken, *The American Language*, 151; and Roback, "You Speak Yiddish, Too."

67. See McCloud, *Understanding Comics*, 28–36.

68. On these characters, see Soper, "From Swarthy Ape," 274; Soper, "Performing 'Jiggs,'" 179; James Swinnerton, *Little Jimmy, Topeka Daily Capital*, April 29, 1911.

69. On these caricatures, see Appel, "Jews in American Caricature," 118; Saguisag, *Incorrigibles and Innocents*, 33, 36–41; Soper, "Performing 'Jiggs,'" 176–180, 189, 191.

70. Joselit, *A Perfect Fit*, 101–107; SFACA, BICL, Hershfield, *Abie the Agent*, May 1914.

71. See Cuddihy, *The Ordeal of Civility*, 14; Gilman, *The Jew's Body*, 10–37, 169–193.

72. See Grant, *The Passing of the Great Race*, 14.

73. On the two-act, see Corio and DiMona, *This Was Burlesque*, 30–34; Laurie, *Vaudeville*, 82–84.

74. On this tradition, see Bakhtin, *Rabelais and His World*, 433–434; Towsen, *Clowns*, 66–67, 74.

75. For a history of the two-act, see Davis, *Baggy Pants Comedy*, 62–63; McLean, *American Vaudeville*, 127–130; Winokur, *American Laughter*, 47–48. For the Three Keatons, see Nesteroff, *The Comedians*, 8–9.

76. Davies, *Ethnic Humor*, 315; Mintz, "Humor and Ethnic Stereotypes," 23.

77. Mintz, "Humor and Ethnic Stereotypes," 22. See also Wickberg, *The Senses of Humor*, 142–143.

78. Staples, *Male-Female Comedy Teams*, 90.

79. Erdman, *Staging the Jew*, 105, 156.

80. See fig. 3.9. Though some comic historians have suggested that Hershfield's wife, Jane, served as the physical model for Reba, who towered over Abie in the comic strip, she was actually four inches shorter than Harry. See "Harry Hershfield," *U.S. Passport Applications*, and "Jane Dellis," *U.S. Passport Applications*.

81. SFACA, BICL, Hershfield, *Abie the Agent*, March 1914; Lewis, *Ish Ga Bibble*, 47.

82. See Metzker, *A Bintel Brief*.

83. SFACA, BICL, Hershfield, *Abie the Agent*, June 24, 1914.

84. SFACA, BICL, Hershfield, *Abie the Agent*, May 1914.

85. Wsevolod W. Isajiw (1974), quoted in Lowe, "Theories of Ethnic Humor," 440.

86. Bial, *Acting Jewish*, 3–4, 16–17.

87. SFACA, BICL, Hershfield, *Abie the Agent*, March 21, 1914.

88. SCAFA, BICL, Hershfield, *Abie the Agent*, January 9, 1918.

89. Weinreich, *Languages in Contact*, vii, 75–79; Cimet, "Ambivalence Acknowledged," 278.

90. See Bodnar, *The Transplanted*, 118, 141; Howe, *World of Our Fathers*, 226–232.

91. Gardner, *Projections*, 14.

92. Saguisag, *Incorrigibles and Innocents*, 12.

93. See, e.g., Fields and Weber, *Drinking Scene*, 78 rpm.

94. Lindenblatt, *The Early Years of Mutt & Jeff*, 31; Smith, *Old Doc Yak*.

95. See Gordon, *Comic Strips and Consumer Culture*, 46–47; Saguisag, *Incorrigibles and Innocents*, 87.

96. See McLean, *American Vaudeville*, 131; Moss, "Racial Anxiety," 104. It is possible that Hershfield's decision not to center the strip around a domestic setting was because he and his wife had no offspring—he simply had no experience of child-rearing to draw on.

97. SFACA, BICL, Hershfield, *Abie the Agent*, September and March 1914.

98. SFACA, BICL, Hershfield, *Abie the Agent*, February 6, 1915.

99. SFACA, BICL, Hershfield, *Abie the Agent*, August 22, 1914.

100. SFACA, BICL, Hershfield, *Abie the Agent*, October 14, 1914.

101. SFACA, BICL, Hershfield, *Abie the Agent*, December 1914.

102. SFACA, BICL, Hershfield, *Abie the Agent* strips, 1914. For a detailed examination of the vacation as a new form of urban leisure, see Heinze, *Adapting to Abundance*, 116–132. For the role of the piano in immigrant homes, see Heinze, *Adapting to Abundance*, chapter 8, "The Parlor and the Piano."

103. SFACA, BICL, Hershfield, *Abie the Agent*, October 6, February 19, and August 18, 1919. See also *Abie the Agent*, May 16–19 and July 26, 1919.

NOTES TO PAGES 91–96

104. SFACA, BICL, Hershfield, *Abie the Agent*, August 31, 1920.

105. SFACA, BICL, Hershfield, *Abie the Agent*, 1919.

106. Soper, "Performing 'Jiggs,'" 204–205.

107. Soper, "Performing 'Jiggs,'" 198.

108. Lee, "Philip Roth, the Art of Fiction." See also Charles McGrath, "Philip Roth, Towering Novelist Who Explored Lust, Jewish Life and America, Dies at 85," *New York Times*, May 22, 2018.

109. On the licensing of comic strip characters, see Dauber, *American Comics*, 6–7; Gordon, *Comic Strips and Consumer Culture*, 44–45; Saguisag, *Incorrigibles and Innocents*, 106, 108; Winchester, "Cartoon Theatricals," 232, 262–273.

110. For these products and theatrical uses of *Abie the Agent*, see John and Selma Appel Collection, *Abie the Agent* postcards, n.d.; "Abie the Agent at the Arlington," *Boston Globe,* September 21,1920; "Contests Right to Present Play from Cartoons," *Harrisburg Telegraph*, January 27, 1921; Jay, "Ink-Slinger Profiles"; Markstein, "Abie the Agent"; Mishler, "Abie the Agent," *Altoona Tribune*, January 31, 1921.

111. Hershfield, "At Abe Kabibble's Kabaret," lyrics.

112. Harry Hershfield, "George Beban in 'An Alien' Made Abie Cry' by 'Abie the Agent,'" *New York Evening Journal*, June 4, 1915.

113. On these films, see Dauber, *American Comics*, 13; Gardner, *Projections*, 19–20; Markstein, "Abie the Agent."

114. Meyer F. Steinglass, "The Clown Playing Hamlet," *Sentinel*, September 5, 1930. See also Hershfield Collection, BICL, photographs of Harry Hershfield apartment, Box 2, Folder 4; "Paintings Are His Hobby."

115. On these income figures, see Dauber, *American Comics*, 19–20; Schoenfeld, "The Laugh Industry," *Saturday Evening Post*, 46; "The Funny Papers," *Fortune*, 49; Wheeler, "A Captain of Comic Industry," 49.

116. SFACA, BICL, Hershfield, *Abie the Agent*, June 28, 1914.

117. SFACA, BICL, Hershfield, *Abie the Agent*, September 11, 1914.

118. See Dormon, "American Popular Culture," 184; Wickberg, *The Senses of Humor*, 76–79.

119. On this class, see Bodnar, *The Transplanted*, 117–118, 208.

120. On automobile production, see Flink, *The Automobile Age*, 37, 57–58, 138–139; Heitmann, *The Automobile*, 24, 41; Susman, *Culture as History*, 135–137.

121. On the cultural meaning of the automobile, see McLean, *American Vaudeville*, 5–6; Susman, *Culture as History*, 263; Zahra, *The Great Departure*, 6–8.

122. SFACA, BICL, Hershfield, *Abie the Agent*, March 18, 1914.

123. Quoted in Byron, "Crank Up the Phonograph," 247. See also Byron, "Crank Up the Phonograph," 241–246.

124. Zagat, *Gimpel Bainish, Warheit*, August 25, October 7, and December 30, 1914.

125. McLean, *American Vaudeville*, 131.

126. See Gardner, *Projections*, 10–11, 14.

127. On these demeaning stereotypes, see *Winsor McCay*, 67–106; Nystrom, "A Rejection of Order," 270. Such stereotypes were also presented in Outcault's strip, *Hogan's Alley*, beginning in 1896. See *R. F. Outcault's The Yellow Kid*, 58, 75, 90.

128. Goldstein, *The Price of Whiteness*, 62. See also Goldstein, *The Price of Whiteness*, 51–52, 58–61.

129. See Goldstein, *The Price of Whiteness*, 86–98.

130. For the effect of the Leo Frank trial on the relationship between Jews and Black Americans, see Goldstein *The Price of Whiteness*, 57, 65–67; Jacobson, *Whiteness of a Different Color*, 62–67; Kibler, *Censoring Racial Ridicule*, 49–50.

131. See Goldstein, *The Price of Whiteness*, 76–81.

132. On Jews in blackface, see Rogin, *Blackface, White Noise*, 155, 182–183.

133. On the contrast between Jews, Chinese, and Black Americans gaining social acceptance in white American society, see Diner, *The Jews of the United States*, 164–165; Jones, *Strange Talk*, 180–181; Rogin, *Blackface, White Noise*, 12–13, 55–56, 68–69.

134. Moss, "Racial Anxiety," 90, 100–102. While Hershfield did, at times, present these racial and ethnic caricatures, Jewish caricatures, conversely, as noted earlier, did not appear in other ethnic cartoon strips. Why this was so merits a separate study. (A rare exception is found in a panel of a 1918 strip, *Fritz Von Blitz*, showing a Jewish salesman with beard, gesticulating hands, and splayed feet.) H. C. Greening, *Fritz Von Blitz*, *New York Herald*, November 10, 1918.

135. "An Exclusive Interview."

136. On women in vaudeville, see Antelyes, *Jewish Women*, s.v. "Vaudeville in the United States"; Erdman, *Staging the Jew*, 156.

137. For example, Reba is almost entirely missing from his 1919 strips. This may be because Hershfield simply didn't know how to do more jokes involving her. Her infrequent appearances in later years may be a reflection of Hershfield's personal life. It appears that about ten years into their marriage, Hershfield's wife, Jane, despite her previous appearance in several theater productions and in the Ziegfeld Follies, began suffering from acute anxiety and avoided leaving their apartment. Consequently, she seldom appeared in public with him despite his frequent appearances as master of ceremonies and toastmaster at hundreds of New York social events in his later years. See Nizer, "Goodbye, Harry," 25; "Whose Photographs Win the Prizes?" *Spokane Press*, March 11, 1909.

138. On this trope, see Erdman, *Staging the Jew*, 156–159.

139. On the Gibson Girl, see Murrell, *A History of American Graphic Humor*, 107–108; Saguisag, *Incorrigibles and Innocents*, 150–153.

140. On the Brinkley Girl, see Conolly-Smith, *Translating America*, 111–112; Robbins, *Nell Brinkley and the New Woman*, 37–39, and *The Brinkley Girls*, 7–10, 30, 33.

141. While there was one strip (August 1914) in which Reba wore a new, fashionable style—a peg-top silhouette dress that followed more of the curves of the woman's body—in all probability, she was drawn in this instance by Nell Brinkley. See Marzio, "Would You Buy a New Car from This Man?," xiii.

142. See Saguisag, *Incorrigibles and Innocents*, 31–32.

143. For an examination of the *belle juive* in Shakespeare and Marlow, see Manganelli, *Transatlantic Spectacles of Race*, 95–96.

144. See Singer, *Melodrama and Modernity*, 240–241.

145. Banta, *Barbarous Intercourse*, 147–148; Jacobson, *Special Sorrows*, 80.

146. On the new woman, see Saguisag, *Incorrigibles and Innocents*, 143–149; Scharff, *Taking the Wheel*, 15–35. On the pushback against her, especially concerning suffrage, see Banta, *Barbarous Conduct*, 351; Bland, "New Life in an Old Movement," 669; and Schuddeboom, "Katherine P Rice," which examines the comic strip *Flora Flirt*, whose character was punished in the concluding panel of each strip for her new woman behavior.

NOTES TO PAGES 103–108

147. On Hearst's approach to the new woman, see Conolly-Smith, *Translating America*, 106–107.

148. Robbins, *Nell Brinkley and the New Woman*, 37–39; Robbins, *The Brinkley Girls*, 7–10, 30, 33. For examples of the new woman in silent films, see Singer, *Melodrama and Modernity*, 226–231.

CHAPTER 4 — BECOMING AMERICAN

Epigraph: Zangwill, *The Melting Pot*, 37.

1. Dash Moore, *At Home in America*, 9.

2. On these characteristics of the stage Jew, see Boyarin, *Unheroic Conduct*, 38–39; Erdman, *Staging the Jew*, 36–37.

3. San Francisco Academy of Comic Art Collection (hereafter, SFACA), Billy Ireland Cartoon Library & Museum (hereafter, BICL), Hershfield, *Abie the Agent*, August 17, 1920.

4. Roosevelt, *Ranch Life and the Hunting Trail*, 55–56. See also Banta, *Barbaric Intercourse*, 160–161, 323–324, 332; Gerstle, *American Crucible*, 25–26.

5. SFACA, BICL, Hershfield, *Abie the Agent*, October 28, 1914.

6. See, for example, SFACA, BICL, Hershfield, *Abie the Agent*, September 31, 1914.

7. SFACA, BICL, Hershfield, *Abie the Agent*, April 6, 1915.

8. SFACA, BICL, Hershfield, *Abie the Agent*, November 20, 1920.

9. SFACA, BICL, Hershfield, *Abie the Agent*, May, 1920. See also *Abie the Agent*, June 26, 1915, in which Abie resists his friends pushing him into a saloon. In over two thousand strips between 1914 and 1920, there are only a handful of times that Abie has an identifiable alcoholic drink. When he does so, it is usually a beer.

10. SFACA, BICL, Hershfield, *Abie the Agent*, April 13, 1915. See also *Abie the Agent*, May 1914, in which Abie does have a drink for courage in order to meet his future father-in-law.

11. See fig. 4.8.

12. Gilman, *The Jew's Body*, 188–189. For examples of the Jew as sexual predator in late nineteenth-century theatre and in early twentieth-century novels, see Erdman, *Staging the Jew*, 17–18; Lambert, *Unclean Lips*, 29–31.

13. See Boyarin, "Masada or Yavneh?," 307, 310–318.

14. Not until 1975, with Howard Chaykin's Dominic Fortune—the former Duvid Fortunov of the Lower East Side—did a suave, attractive, masculine Jewish protagonist appear again in the comics. Though Siegel and Shuster's *Funnyman*, featuring a Jewish hero, had appeared earlier (1948), he dressed in a clown costume and defeated villains not through physical prowess but through jokes and tricks. (Note here the return of the earlier stage and print tropes of the Jew: frumpy clothes, unmanliness, and sneakiness.) See Chaykin, *Dominic Fortune* #1; Costello, "America Makes Strange Jews"; Howard Chaykin, interview by author, December 23, 2019; Andrae and Gordon, *Siegel and Shuster's Funnyman*, 86–105.

15. On the *schlemiel*, see Biale, *Eros and the Jews*, 204–209.

16. Eliot, "Democracy and Manners," 173.

17. Cuddihy, *The Ordeal of Civility*, 12–13; Eliot, "Democracy and Manners," 178.

18. See Wickberg, *The Senses of Humor*, 77–79.

19. Persons, *The Decline of American Gentility*, 277.

20. Cohen, "Antisemitism in the Gilded Age," 198, 200–201.

160 NOTES TO PAGES 108–114

21. Ross, "The Hebrews of Eastern Europe in America," 791.

22. "Dr. Felix Adler," *Life*, 554. It is also possible that these protestations regarding the Jews' lack of manners were actually an expression of more deep-rooted anti-Semitic prejudices. See Tevis, "'Jews Not Admitted.'"

23. Jenkins, *What Made Pistachio Nuts*, 222–27. See also Davis, *Baggy Pants Comedy*, 237.

24. Saguisag, *Incorrigibles and Innocents*, 25.

25. See Saguisag, *Incorrigibles and Innocents*, 73–83. John Hart's short-lived *Little Jap "It"* strip (March–April 1904) provides another example of an ethnic (in this case, Japanese) adult rendered as a short child. Holtz, "Obscurity of the Day: Little Jap It"; Saguisag, *Incorrigibles and Innocents*, 32–36.

26. SFACA, BICL, Hershfield, *Abie the Agent*, January 17, 1915.

27. Kelman, *Is Diss a System?*, 141; *R. F. Outcault's The Yellow Kid*, #9.

28. See Banta, *Barbarous Intercourse*, 161, 305–307; Saguisag, *Incorrigibles and Innocents*, 51.

29. See, for example, SFACA, BICL, Hershfield, *Abie the Agent*, January 9, 1915. See also Marschall, *The Complete Little Nemo in Slumberland*, 34; "Paintings Are His Hobby."

30. SFACA, BICL, Hershfield, *Abie the Agent*, March 1914.

31. SFACA, BICL, Hershfield, *Abie the Agent*, August 6, 1919.

32. SFACA, BICL, Hershfield, *Abie the Agent*, May 4, 1915.

33. SFACA, BICL, Hershfield, *Abie the Agent*, July 15, 1915 and May 2, 1916.

34. SFACA, BICL, Hershfield, *Abie the Agent*, January 1915.

35. SFACA, BICL, Hershfield, *Abie the Agent*, March 7, 1920.

36. SFACA, BICL, Hershfield, *Abie the Agent*, November 17, 1914. For a list of hen-pecked husbands in early comics, see Blackbeard and Williams, *The Smithsonian Collection of Newspaper Comics*, 52.

37. SFACA, BICL, Hershfield, *Desperate Desmond*, 1912.

38. On union organizing activities, see Brodkin, *How Jews Became White Folks*, 108–110; Madison, *Jewish Publishing in America*, 124–126; Painter, *Standing at Armageddon*, 249–252.

39. Gardner, *Projections*, 43.

40. Schoenfeld, "The Laugh Industry," 12. See also Seldes, *The 7 Lively Arts*, 194; Soper, "Performing 'Jiggs,'" 182–183.

41. See Erdman, *Blue Vaudeville*, 20.

42. On the politics of the *New York Evening Journal*, see Campbell, *Yellow Journalism*, 3, 52; Cherny, *American Politics in the Gilded Age*, 133; Gardner, *Projections*, 43; Painter, *Standing at Armageddon*, 195–197.

43. Though the *Warheit* began as a socialist newspaper, its owner, Louis Miller, had abandoned socialism by 1906 and was supporting Democratic Party candidates. He still remained, nonetheless, a supporter of labor. See Madison, *Jewish Publishing*, 124; Zagat, *Gimpel Bainish, Warheit*, February 5, August 8, October 24, and November 11, 1913.

44. Freedman, "From the American Scene," 2.

45. SFACA, BICL, Hershfield, *Abie the Agent*, January 14, 1915.

46. Zagat, *Gimpel Bainish, Wahrheit*, October 12, 1914, author's translation from the Yiddish.

47. See Rappaport, "The American Yiddish Press and the European Conflict in 1914."

48. On the draft, see Sterba, *Good Americans*, 32.

49. Russotto and Rosenfeld, *My America, Our New Hymn*, notated music.

NOTES TO PAGES 114-122

50. Quoted in Painter, *Standing at Armageddon*, 298.

51. Gerstle, *American Crucible*, 8.

52. Roosevelt, "The Children of the Crucible," quoted in Bishop, *Theodore Roosevelt and His Time*, 435-436.

53. Haenni, *The Immigrant Scene*, 222.

54. See Ribak, *Gentile New York*, 162; Sterba, *Good Americans*, 63, 66-67.

55. Hershfield, *Abe Kabibble "Does His Bit,"* 78 rpm.

56. See, for example, SFACA, BICL, Hershfield, *Abie the Agent*, April 19, 1918, and March 12, 1919.

57. SFACA, BICL, Hershfield, *Abie the Agent*, May 7, 1915.

58. See SFACA, BICL, Hershfield, *Abie the Agent*, 1919 strips; "An Exclusive Interview."

59. On these efforts, see Baigell, *The Implacable Urge to Defame*, 130, 132-134; Sterba, *Good Americans*, 163-165.

60. The efforts of Jewish community members to aid their overseas brethren, however, did not escape the attention of *Puck*. Its 1917 cartoon, "In the Theatre of War," contrasted the (favorable) ability of the "American Hebrews" to work together in raising funds for "war zone Hebrews" with the acrimonious public dissent regarding President Woodrow Wilson's efforts to help mediate the conflict in Europe. *Puck*, January 13, 1917. Here, I disagree with Baigell's interpretation of the cartoon. Baigell, *The Implacable Urge to Defame*, 130-131.

61. On the divisions within the Jewish community concerning Zionism, see Baigell, *The Implacable Urge to Defame*, 133; Goldstein, *The Price of Whiteness*, 90-93.

62. SFACA, BICL, Hershfield, *Abie the Agent*, May 5, 1915.

63. SFACA, BICL, Hershfield, *Abie the Agent*, August 12, 1915.

64. SFACA, BICL, Hershfield, *Abie the Agent*, October 21, 1915.

65. Sol Davidson, "Culture in the Comic Strips," PhD diss., New York University, quoted in Nystrom, "A Rejection of Order," 192. See also Nystrom, "A Rejection of Order," 224-225. Only in later decades of the twentieth century would strips begin to feature the suburbs as their setting.

66. "Harry Hershfield," recorded interview by Bob and Betty Lewis; "Harry Hershfield's Books Stolen from Friend's Car: 21 First Editions Worth $1,000 Vanish in Newark," *New York Herald Tribune*, December 6, 1932; Hershfield Collection, BICL, photographs of Harry Hershfield apartment, Box 2, Folder 4; "The Press: Nisht Gehdelt," *Time*.

67. SFACA, BICL, Hershfield, *Abie the Agent*, August 1914.

68. SFACA, BICL, Hershfield, *Abie the Agent*, January 12, 1916. See also *Abie the Agent*, February 9, 1915, in which Abie declares: "I come from the best neighborhood in Europe!"

69. Bodnar, *The Transplanted*, 120-30; Brodkin, *How Jews Became White Folks*, 119-120; Conolly-Smith, *Translating America*, 74.

70. SFACA, BICL, Hershfield, *Abie the Agent*, June 12, 1914.

71. SFACA, BICL, Hershfield, *Abie the Agent*, October 1914.

72. Zagat, *Gimpel Bainish*, *Warheit*, April 19, May 5, May 26, August 1, August 9, October 12, October 16, October 17, October 20, October 23, 1913.

73. SFACA, BICL, Hershfield, *Abie the Agent*, 1914, and May 27, 1914.

74. SFACA, BICL, Hershfield, *Abie the Agent*, December 15, 1919.

162 NOTES TO PAGES 122–137

75. "An Exclusive Interview." For Abie's Yiddish expressions, see SFACA, BICL, Hershfield, *Abie the Agent*, 1915.

76. On the grim realities of city life wrought by modernity, see Flanagan, *America Reformed*, 20; Singer, *Melodrama and Modernity*, 66–90. On the efforts of the comic strips to eliminate disturbing features of urban life, see Gardner, *Projections*, 15; Soper, "Performing 'Jiggs,'" 182–184.

77. See Riis, *How the Other Half Lives*; Saguisag, *Incorrigibles and Innocents*, 20–21; Westgate, *Staging the Slums*, 56; Yochelson and Czitrom, *Rediscovering Jacob Riis*, 86–92.

78. On depictions of the Lower East Side, see Diner, *Lower East Side Memories*, 3–7; Haenni, *The Immigrant Scene*, 48, 50; Westgate, *Staging the Slums*, 135.

79. Winokur, *American Laughter*, 5 (quotation), 60–62.

80. See Altschuler, *Race, Ethnicity, and Class in American Social Thought*, 52–53; Gordon, *Assimilation in American Life*, 114.

81. SFACA, BICL, Hershfield, *Abie the Agent*, February 14, 1916. The character Max Sax, whom Hershfield sometimes inserted into his strip, was his close childhood friend from Chicago. Rick Burke, interview by author, January 10, 2018; Scrapbook, Box 2, Folder 1, Harry Hershfield Collection, BICL.

82. On these depictions of interfaith marriage, see Erdman, *Staging the Jew*, 120–121, 139–143, 155–156.

83. Goldstein, *The Price of Whiteness*, 101.

84. Molly Eda Osherman, "Dr. Hirsch Scored. Intermarriage A Myth of His Own Making and Cherishing," *American Israelite*, November 26, 1908. See also Goldstein, *The Price of Whiteness*, 101.

85. "Mrs. Sarah Jane Isdell Hershfield," *Menands, New York, Rural Cemetery Burial Cards*; "Samuel Isdall," *1850 U.S. Census*.

86. Saguisag, *Incorrigibles and Innocents*, 16.

87. SFACA, BICL, Hershfield, *Abie the Agent*, May 24, 1915.

88. SFACA, BICL, Hershfield, *Abie the Agent*, February 4, 1915.

89. See Yaszek, "Them Damn Pictures," 36–37.

90. Zagat, *Gimpel Bainish*, *Warheit*, August 7, 1913.

91. SFACA, BICL, Hershfield, *Abie the Agent*, May 25, 28, 29, 30, 1915.

92. Prell, *Fighting to Become Americans*, 19–20.

93. Reba's relative immobility may also be because the Gibson Girl's clothing style in which she was dressed was not really meant for moving, as opposed to the Brinkley Girl style of short skirts that allowed for more freedom of motion. See Banta, *Barbaric Intercourse*, 139–141, 185–187; Conolly-Smith, *Translating America*, 43.

CONCLUSION

1. See Dash Moore, *At Home in America*.

2. Dash Moore, *At Home in America*, 9, 87, 233.

3. Kallen, "Democracy versus the Melting-Pot," 220.

4. See Leveen, "Only When I Laugh," 49–50; Sollors, *Beyond Ethnicity*, 172.

5. As discussed in Marx, "Eating Up."

6. Bial, *Acting Jewish*, 8.

7. See Erdman, *Staging the Jew*, 145, 155; Zurawik, *The Jews of Prime Time*.

NOTES TO PAGE 138

8. See, for example, Milt Gross, "Gross Exaggerations in the Dumbwaiter," *Buffalo Courier*, September 20, 1925. See also Liebman, *Vot Is Kemp Life?*, and Romeyn, *Street Scenes*, 204–205.

9. Siegel and Siegel, *Radio and the Jews*, 23.

10. On this trend, see Baskind and Omer-Sherman, *The Jewish Graphic Novel*, xv–xxvii; Roth, "Contemporary American Jewish Comic Books," 3–14; Royal, *Visualizing Jewish Narrative*, 1–11. It should be noted that this trend has also been taking place in other countries, as well. See, for example, Joann Sfar's *The Rabbi's Cat*; Harris, "Borderlands: Places, Spaces, and Jewish Identity."

11. Jeremy Love did the same with Black American caricature in his comic *Bayou* (2007). See Wanzo, *The Content of Our Caricature*, 61–66.

12. Chaykin, *Dominic Fortune;* Kaplan, *From Krakow to Krypton*, 198–199, 202; Stromberg, *Jewish Images in the Comics*, 141.

Bibliography

WORKS CITED

Collections

Biographical Files. Billy Ireland Cartoon Library & Museum (BICL), Ohio State University.

Harry Hershfield Collection. Billy Ireland Cartoon Library & Museum, Ohio State University.

Harry Hershfield Collection. Billy Rose Theatre Division, New York Public Library for the Performing Arts.

Jeff Marx Collection on Harry Hershfield and Bert Levy. Billy Ireland Cartoon Library & Museum, Ohio State University.

John and Selma Appel Collection. Michigan State University Museum.

San Francisco Academy of Comic Art Collection (SFACA): Part 1, Newspaper Comic Strips. Billy Ireland Cartoon Library & Museum, Ohio State University.

Tamiment Library & Robert F Wagner Labor Archives. New York University.

Toni Mendez Collection on Harry Hershfield. Billy Ireland Cartoon Library & Museum, Ohio State University.

WNYC Collection. New York City Municipal Archives.

Books, Journals, Magazines, Websites

"Abe and Mawrus." *Bookman: A Magazine of Literature and Life*, September (1914): 15–17.

"Abe Kabibble." Vance's Fantastic Tap Dictionary. 2022. Theatre.Dance.com. http://www.theatredance.com/dictionary.html.

"Abe Kabibble Breaks In." *Cartoons Magazine* 9 (May 1916): 796.

Abel, Richard. *Menus for Movieland: Newspapers and the Emergence of American Film Culture, 1913–1916.* Oakland: University of California Press, 2015.

Aldrich, Thomas Bailey. "The Unguarded Gates." *Atlantic Monthly*, July 1892.

Allen, Robert C. *Horrible Prettiness: Burlesque and American Culture.* Chapel Hill: University of North Carolina Press, 1991.

166 BIBLIOGRAPHY

Altschuler, Glenn C. *Race, Ethnicity, and Class in American Social Thought, 1865–1919.* Wheeling, IL: Harland Davidson, 1982.

Andrae, Thomas, and Mel Gordon. *Siegel and Shuster's Funnyman.* Port Townsend, WA: Feral House, 2010.

Antelyes, Peter. *Jewish Women: A Comprehensive Historical Encyclopedia.* 2009. Jewish Women's Archive. https://jwa.org/encyclopedia/article/vaudeville-in-united-states%20.

Anti-Defamation League. *Report of the Anti-Defamation League: Together with Principles of League and Correspondence.* San Francisco: Office of the Executive Committee, 1915.

Appel, John J. "Abie the Agent, Gimpl the Matchmaker, Berl Schliemazel, Et Al." *Nemo,* no. 28 (1988): 12–14.

———. "Jews in American Caricature: 1820–1914." *Jewish History* 71, no. 1 (1981): 103–132.

Appel, John J., and Selma Appel. *Jews in American Graphic Satire and Humor.* Cincinnati: American Jewish Archives, 1984.

Baigell, Matthew. *The Implacable Urge to Defame: Cartoon Jews in the American Press, 1877–1935.* Syracuse: Syracuse University Press, 2017.

Bakhtin, Mikhail. *Rabelais and His World.* Bloomington: Indiana University Press, 1984.

Banta, Martha. *Barbaric Intercourse: Caricature and the Culture of Conduct, 1841–1936.* Chicago: University of Chicago Press, 2003.

Barry, Peter. *Beginning Theory: An Introduction to Literary and Cultural Theory.* 4th ed. Manchester: Manchester University Press, 2017.

Baskind, Samantha, and Ranen Omer-Sherman, eds. *The Jewish Graphic Novel: Critical Approaches.* New Brunswick, NJ: Rutgers University Press, 2010.

Baumgarten, Jean. "Yiddish Oral Traditions of the Batkhonim and Multilingualism in Hasidic Communities." *Bulletin du Centre de Recherche Francais a Jerusalem,* 99–120. March 30, 2000. http://bcrfj.revues.org/2862.

Belkin, Ahuva. "The 'Low' Culture of the Purimshpil." In *Yiddish Theatre: New Approaches,* edited by Joel Berkowitz, 29–43. Oxford: Littman Library of Jewish Civilization, 2003.

Belth, Nathan C. *A Promise to Keep: A Narrative of the American Encounter with Anti-Semitism.* New York: Schocken Books, 1979.

Ben-Amos, Dan. "The 'Myth' of Jewish Humor." *Western Folklore* 32, no. 2 (April 1973): 112–131.

"Benjamin Barnett." *1870 US Census, New York.* 2009. Ancestry.com. https://www.ancestry.com/search/collections/7163/.

Bial, Henry. *Acting Jewish: Negotiating Ethnicity on the American Stage and Screen.* Ann Arbor: University of Michigan Press, 2005.

Biale, David. *Eros and the Jews: From Biblical Israel to Contemporary America.* New York: Basic Books, 1992.

Bingham, Theodore A. "Foreign Criminals in New York." *New York Review* 188 (1908): 383–394.

Bishop, Joseph Bucklin, ed. *Theodore Roosevelt and His Time.* New York: Charles Scribner's Sons, 1920.

Blackbeard, Bill, ed. *Abie the Agent, 1914–1915.* Westport, CT: Hyperion Press, 1977.

———. *Dauntless Durham of the U.S.A. 1913–1914.* Westport, CT: Hyperion Press, 1977.

BIBLIOGRAPHY

Blackbeard, Bill. "Desperate Measures: How Harry Hershfield Hung a Cliff A Day in 1913." In *Dauntless Durham of the U.S.A. 1913–1914*, edited by Bill Blackbeard, v–xv. Westport, CT: Hyperion Press, 1977.

Blackbeard, Bill, and Martin Williams, eds. *The Smithsonian Collection of Newspaper Comics*. Washington, DC: Smithsonian Press, 1977.

Blair, Walter, and Raven I. McDavid, Jr., eds. *The Mirth of a Nation: America's Great Dialect Humor*. Minneapolis: University of Minnesota Press, 1983.

Bland, Sidney R. "New Life in an Old Movement: Alice Paul and the Great Suffrage Parade of 1913 in Washington, D.C." *Records of the Columbia Historical Society* 71/72 (1972): 657–678.

Bodnar, John. *The Transplanted: A History of Immigrants in Urban America*. Bloomington: University of Indiana Press, 1985.

Boskin, Joseph, and Joseph Dorinson. "Ethnic Humor: Subversion and Survival." *American Quarterly* 37, no. 1 (Spring 1985): 81–97.

Bourne, Rudolph S. "Trans-National America." *Atlantic*, 118 (July 1916): 86–97.

Boyarin, Daniel. "Masada or Yavneh? Gender and the Arts of Jewish Resistance." In *Jews and Other Differences: The New Jewish Cultural Studies*, edited by Jonathan Boyarin and Daniel Boyarin, 306–329. Minneapolis: University of Minnesota Press, 1997.

———. *Unheroic Conduct: The Rise of Heterosexuality and the Invention of the Jewish Man*. Berkeley: University of California Press, 1997.

Brandes, Stanley. "Jewish-American Dialect Jokes and Jewish-American Identity." *Jewish Social Studies* 45, no. 3/4 (1983): 233–240.

Brodkin, Karen. *How Jews Became White Folks & What That Says about Race in America*. New Brunswick, NJ: Rutgers University Press, 1998.

"Bruno Lessing." *Bookman: A Magazine of Literature and Life* 18 (1904): 468–469.

Buhle, Paul, ed. *Jews and American Comics*. New York: New Press, 2008.

Business Educational Diet. Drawing. *Judge's Library* 133 (April 1900).

Byron, Eric. "Crank Up the Phonograph: Who We Are and Where We Came From in Early Sound Recordings." unpublished manuscript, Ellis Island Discography Project. Ellis Island Immigration Museum, New York, 2006.

Campbell, W. Joseph. *Yellow Journalism: Puncturing the Myths, Defining the Legacies*. Westport, CT: Praeger, 2001.

Canaday, John. "Foreword." In *The Smithsonian Collection of Newspaper Comics*, edited by Bill Blackbeard and Martin Williams, 7–8. Washington, DC: Smithsonian Press, 1977.

Carlson, Marvin. *The Haunted Stage: The Theatre as Memory Machine*. Ann Arbor: University of Michigan Press, 2001.

Catalog of Copyright Entries: Musical Compositions, Part 3, Volume 15. Washington, DC: US Government Printing Office, 1920.

Cather, Willa. "New Types of Acting: The Character Actor Displaces the Star." *McClure's Magazine* 42 (February 1914): 41–51.

———. "The Sweated Drama." *McClure's Magazine* 44, no. 3 (January 1915): 17–28.

Central Conference of American Rabbis. *Yearbook* 19 (1909).

———. *Yearbook* 20 (1910).

———. *Yearbook* 21 (1911).

———. *Yearbook* 22 (1912).

———. *Yearbook* 23 (1913).

168 BIBLIOGRAPHY

———. *Yearbook* 24 (1914).

———. *Yearbook* 25 (1915).

Chaykin, Howard. *Dominic Fortune #1*. Marvel Comics, 1975.

Cherny, Robert W. *American Politics in the Gilded Age 1868–1900*. Wheeling, WV: Harlan Davidson, 1997.

Cimet, Adina. "Ambivalence Acknowledged: Jewish Identities and Language Strategies in Mexico." In *The Collective and the Public in Latin America: Cultural Identities and Political Order*, edited by Luis Roniger and Tamar Herzog, 273–285. Portland: Sussex Academic Press, 2000.

Cohan, George M., and George J. Nathan. "The Mechanics of Emotion." *McClure's Magazine*, no. 42 (November 1913): 70–77.

Cohen, Naomi W. "Antisemitism in the Gilded Age: The Jewish View." *Jewish Social Studies* 41, no. 3/4 (1979): 187–210.

Cole, Jean Lee. *How the Other Half Laughs*. Jackson: University of Mississippi, 2020.

Coniam, Matthew. *The Annotated Marx Brothers: A Filmgoer's Guide to In-Jokes, Obscure References and Sly Details*. Jefferson, NC: McFarland, 2015.

Conolly-Smith, Peter. "Transforming an Ethnic Readership through 'Word and Image': William Randolph Hearst's *Deutsches Journal* and New York's German-Language Press, 1895–1918." *American Periodicals* 19, no. 1 (2009): 66–84.

———. *Translating America: An Immigrant Press Visualizes American Popular Culture, 1895–1918*. Washington, DC: Smithsonian Books, 2004.

Cooper, George. *Yankee, Hebrew, and Italian Dialect Readings & Recitations*. New York: Wehman Bros., 1891.

Corenthal, Michael G. *Cohen on the Telephone: A History of Jewish Recorded Humor and Popular Music, 1892–1942*. Milwaukee: Yesterday's Memories, 1984.

Corio, Ann, and Joseph DiMona. *This Was Burlesque*. New York: Grosset & Dunlap, 1968.

Costello, Brannon. "America Makes Strange Jews: Superheroes, Jewish Masculinity, and Howard Chaykin's Dominic Fortune." In *Visualizing Jewish Narrative*, edited by Derek Parker Royal, 115–128. London: Bloomsbury, 2016.

Cross, Gary S., and Robert N. Proctor. *Packaged Pleasures: How Technology & Marketing Revolutionized Desire*. Chicago: University of Chicago Press, 2014.

Cuddihy, John Murray. *The Ordeal of Civility: Freud, Marx, Lévi-Strauss, and the Jewish Struggle with Modernity*. New York: Basic Books, 1974.

Cullen, Frank. *Vaudeville Old & New: An Encyclopedia of Variety Performer in America*. Vol. 1. New York: Routledge, 2007.

Cutler, Irving. *The Jews of Chicago: From Shtetl to Suburb*. Chicago: University of Chicago Press, 1976.

Daniels, Roger. *Coming to America: A History of Immigration and Ethnicity in American Life*. 2nd ed. New York: Perennial, 2002.

Dash Moore, Deborah. *At Home in America: Second Generation New York Jews*. New York: Columbia University Press, 1981.

Dauber, Jeremy. *American Comics: A History*. New York: W.W. Norton, 2021.

———. *Jewish Comedy: A Serious History*. New York: W.W. Norton, 2017.

———. *The Worlds of Sholem Aleichem*. New York: Schocken Books, 2013.

Davies, Christie. *Ethnic Humor around the World: A Comparative Analysis*. Bloomington: Indiana University Press, 1996.

BIBLIOGRAPHY

———. "Exploring the Thesis of the Self-Deprecating Jewish Sense of Humor." In *Semites and Stereotypes: Characteristics of Jewish Humor*, edited by Avner Ziv and Anat Zajdman, 29–46. Westport, CT: Greenwood Press, 1993.

Davis, Andrew. *Baggy Pants Comedy*. New York: Palgrave Macmillan, 2011.

DiMeglio, John E. *Vaudeville U.S.A.* Bowling Green, OH: Bowling Green University Popular Press, 1973.

Diner, Hasia R. "The Encounter between Jews and America in the Gilded Age and Progressive Era." *The Journal of the Gilded Age and Progressive Era* 11, no. 1 (January 2012): 3–25.

———. *Hungering for America: Italian, Irish, & Jewish Foodways in the Age of Migration*, Cambridge, MA: Harvard University Press, 2001.

———. *The Jews of the United States, 1654 to 2000*. Berkeley: University of California Press, 2004.

———. *Lower East Side Memories: A Jewish Place in America*. Princeton, NJ: Princeton University Press, 2000.

———. *A Time for Gathering: The Second Migration, 1820–1880*. Baltimore: The Johns Hopkins University Press, 1992.

Dinnerstein, Leonard. *Antisemitism in America*. New York: Oxford University Press, 1994.

Distler, Paul. "The Rise and Fall of the Racial Comics in American Vaudeville." PhD diss., Tulane University, 1963.

Dobkowski, Michael N. *The Tarnished Dream: The Basis of American Anti-Semitism*. Westport, CT: Greenwood Press, 1979.

Dorinson, Joseph. *Kvetching and Shpritzing: Jewish Humor in American Popular Culture*. Jefferson, NC: McFarland, 2015.

Dormon, James H. "American Popular Culture and the New Immigration Ethics: The Vaudeville Stage and the Process of Ethnic Ascription." *Amerikastudien* 36, no. 2 (1991): 179–193.

———. "Ethnic Stereotyping." *Amerikastudien* 30, no. 4 (1985): 489–507.

"Dr. Felix Adler." *Life* 30, no. 784 (December 23, 1897).

Du Bois, W.E.B. *The Souls of Black Folks* (1903). New York: Signet Classics, 1995.

Eliot, Charles W. "Democracy and Manners." *Century* 83, no. 2 (1911).

Epstein, Jacob, *Working Girls Returning from Work*. Drawing. In *The Spirit of the Ghetto: Studies of the Jewish Quarter in New York*, edited by Hutchins Hapgood, 84. New York: Funk & Wagnalls, 1902.

Erdman, Andrew L. *Blue Vaudeville: Sex, Morals and the Mass Marketing of Amusement, 1895–1915*. Jefferson, NC: McFarland, 1965.

Erdman, Harley. *Staging the Jew: The Performance of an American Ethnicity, 1860–1920*. New Brunswick, NJ: Rutgers University Press, 1997.

Erens, Patricia. *The Jew in American Cinema*. Bloomington: Indiana University Press, 1982.

Facing History and Ourselves. *Race and Membership in American History: The Eugenics Movement*. Brookline, MA: Facing History and Ourselves Foundation, 2002.

Fischer, Roger A. *Them Damned Pictures: Explorations in American Political Cartoon Art*. North Haven, CT: Archon Books, 1996.

Flanagan, Maureen A. *America Reformed: Progressives and Progressivisms, 1890s–1920s*. New York: Oxford University Press, 2007.

BIBLIOGRAPHY

Flink, James. J. *The Automobile Age*. Cambridge, MA: MIT Press, 1988.

Freedman, Morris. "From the American Scene: The Real Molly Goldberg." *Commentary* 21 (April 1956): 359–364.

Friedman, Andrea. *Prurient Interests: Gender, Democracy, and Obscenity in New York City, 1909–1945*. New York: Columbia University Press, 2000.

Friedman, Lester J. *The Jewish Image in American Film*. Secaucus, NJ: Citadel Press, 1987.

"The Funny Papers." *Fortune* 7, no. 4 (April 1933): 44–49, 92–101.

Gardner, Jared. *Projections: Comics and the History of Twenty-First-Century Storytelling*. Stanford, CA: Stanford University Press, 2012.

Gebhardt, Nicholas. *Vaudeville Melodies: Popular Musicians and Mass Entertainment in American Culture, 1870–1929*. Chicago: University of Chicago Press, 2017.

Gerstle, Gary. *American Crucible: Race and Nation in the Twentieth Century*. Princeton, NJ: Princeton University Press, 2017.

Gilman, Sandor L. *The Jew's Body*. New York: Routledge, 1991.

Glanz, Rudolf. *The Jew in Early American Wit and Graphic Humor*. New York: KTAV Publishing House, 1973.

Glass, Montague. *Abe and Mawruss: Being Further Adventures of Potash and Perlmutter*. New York: Grosset & Dunlap, 1911.

———. "Business and Pleasure." *Saturday Evening Post*, March 12, 1910, 8–11.

———. "Celestine and Coralie." *Book-Keeper* 21, no. 2 (August 1908): 104–107.

———. "A Cloak and Suit Comedy." *Scrap Book* 6, no. 2 (August 1908): 239–243.

———. "Dead Men's Shoes." *Saturday Evening Post*, November 19, 1910, 5–8, 57–58, 61.

———. "The Early Bird." *Saturday Evening Post*, April 23, 1910. In *Potash & Perlmutter: Stories of the American Jewish Experience*, edited by Sunand T. Joshi, 25–33. Rockville, MD: Wildside Press, 2010.

———. "Firing Miss Cohen." *Munsey's Magazine* 41, no. 2 (May 1909): 284–288.

———. "The Fly in the Ointment." *Saturday Evening Post*, January 15, 1910, 5–7, 30–32.

———. "Keeping Expenses Down: Potash and Perlmutter Once More at the Old Stand." *Hearst's International* 40, no. 2 (August 1921): 10–12, 70–71.

———. *Potash and Perlmutter: Their Copartnership Ventures and Adventures*. Philadelphia: Henry Altemus, 1910.

———. "A Present for Mr. Geigermann." *Saturday Evening Post*, February 4, 1911, 14–16, 52–54.

———. "The Striped Tourists." *Book-Keeper* 20, no. 12 (June 1908): 475–478.

———. "Sympathy." *Saturday Evening Post*, October 15, 1910. In *Potash & Perlmutter: Stories of the American Jewish Experience*, edited by Sunand T. Joshi, 131–146. Rockville, MD: Wildside Press, 2010.

———. "Taking It Easy: Which Shows That It Sometimes Pays to Be Sick." *Saturday Evening Post*, May 22, 1909, 12–13, 55.

———. "The Truth about Potash and Perlmutter and Their Founder." *American Hatter* 39, no. 7 (February 1910): 55–56, 68.

———. "An Up-to-Date Feller." *Saturday Evening Post*, October 23, 1909, 7, 32–34.

Goldman, Herbert G. *Fanny Brice: The Original Funny Girl*. New York: Oxford University Press, 1992.

Goldstein, Eric L. *The Price of Whiteness: Jews, Race, and American Identity*. Princeton, NJ: Princeton University Press, 2006.

BIBLIOGRAPHY

Gordon, Ian. *Comic Strips and Consumer Culture, 1890–1945.* Washington, DC: Smithsonian Institution Press, 1998.

Gordon, Mel. "The Farblondjet Superhero and His Cultural Origins." In *Siegel and Shuster's Funnyman,* edited by Thomas Andrae and Mel Gordon, 1–37. Port Townsend, WA: Feral House, 2010.

Gordon, Milton M. *Assimilation in American Life: The Role of Race, Religion, and National Origins.* New York: Oxford University Press, 1964.

Gottlieb, Jack. *Funny, It Doesn't Sound Jewish: How Yiddish Songs and Synagogue Melodies Influenced Tin Pan Alley, Broadway, and Hollywood.* Albany: State University of New York, 2004.

Goulart, Ron. *The Funnies.* Holbrook, MA: Adams Media Corporation, 1995.

Grant, Madison. *The Passing of the Great Race.* New York: Charles Scribner's Sons, 1916.

Gravett, Paul. *Comics Art.* New Haven, CT: Yale University Press, 2013.

Green, Abel, and Joe Laurie Jr. *Show Biz: From Vaude to Video.* New York: Henry Holt, 1951.

Greene, Victor R. *A Singing Ambivalence: American Immigrants between Old World and New, 1830–1930.* Kent, OH: Kent State University Press, 2004.

Haenni, Sabine. *The Immigrant Scene: Ethnic Amusements in New York, 1880–1920.* Minneapolis: University of Minnesota Press, 2008.

Handlin, Oscar. "American Views of the Jew at the Opening of the Twentieth Century." *Publications of the American Jewish Historical Society* 40 (June 1951): 323–344.

———. *The Uprooted: The Epic Story of the Great Migrations That Made the American People.* Boston: Little, Brown, 1973.

Hapgood, Hutchins. *The Spirit of the Ghetto: Studies of the Jewish Quarter in New York.* New York: Funk & Wagnalls, 1902.

Harap, Louis. *Dramatic Encounters: The Jewish Presence in Twentieth-Century American Drama, Poetry, and Humor and the Black-Jewish Literary Relationship.* Westport, CT: Greenwood Press, 1987.

———. *The Image of the Jew in American Literature.* 2nd ed. Syracuse: Syracuse University Press, 1978.

Harris, Marla. "Borderlands: Places Spaces, and Jewish Identity in Joann Sfar's *The Rabbi's Cat* and *Klezmer.*" In *The Jewish Graphic Novel: Critical Approaches,* edited by Samantha Baskind and Ranen Omer-Sherman, 181–197. New Brunswick, NJ: Rutgers University Press, 2008.

"Harry Hershfield." *Iowa Delayed Birth Records, 1856–1940.* 2017. Ancestry.com. https://www.ancestry.com/search/collections/61441/.

"Harry Hershfield." *U.S. Passport Applications, 1795–1925.* 2007. Ancestry.com. https://www.ancestry.com/search/collections/1174/.

Heinze, Andrew R. *Adapting to Abundance.* New York: Columbia University Press, 1990.

Heitmann, John A. *The Automobile and American Life.* Jefferson, NC: McFarland, 2009.

Hendrick, Burton J. "The Great Jewish Invasion." *McClures Magazine* 28 (1907): 307–321.

———. "The Jewish Invasion of America." *McClures Magazine* 40 (1913): 125–165.

"Henry Hershfield." *1885 Iowa State Census.* 2003. Ancestry.com. https://www.ancestry.com/search/collections/6812/.

Herman, Lewis, and Marguerite Shalett Herman. *Foreign Dialects: A Manual for Actors, Directors, and Writers* (1943). New York: Routledge, 1997.

Hershfield, Harry. *Laugh Louder Live Longer.* New York: Gramercy, 1959.

Hess, Stephen, and Milton Kaplan. *The Ungentlemanly Art: A History of American Political Cartoons.* New York: Macmillan, 1975.

Higham, John. *Send These to Me: Jews and Other Immigrants in Urban America.* New York: Atheneum, 1975.

Hobbs, Allyson. *A Chosen Exile: A History of Racial Passing in American Life.* Cambridge, MA: Harvard University Press, 2014.

Holtz, Allan. *American Newspaper Comics: An Encyclopedic Reference Guide.* Ann Arbor: University of Michigan Press, 2012.

———. "Mutt, Jeff and Bud: The Trio Who Revolutionized Comics." In *The Early Years of Mutt & Jeff,* edited by Jeffrey Lindenblatt, 5–16. New York: Nantier Beall Minoustchine, 2007.

———. "Obscurity of the Day: Little Jap It." 2012. Stripper's Guide. http://strippersguide.blogspot.com/2012/09/obscurity-of-day-little-jap-it.html.

———. "Obscurity of the Day: Potash and Perlmutter." 2021. Stripper's Guide. http://strippersguide.blogspot.com/2021/08/obscurity-of-day-potash-and-perlmutter.html.

———. "Obscurity of the Day: Signor de Pluro." 2018. Stripper's Guide. http://strippersguide.blogspot.com/2008/12/obscurity-of-day-signor-de-pluro.html.

Howe, Irving. *World of Our Fathers: The Journey of the East European Jews to America and the Life They Found and Made.* New York: Harcourt Brace Jovanovich, 1976.

Idelsohn, A. Z. *Jewish Music in its Historical Development* (1929). New York: Schocken Books, 1967.

Jacobs, Joseph. "The Damascus Affair of 1840 and the Jews of America" (1902). In *The Jewish Experience in America, Vol. II,* edited by Abraham J. Karp, 271–280. New York: KTAV Publishing House, 1969.

Jacobson, Matthew Frye. *Special Sorrows.* Berkeley: University of California Press, 2002.

———. *Whiteness of a Different Color: European Immigrants and the Alchemy of Race.* Cambridge, MA: Harvard University Press, 1998.

James, Henry. *The American Scene.* London: Chapman and Hall, 1907.

"James David Glass." *1870–1916 United Kingdom Naturalisation Certificates and Declarations.* 2014. Ancestry.com. https://www.ancestry.com/scarch/collections/9156/.

"Jane Dellis." *U.S. Passport Applications.* 2007. Ancestry.com. https://www.ancestry.com/search/collections/1174/.

Jay, Alex. "Ink-Slinger Profiles by Alex Jay: Harry Hershfield." September 11, 2014. Stripper's Guide. https://www.strippersguide.blogspot.com/2014/09/ink-slinger-profiles-by-alex-jay-harry.html.

Jenkins, Henry, III. "Anarchistic Comedy and the Vaudeville Aesthetic." In *Hollywood Comedians: The Film Reader,* edited by Frank Krutnik, 91–104. New York: Routledge, 2003.

———. *What Made Pistachio Nuts? Early Sound Comedy and the Vaudeville Aesthetic.* New York: Columbia University Press, 1992.

The Jewish Community (Kehillah) of New York City. *Proceedings of the Fifth Annual Convention of the Jewish Community Kehillah.* New York, 1914.

Jones, Gavin. *Strange Talk: The Politics of Dialect Literature in Gilded Age America.* Berkeley: University of California Press, 1999.

Joselit, Jenna Weissman. *Our Gang: Jewish Crime and the New York Jewish Community, 1900–1940.* Bloomington: Indiana University Press, 1983.

BIBLIOGRAPHY

———. *A Perfect Fit: Clothes, Character, and the Promise of America.* New York: Henry Holt, 2001.

Joshi, Sunand T., ed. *Potash & Perlmutter: Stories of the American Jewish Experience.* Rockville, MD: Wildside Press, 2010.

Kallen, Horace. "Democracy versus the Melting-Pot: A Study of American Nationality." *Nation* 100, no. 2591 (1915): 217–220.

Kaplan, Arie. *From Krakow to Krypton: Jews and Comic Books.* Philadelphia: Jewish Publication Society, 2008.

The Katzenjammer Kids: Early Strips in Full Color by Rudolph Dirks. New York: Dover Publications, 1974.

Keire, Mara L. "The Committee of Fourteen and Saloon Reform in New York City, 1905–1920." *Business and Economic History* 26, no. 2 (Winter 1997): 573–583.

Kelman, Ari. *Is Diss a System? A Milt Gross Comic Reader.* New York: New York University Press, 2010.

Kenney, William Howland. *Recorded Music in American Life: The Phonograph and Popular Memory, 1890–1945.* New York: Oxford University Press, 1999.

Kibler, M. Alison. *Censoring Racial Ridicule: Irish, Jewish, and African American Struggles over Race and Representation, 1890–1930.* Chapel Hill: University of North Carolina Press, 2015.

Kilmer, Joyce. *Literature in the Making, by Some of Its Makers.* New York: Harper & Brothers, 1917.

Koffman, David S. *The Jews' Indian: Colonialism, Pluralism, and Belonging in America.* New Brunswick, NJ: Rutgers University Press, 2019.

Korn, Bertram Wallace. *The American Reaction to the Mortara Case: 1858–1859.* Cincinnati: American Jewish Archives, 1957.

Krasney, Ariela. "The *Badkn*: From Wedding Stage to Writing Desk." *Polin* 16 (2003): 7–28.

Kraut, Alan M. *The Huddled Masses: The Immigrant in American Society, 1880–1921.* 2nd ed. Wheeling, WV: Harlan Davidson, 2001.

———. *Silent Travelers: Germs, Genes, and the "Immigrant Menace."* New York: Basic Books, 1994.

Kun, Josh. *Audiotopia: Music, Race, and America.* Berkeley: University of California Press, 2005.

———. "Strangers among Sounds: Listening, Difference, and the Unmaking of Americans." PhD diss., University of California, Berkeley, 1998.

Kurtzman, Harvey. "Lone Stranger!" in *Tales Calculated to Drive You Mad*, no. 3 (January–February 1953).

LaDelle, Frederic. *How to Enter Vaudeville.* Jackson, MI: Frederic LaDelle, 1913.

Lambert, Josh. "'Wait for the Next Pictures': Intertextuality and Cliffhanger Continuity in Early Cinema and Comic Strips." *Cinema Journal* 48, no. 2 (Winter 2009): 3–25.

Laurie, Joe, Jr. *Vaudeville: From the Honky-Tonks to the Palace.* New York: Henry Holt, 1953.

Lazarus, Emma. "The New Colossus." 1883. Poetry Foundation. https://www.poetryfoundation.org/poems/46550/the-new-colossus.

Lee, Hermione. "Philip Roth, the Art of Fiction." *Paris Review* 93, no. 84 (1984). https://www.theparisreview.org/interviews/2957/ the-art-of-fiction-no-84–philip-roth.

"Leo Fuchs." December 8, 2013. SaveTheMusic.com. https://web.archive.org/web/20131208070720/http://savethemusic.com/bin/archives.cgi?q=bio&id=Leo%2BFuchs.

Lessing, Bruno. "Bimberg's Night Off." *Cosmopolitan Magazine* 54, no. 1 (December 1912), 136–142.

———. "Ingratitude of Mister Rosenfeld: A Tale of the New York Ghetto." *Cosmopolitan* 41, no. 4 (August 1906), 387–392.

Leveen, Lois. "Only When I Laugh: Textual Dynamics of Ethnic Humor." *MELUS* 21, no. 4 (Winter 1996): 29–55.

Levine, Lawrence W. *Highbrow/Lowbrow: The Emergence of Cultural Hierarchy in America.* Cambridge, MA: Harvard University Press, 1988.

Levy, Bert. "Oh, Jew! Suppress Thyself!" (1914). Renamed and reprinted as "For the Good of the Race." *For the Good of the Race and Other Stories*, 1–26. New York: Ad Press, 1921.

———. "A Stranger among His People." *Broadway Magazine* 13, no. 11 (February 1905): 16–23.

Lewis, E. C. *Ish ga Bibble (I Should Worry).* Boston: Mutual Book, 1914.

Lewis, Robert M. *From Traveling Show to Vaudeville.* Baltimore: Johns Hopkins University Press, 2003.

"Life and the Jews." *Life* 51, no. 1319 (February 6, 1908).

Lifschutz, E. "Merrymakers and Jesters among Jews" (1930). *YIVO Annual of Jewish Social Science* 7, 1952, 43–69.

Lifson, David S. "Yiddish Theatre." In *Ethnic Theatre in the United States*, edited by Maxine Schwartz Seller, 549–587. Westport, CT: Greenwood Press, 1983.

Lindenblatt, Jeffrey, ed. *The Early Years of Mutt & Jeff.* New York: Nantier Beall Minoustchine, 2007.

Lipsitz, George. *Time Passages: Collective Memory and American Popular Culture.* Minneapolis: University of Minnesota Press, 1990.

Lowe, John. "Theories of Ethnic Humor: How to Enter, Laughing." *American Quarterly* 38, no. 3 (1986): 439–460.

Luthi, Barbara. "Germs of Anarchy, Crime, Disease, and Degeneracy." In *Points of Passage: Jewish Transmigrants from Eastern Europe in Scandinavia, Germany, and Britain, 1880–1914*, edited by Tobias Brinkmann, 27–46. New York: Berghahn Books, 2013.

Madison, Charles A. *Jewish Publishing in America: The Impact of Jewish Writing on American Culture.* New York: Sanhedrin Press, 1976.

Magnes, Judah L. "A Republic of Nationalities." *Emmanuel Pulpit,* February 13, 1909. In *The Jew in the Modern World,* edited by Paul Mendes-Flohr and Jehudah Reinharz, 392. New York: Oxford University Press, 1980.

Manganelli, Kimberly Snyder. *Transatlantic Spectacles of Race: The Tragic Mulatta and the Tragic Muse.* New Brunswick, NJ: Rutgers University Press, 2012.

Mannheim, Karl. "The Problem of Generations." 1927/1928. In *Karl Mannheim: Essays on the Sociology of Knowledge,* edited by Paul Kecskemeti, 276–322. New York: Routledge, 1952.

Marble, Annie Russell. "The Reign of the Spectacular." *Dial* 35, no. 417 (November 1903): 297–299.

Marcus, Jacob. *United States Jewry, 1776–1985,* Vol. 3. Detroit: Wayne State University Press, 1993.

Marinari, Maddalena. *Unwanted: Italian and Jewish Mobilization against Restrictive Immigration Laws, 1882–1965.* Chapel Hill: University of North Carolina Press, 2020.

BIBLIOGRAPHY

Markstein, Don. "Abie the Agent." July 2003. Toonopedia. http://www.toonopedia.com/Abie.htm.

Marschall, Richard. ed. *The Complete Little Nemo in Slumberland, Vol. III: 1908–1910.* Seattle: Fantagraphics Books, 1990.

Marx, Jeffrey. "Eating Up: The Origins of Bagels and Lox." In *Tastes of Faith: Jewish Eating in the United States,* edited by Leah Hochman, 77–114. West Lafayette, IN: Purdue University Press, 2017.

———. "Moral Hazard: The 'Jew Risks' Affair of 1867." *American Jewish History* 106, no. 3 (2022): 255–281.

———. "A Stranger among His People: The Art, Writing, and Life of Bert Levy." *Australian Journal of Jewish Studies* 33 (2020): 140–164.

Marzio, Peter. "Would You Buy a New Car from This Man? How Comic Strips Went into Business with Abie Kabibble." In *Abie the Agent 1914–1915,* v–xiii. Westport, CT: Hyperion Press, 1977.

Masson, Thomas L. *Our American Humorists.* New York: Moffat, Yard, 1922.

Matras, Yaron. *Language Contact.* New York: Cambridge University Press, 2009.

May, Lary. *Screening Out the Past: The Birth of Mass Culture and the Motion Picture Industry.* New York: Oxford University Press, 1980.

Mayo, Louise A. *The Ambivalent Image: Nineteenth-Century America's Perception of the Jew.* Cranbury, NJ: Associated University Presses, 1988.

McCloud, Scott. *Understanding Comics.* New York: HarperCollins, 1993.

McLean, Albert F., Jr. *American Vaudeville as Ritual.* Lexington: University of Kentucky Press, 1965.

McNamara, Brooks. *The Shuberts of Broadway: A History Drawn from the Collections of the Shubert Archive.* New York: Oxford University Press, 1990.

Mencken, H. L. "The Burden of Humor." *Smart Set: A Magazine of Cleverness* 39, no. 2 (February 1913): 151–158.

Merwin, Ted. *In Their Own Image: New York Jews in Jazz Age Popular Culture.* New Brunswick, NJ: Rutgers University Press, 2006.

Mintz, Lawrence. "Humor and Ethnic Stereotypes in Vaudeville and Burlesque." *MELUS* 21, no. 4 (Winter 1996): 19–28.

"Mollie Osherman." *1900 U.S. Census, New York.* 2004. Ancestry.com. https://www.ancestry.com/search/collections/7602/.

"Montague Israel Glass." *1837–1915 England and Wales Civil Registration Birth Index.* 2006. Ancestry.com. https://www.ancestry.com/search/collections/8912/.

Mooney, Jennifer. *Irish Stereotypes in Vaudeville, 1865–1905.* New York: Palgrave Macmillan, 2015.

Morris, Jon. *The League of Regrettable Superheroes.* Philadelphia: Quirk Books, 2015.

Moss, Richard. "Racial Anxiety on the Comics Page: Harry Hershfield's 'Abie the Agent,' 1914–1940." *The Journal of Popular Culture* 40, no. 1 (2007): 90–108.

"Mrs. Sarah Jane Isdell Hershfield." *Menands, New York, Rural Cemetery Burial Cards.* 2011. Ancestry.com. https://www.ancestry.com/search/collections/2226/.

Mullaney, Steven. "Brothers and Others, or the Art of Alienation." In *Cannibals, Witches, and Divorce: Estranging the Renaissance,* edited by Marjorie Garber, 67–89. Baltimore: Johns Hopkins University Press, 1987.

Murrell, William. *A History of American Graphic Humor (1865–1938).* New York: Macmillan, 1938.

Nadel, Dan. *Art out of Time: Unknown Comics Visionaries, 1900–1969.* New York: Abrams, 2006.

Nahshon, Edna. "Entertaining the Crowd." In *New York's Yiddish Theater: From the Bowery to Broadway,* edited by Edna Nahshon, 240–44. New York: Columbia University Press, 2016.

———. "The Pulpit and the Stage: Rabbi Joseph Silverman and the Actors' Church Alliance." *American Jewish History* 91, no. 1 (2003): 5–27.

Nathans, Heather S. *Hideous Characters and Beautiful Pagans: Performing Jewish Identity on the Antebellum American Stage.* Ann Arbor: University of Michigan Press, 2017.

Nesteroff, Kliph. *The Comedians: Drunks, Thieves, Scoundrels and the History of American Comedy.* New York: Grove Press, 2015.

Nizer, Louis. "Goodbye, Harry." *Cartoonist Profiles* 26 (June 1975).

Nystrom, Elsa A. "A Rejection of Order, the Development of the Newspaper Comic Strip in America, 1830–1920." PhD diss., Loyola University of Chicago, 1989.

"Objectionable Films." *Jewish Charities* 6, no. 4 (1915).

"Offensive Caricature." *Judge* 62, no. 1592 (1912).

Oldstone-Moore, Christopher. *Of Beards and Men: The Revealing History of Facial Hair.* Chicago: University of Chicago Press, 2016.

Oring, Elliott, ed. *The First Book of Jewish Jokes: The Collection of L.M. Buschenthal.* Bloomington: Indiana University Press, 2018.

Oring, Elliott. *Jokes and Their Relations.* Lexington: University Press of Kentucky, 1992.

Painter, Nell Irvin. *Standing at Armageddon: The United States, 1877–1919.* New York: W.W. Norton, 2008.

Peiss, Kathy. *Cheap Amusements: Working Women and Leisure in Turn-of-the-Century New York.* Philadelphia: Temple University Press, 1986.

Peppler, Jane, ed. and trans. *Gimpel Beynish, Volume 2: Gimpel Goes to War Twice.* San Bernadino, CA: Self-published, 2016.

———. *Gimpel Beynish the Matchmaker: Samuel Zagat's Yiddish Comic Strips, 1912–1914.* San Bernadino, CA: Self-published, 2015.

Perry, George, and Alan Aldridge. *The Penguin Book of Comics.* Harmondsworth, England: Penguin Books, 1971.

Persons, Stow. *The Decline of American Gentility.* New York: Columbia University Press, 1973.

Pinsker, Sanford. *The Schlemiel as Metaphor.* Carbondale: Southern Illinois University Press, 1971.

Prell, Riv-Ellen. *Fighting to Become Americans: Jews, Gender, and the Anxiety of Assimilation.* Boston: Beacon Press, 1980.

"The Press: Nisht Gehdelt." *Time,* March 7, 1932.

Rappaport, Joseph. "The American Yiddish Press and the European Conflict in 1914." *Jewish Social Studies* 19, no. 3 (1957): 113–128.

R.F. Outcault's The Yellow Kid: A Centennial Celebration of the Kid Who Started the Comics. Northampton, MA: Kitchen Sink Press, 1995.

Ribak, Gil. *Gentile New York.* New Brunswick, NJ: Rutgers University Press, 2012.

Riesman, David. "The Found Generation." *The American Scholar* 25, no. 4 (1956): 421–436.

BIBLIOGRAPHY

Riis, Jacob A. *How the Other Half Lives: Studies Among the Tenements of New York* (1890). New York: Hill and Wang, 1957.

Rischin, Moses. "Toward the Onomastics of the Great New York Ghetto: How the Lower East Side Got Its Name." In *Remembering the Lower East Side: American Jewish Reflections*, edited by Dasia Diner, Jeffrey Shandler, and Beth Wenger, 13–27. Bloomington: Indiana University Press, 2000.

Robbins, Trina, ed. *The Brinkley Girls: The Best of Nell Brinkley's Cartoons from 1913–1940*. Seattle: Fantagraphics Books, 2009.

Robbins, Trina. *Nell Brinkley and the New Woman in the Early 20th Century*. Jefferson, NC: McFarland, 2001.

Robinson, Jerry. "Introduction." In *Comic Books and Comic Strips in the United States: An International Bibliography*, edited by John A. Lent, xix-xxvi. Westport, CT: Greenwood Press, 1994.

Rochelson, Meri-Jane. "Language, Gender, and Ethnic Anxiety in Zangwill's *Children of the Ghetto.*" *English Literature in Transition, 1880–1920* 31, no. 4 (1988): 399–412.

Rodgers, Daniel T. "In Search of Progressivism." *Reviews in American History* 10, no. 4 (1982): 113–132.

Rogin, Michael. *Blackface, White Noise: Jewish Immigrants in the Hollywood Melting Pot*. Berkeley: University of California Press, 1996.

Romeyn, Esther. "My Other/My Self: Impersonation, Masquerade, and the Theater of Identity in Turn-of-the-Century New York City." PhD diss., University of Minnesota, 1998.

———. *Street Scenes: Staging the Self in Immigrant New York, 1880–1924*. Minneapolis: University of Minnesota Press, 2008.

Romeyn, Esther, and Jack Kugelmass. *Let There Be Laughter: Jewish Humor in America*. Chicago: Spertus Press, 1997.

Roosevelt, Theodore. *Ranch Life and the Hunting Trail*. New York: Century, 1902.

Ross, Edward Alsworth. "The Hebrews of Eastern Europe in America." *Century* 88 (1914): 785–792.

———. *The Old World in the New: The Significance of Past and Present Immigration to the American People*. New York: Century, 1914.

Roth, Laurence. "Contemporary American Jewish Comic Books: Abject Pasts, Heroic Futures." In *The Jewish Graphic Novel: Critical Approaches*, edited by Samantha Baskind and Ranen Omer-Sherman, 3–21. New Brunswick, NJ: Rutgers University Press, 2010.

Royal, Derek Parker, ed. *Visualizing Jewish Narrative*. London: Bloomsbury, 2016.

Rubinstein, Rachel. *Members of the Tribe: Native America in the Jewish Imagination*. Detroit: Wayne State University Press, 2010.

Sable, Jacob M. "Some American Jewish Organizational Efforts to Combat Anti-Semitism, 1906–1930." PhD diss., Yeshiva University, 1964.

Saguisag, Lara. *Incorrigibles and Innocents: Constructing Childhood and Citizenship in Progressive Era Comics*. New Brunswick, NJ: Rutgers University Press, 2019.

"Sam M Lewis." *U.S. Passport Applications*. 2007. Ancestry.com. https://www.ancestry.com/search/collections/1174/.

Samberg, Joel. *Grandpa Had a Long One: Personal Notes on the Life, Career & Legacy of Benny Bell*. Albany, GA: BearManor Media, 2009.

"Samuel Isdall," *1850 U.S. Census, New York.* 2009. Ancestry.com. https://www.ancestry.com/search/collections/8054/.

"Samuel Lavine." *1900 U.S. Census, New York.* 2004. Ancestry.com. https://www.ancestry.com/search/collections/7602/.

Sandrow, Nahma. *Vagabond Stars: A World History of Yiddish Theater.* New York: Harper & Row, 1977.

Saper, Bernard. "Since When Is Jewish Humor Not Anti-Semitic?" In *Semites and Stereotypes: Characteristics of Jewish Humor,* edited by Avner Ziv and Anat Zajdman, 77–86. Westport, CT: Greenwood Press, 1993.

Sapoznik, Henry. *Klezmer! Jewish Music from Old World to our World.* New York: Schirmer Trade Books, 1999.

Sarna, Jonathan. *American Judaism: A History.* New Haven, CT: Yale University Press, 2004.

Sartre, Jean-Paul. *Anti-Semite and Jew: An Exploration of the Etiology of Hate.* New York: Schocken, 1948.

Scharff, Virginia. *Taking the Wheel: Women and the Coming of the Motor Age.* New York: Free Press, 1991.

Schiff, Ellen. "Shylock's *Mishpocheh*: Anti-Semitism on the American Stage." In *Anti-Semitism in American History,* edited by David A. Gerber, 79–99. Urbana: University of Illinois Press, 1986.

Schoenfeld, Amram. "The Laugh Industry." *Saturday Evening Post,* February 1, 1930.

Seldes, Gilbert. *The 7 Lively Arts.* New York: Sagamore Press, 1924.

Siegel, David S., and Susan Siegel. *Radio and the Jews: The Untold Story of How Radio Influenced America's Image of Jews, 1920s–1950s.* Yorktown Heights, NY: Book Hunter Press, 2007.

Simons, Manly H. "The Origin and Condition of the Peoples Who Make Up the Bulk of Our Immigrants at the Present Time and the Probable Effect of Their Absorption upon Our Population." *The Military Surgeon* 23, no. 6 (December 1908): 427–441.

Singer, Ben. *Melodrama and Modernity: Early Sensational Cinema and Its Contexts.* New York: Columbia University Press, 2001.

Slide, Anthony. *New York City Vaudeville.* Charleston, SC: Arcadia, 2006.

Slobin, Mark. *Tenement Songs: The Popular Music of the Jewish Immigrants.* Urbana: University of Illinois Press, 1982.

Smith, Sidney. *Old Doc Yak.* Drawing. 1917. In *The Smithsonian Collection of Newspaper Comics,* edited by Bill Blackbeard and Martin Williams, 72. Washington, DC: Smithsonian Press, 1977.

Snyder, Robert W. *The Voice of the City: Vaudeville and Popular Culture in New York.* New York: Oxford University Press, 1989.

Sollors, Werner. *Beyond Ethnicity: Consent and Descent in American Culture.* New York: Oxford University Press, 1986.

Soper, Kerry. "From Swarthy Ape to Sympathetic Everyman and Subversive Trickster: The Development of Irish Caricature in American Comic Strips between 1890 and 1920." *Journal of American Studies* 39, no. 2 (August 2005): 257–296.

———. "Performing 'Jiggs': Irish Caricature and Comedic Ambivalence toward Assimilation and the American Dream in George McManus' "Bringing Up Father." *The Journal of the Gilded Age & Progressive Era* 4, no. 2 (April 2005): 173–213.

BIBLIOGRAPHY

Sorin, Gerald. *A Time for Building: The Third Migration, 1880–1920.* Baltimore: Johns Hopkins University Press, 1992.

Springhall, John. *The Genesis of Mass Culture: Show Business Live in America, 1840–1940.* New York: Palgrave Macmillan, 2008.

Standard Dramatic Comic Recitations: Hebrew, Dutch, Irish and Yankey Dialect. Philadelphia: Royal Publishing, 1904.

Staples, Shirley. *Male-Female Comedy Teams in American Vaudeville, 1865–1932.* Ann Arbor: UMI Research Press, 1984.

Sterba, Christopher M. *Good Americans: Italian and Jewish Immigrants during the First World War.* New York: Oxford University Press, 2003.

Stewart, D. Travis. *No Applause—Just Throw Money.* New York: Faber and Faber, 2005.

Stromberg, Fredrik. *Jewish Images in the Comics: A Visual History.* Seattle: Fantagraphics Books, 2012.

Susman, Warren I. *Culture as History: The Transformation of American Society in the Twentieth Century.* New York: Pantheon Books, 1973.

Tavares, Judith. "Mr. Charles Klein." 2011. The Lusitania Resource. http://www.rmslusitania.info/people/saloon/charles-klein/.

Thissen, Judith. "Beyond the Nickelodeon: Cinemagoing, Everyday Life and Identity Politics." In *Audiences,* edited by Ian Christie, 45–65. Amsterdam: Amsterdam University Press, 2012.

———. "Early Yiddish Vaudeville in New York City." In *New York's Yiddish Theater,* edited by Edna Nahshon, 248–254. New York: Columbia University Press, 2016.

Towsen, John H. *Clowns.* New York: Hawthorne Books, 1976.

Turner, George Kibbe. "The Daughters of the Poor: A Plain Story of the Development of New York City as a Leading Centre of the White Slave Trade of the World, under Tammany Hall." *McClure's Magazine* 34 (November 1909): 45–61.

Varat, Deborah. "'Their New Jerusalem': Representations of Jewish Immigrants in the American Popular Press, 1880–1903." *The Journal of the Gilded Age and Progressive Era* 20, no. 2 (2021): 277–300.

Wallace, Mike. *Greater Gotham: A History of New York City from 1898–1919.* New York: Oxford University Press, 2017.

Waller, Gregory A. "Locating Early Non-Theatrical Audiences." In *Audiences,* edited by Ian Christie, 81–95. Amsterdam: Amsterdam University Press, 2012.

Wanzo, Rebecca. *The Content of Our Caricature: African American Comic Art and Political Belonging.* New York: New York University Press, 2020.

Wardhaugh, Ronald. *An Introduction to Sociolinguistics.* 5th ed. Malden, MA: Blackwell, 2006.

Warfield, David, and Margherita Arlina Hamm. *Ghetto Silhouettes.* New York: James Pott, 1902.

Weber, Donald. *Haunted in the New World.* Bloomington: Indiana University Press, 2005.

Weingarten, Irving. "The Image of the Jew in the American Periodical Press, 1881–1921." PhD diss., New York University, 1979.

Westgate, J. Chris. *Staging the Slums, Slumming the Stage: Class, Poverty, Ethnicity, and Sexuality in American Theatre, 1890–1916.* New York: Palgrave Macmillan, 2014.

Wheeler, John N. "A Captain of Comic Industry and Other Interesting People." *American Magazine,* May 1916.

180 BIBLIOGRAPHY

Whitfield, Stephen J. *In Search of American Jewish Culture*. Hanover, NH: University Press of New England, 1999.

———. "Towards an Appreciation of American Jewish Humor." *Journal of Modern Jewish Studies* 4, no. 1 (2005): 33–48.

Wickberg, Daniel. *The Senses of Humor*. Ithaca, NY: Cornell University Press, 1998.

Wiener, Meyer. "On Sholom Aleichem's Humor." In *Jewish Wry: Essays on Jewish Humor*, edited by Sarah Blacher Cohen, 37–52. Detroit: Wayne State University Press, 1987.

Williams, Taylor. "Visual Continuity in Winsor McCay's Slumberland." MA thesis, Maryland Institute College of Art, 2015.

Winchester, Mark David. "Cartoon Theatricals from 1896 to 1927: Gus Hill's Cartoon Shows for the American Road Theatre." PhD diss., Ohio State University, 1995.

Winokur, Mark. *American Laughter: Immigrants, Ethnicity, and 1930s Hollywood Film Comedy*. New York: St. Martin's Press, 1996.

Wisse, Ruth R. *The Schlemiel as Modern Hero*. Chicago: University of Chicago Press, 1971.

Yaszek, Lisa. "Them Damn Pictures: Americanization and the Comic Strip in the Progressive Era." *Journal of American Studies* 28, no. 1 (April 1994): 23–38.

Yochelson, Bonnie, and Daniel Czitrom. *Rediscovering Jacob Riis: Exposure Journalism and Photography in Turn of the Century New York*. Chicago: University of Chicago Press, 2007.

Zahra, Tara. *The Great Departure: Mass Migration from Eastern Europe and the Making of the Free World*. New York: W.W. Norton, 2016.

Zangwill, Israel. *The Melting-Pot: Drama in Four Acts* (1908). New York: MacMillan, 1909.

Zurawik, David. *The Jews of Prime Time*. Hanover, NH: University Press of New England, 2003.

Zurier, Rebecca. *Picturing the City: Urban Vision and the Ashcan School*. Berkeley: University of California Press, 2006.

Multimedia

Bernard, Rhoda, vocalist, and Addison Burkhardt, lyricist. *My Yiddish Matinee Girl*. 78 rpm. Victor matrix B-17242, 1916.

Branen, Jeff T., lyricist. *Big Chief Dynamite*. Notated music. Chicago: Will Rossiter, The Chicago Publisher, 1909.

Brice, Fanny, vocalist. *I'm an Indian*. 78 rpm. Victor matrix B-25769, 1921.

Brooks, Mel, director. *Blazing Saddles*. 35 mm. Burbank, CA: Crossbow Productions, Warner Brothers, 1974.

Fields, Lew, vocalist, and Joe Weber, vocalist. *Drinking Scene: Mike and Meyer*. 78 rpm. Columbia A-1159, 1912.

Fuchs, Leo, composer and vocalist. *Der Galitzianer Badchen*. 78 rpm. Banner Records B2027B, [1948?].

———. *Yiddisha Cowboy*. 78 rpm. Banner Records B516A, [1948?].

"Harry Hershfield." Interview by Bob Lewis and Betty Lewis. Sound Recording. June 24, 1964. Performing Arts Research Collections—Recorded Sound. Billy Rose Theatre Division, New York Public Library.

Hayman, Joe, vocalist. *Cohen on the Telephone*. 78 rpm. Columbia Records, 1913.

BIBLIOGRAPHY

181

Hershfield, Harry, vocalist. *Abe Kabibble at the Ballgame.* Monologue. 78 rpm. Columbia Graphophone Company A2907, 1920.

———. *Abe Kabibble Dictates a Letter.* Monologue. 78 rpm. Columbia Graphophone Company A2907, 1920.

———. *Abe Kabibble "Does His Bit."* Monologue. 78 rpm. Little Wonder Records no. 684, ca. 1917.

———. *At Abe Kabibble's Kabaret.* Lyrics. New York: Leo. Feist, 1915.

Jones, Ada, vocalist, and Len Spencer, vocalist. *Becky and Izzy.* 78 rpm. Victor 5034, 1907.

———. *Fritz and Louisa.* 78 rpm. Zonophone Records 5113B, 1906.

———. *Maggie Clancy's Grand Piano.* 78 rpm. Victor 31519, March 16, 1906.

———. *Mammy Chloe and Her Joe.* 78 rpm. Zonophone Records 5193B, 1909.

Leslie, Edgar, lyricist. *I'm a Yiddish Cowboy (Tough Guy Levi).* Notated music. New York: Ted S. Barron Music Publisher, 1907.

Lewis, Sam M., lyricist. *Isch Ga-Bibble (I Should Worry).* Notated music. New York: Geo. W. Meyer Music, 1913.

Lewis, Sam M., lyricist, and Eddie Morton, vocalist. *Isch ka Bibble (I Should Worry).* 78 rpm. Victor Record 17451, 1913.

Rose, Julian, vocalist. *Levinsky at the Wedding.* 78 rpm. Columbia A2310, 1918.

Russotto, Henry, composer, and Morris Rosenfeld, lyricist. *My America, Our New Hymn.* Notated music. New York: Hebrew Publishing, 1917. https://www.loc.gov/item/ihas .200182308/.

Swerling, Jo, lyricist. *Abie! (Stop Saying Maybe).* Notated music. New York: Shapiro, Bernstein, 1924.

WORKS CONSULTED

Alharizi, Judah. *The Book of Tahkemoni: Jewish Tales from Medieval Spain.* Translated by David Simha Segal. London: Littman Library of Jewish Civilization, 2001.

Alexander, Michael. *Jazz Age Jews.* Princeton, NJ: Princeton University Press, 2001.

Altman, Sig. *The Comic Image of the Jew: Explorations of a Pop Culture Phenomenon.* Rutherford, NJ: Fairleigh Dickinson University Press, 1971.

American Jewish Committee. *American Jewish Yearbook* 16 (1914).

Anti-Defamation League. *The Distorted Image: Stereotype and Caricature in American Popular Graphics, 1850–1922.* DVD. New York: Anti-Defamation League, 1995.

Antin, Mary. *The Promised Land.* Boston: Houghton Mifflin, 1912.

Avery, Elroy M. *A History of Cleveland and Its Environs.* Chicago: Lewis, 1918.

Baigell, Matthew. *Social Concern and Left Politics in Jewish American Art, 1880–1940.* Syracuse: Syracuse University Press, 2015.

Bale, Anthony. *Feeling Persecuted: Christians, Jews and Images of Violence in the Middle Ages.* London: Reaktion Books, 2010.

Band, Arnold J. "Popular Fiction and the Shaping of Jewish Identity." In *Jewish Identity in America,* edited by David M. Gordis and Yoav Ben-Horin, 215–225. Los Angeles: Wilstein Institute, University of Judaism, 1991.

Barker, Martin. "Crossing Out the Audience." In *Audiences,* edited by Ian Christie, 187–205. Amsterdam: Amsterdam University Press, 2012.

Benor, Sarah Bunin. *Becoming Frum: How Newcomers Learn the Language and Culture of Orthodox Judaism.* New Brunswick, NJ: Rutgers University Press, 2012.

BIBLIOGRAPHY

Berger, Arthur A. *The Genius of the Jewish Joke* (1977). New York: Routledge, 2017.

Bergquist, James M. "The Concept of Nativism in Historical Study since *Strangers in the Land*." *American Jewish History* 76, no. 2 (1986): 125–141.

Berrol, Selma C. "In Their Image: German Jews and the Americanization of the Ost Juden in New York City." *New York History* 63, no. 4 (1982): 417–433.

Blair, Walter, and Hamlin Hill. *America's Humor: From Poor Richard to Doonesbury*. New York: Oxford University Press, 1978.

Bloom, Harold. *The Anxiety of Influence: A Theory of Poetry* (1973). New York: Oxford University Press, 1997.

Boelhower, William. *Through a Glass Darkly: Ethnic Semiosis in American Literature*. New York: Oxford University Press, 1987.

Boskin, Joseph. "Beyond Kvetching and Jiving: The Thrust of Jewish and Black Folkhumor." In *Jewish Wry: Essays on Jewish Humor*, edited by Sarah Blacher Cohen, 53–79. Detroit: Wayne State University Press, 1987.

Brod, Harry. *Superman Is Jewish? How Comic Book Superheroes Came to Serve Truth, Justice, and the Jewish-American Way*. New York: Free Press, 2012.

Brown, Peter Jensen. "The Real Alfred E." March 10, 2013. The Real Alfred E. http://www .therealalfrede.blogspot.com/2013/03/what-me-worry-isch-ka-bibble-and-alfred.html.

———. "What? Me Worry? Isch ka Bibble and Alfred E. Neuman." March 13, 2013. The Real Alfred E. http://www.therealalfrede.blogspot.com/2013/03/what-me-worry-isch -ka-bibble-and-alfred.html.

Buenker, John D., John C. Burnham, Robert M. Crunden. *Progressivism*. Cambridge, MA: Schenkman, 1977.

Byom, Clara. "Mixing In Too Much Jewish: American Klezmorim in New York City from 1950–1970." MA thesis, University of New Mexico, 2017.

Cahan, A. (Abraham). *Yekl: A Tale of the New York Ghetto*. New York: D. Appleton, 1896.

Canwell, Bruce. "Gags, Situation Comedies." In *King of the Comics: One Hundred Years of King Features Syndicate*, edited by Dean Mullaney, 39–70. San Diego: IDW Publishing, 2016.

Cassen, Flora. "From Iconic O to Yellow Hat: Anti-Jewish Distinctive Signs in Renaissance Italy." In *Fashioning Jews: Clothing, Culture, and Commerce*, edited by Leonard J. Greenspoon, 29–48. West Lafayette, IN: Purdue University Press, 2013.

"Charles Klein: An Inventory of His Plays." 2003. Harry Ransom Humanities Research Center. The University of Texas at Austin. https://norman.hrc.utexas.edu/fasearch /findingAid.cfm?eadid=00335.

Charmé, Stuart Z. "Varieties of Authenticity in Contemporary Jewish Identity." *Jewish Social Studies*, New Series 6, no. 2 (2000): 133–155.

Cogswell, Robert Gireud. "Jokes in Blackface: A Discographic Folklore Study." PhD diss., Indiana University, 1984.

Cohen, Lester. *The New York Graphic*. Philadelphia: Chilton Books, 1964.

Contento, William G., and Phil Stephensen-Payne. "Glass, Montague." 2003. FictionMags Index. http://www.philsp.com/homeville/fmi/n03/n03614.htm#A11.

Conzen, Kathleen Neils, et al. "The Invention of Ethnicity: A Perspective from the U.S.A." *Journal of American Ethnic History* 12, no. 1 (Fall 1992): 3–41.

Crafton, Donald. *Before Mickey: The Animated Film, 1898–1928*. Cambridge, MA: MIT Press, 1982.

BIBLIOGRAPHY

Cushman, Philip. *Constructing the Self, Constructing America: A Cultural History of Psychotherapy.* Reading, MA: Addison-Wesley, 1996.

Davies, Christie. "Jewish Jokes, Anti-Semitic Jokes, and Hebredonian Jokes." In *Jewish Humor,* edited by Avner Ziv, 75–96. Tel Aviv: Papyrus Publishing House, 1986.

Degg, D. D. "It Was Twenty Years Ago Today." March 11, 2020. Daily Cartoonist.com. https://www.dailycartoonist.com/index.php/2020/03/11/it-was-120-years-ago-today/.

Dell, Robert Merritt. "The Representation of the Immigrant on the New York Stage, 1881 to 1910." PhD diss., School of Education of New York University, 1960.

Dinnerstein, Leonard, and David M. Reimers. *Ethnic Americans: A History of Immigration.* New York: Columbia University Press, 1999.

Dreams of the Rarebit Fiend: Winsor McCay. Toronto: Dover Publications, 1973.

Dundes, Alan. *Cracking Jokes: Studies of Sick Humor Cycles & Stereotypes.* Berkeley: Ten Speed Press, 1987.

———. "A Study of Ethnic Slurs: The Jew and the Polack in the United States." *The Journal of American Folklore* 84, no. 332 (1971): 186–203.

Dunn, Bob. "Harry Hershfield." *Cartoonist* (October 1966).

Dunning, John. *On the Air: The Encyclopedia of Old-Time Radio.* New York: Oxford University Press, 1988.

Elkind, David, and Robert Bowen. "Imaginary Audience Behavior in Children and Adolescents." *Developmental Psychology* 15, no. 1 (1979): 38–44.

Epstein, Lawrence J. *The Haunted Smile: The Story of Jewish Comedians in America.* New York: PublicAffairs, 2001.

Esar, Evan. *The Humor of Humor.* New York: Horizon, 1952.

Ewen, David. "The Jew as Cartoonist." *The Jewish Forum* 12, no. 8 (1929): 355–357.

Farrell, James T. *Judgement Day* (1935). New York: Avon, 2018.

———. *Young Lonigan* (1932). New York: Penguin, 2003.

Feinstein, Mark H. "Ethnicity and Topicalization in New York City English." *International Journal of the Sociology of Language* 26 (1980): 15–24.

Fingeroth, Danny. *Disguised as Clark Kent: Jews, Comics, and the Creation of the Superhero.* New York: Continuum, 2007.

Fisher, Bud. *The Mutt and Jeff Cartoons, Book Two.* Boston: Ball, 1911.

Fishman, Sylvia Barack. *Jewish Life and American Culture.* Albany: State University of New York Press, 2000.

Frank, Armin Paul. *Off-Canon Pleasures.* Gottingen, Germany: Universitatsverlag Gottingen, 2011.

Frederick J. Drake & Company. *Choice Dialect and Vaudeville Stage Jokes.* Chicago: Frederick J. Drake, 1902.

Freimark, Peter. "Language Behavior and Assimilation: The Situation of the Jews in Northern Germany in the First Half of the Nineteenth Century." *The Leo Baeck Institute Year Book* 24, no. 1 (1979): 157–177.

Freud, Sigmund. *Jokes and Their Relation to the Unconscious* (Vienna, 1905). Translated by James Strachey. New York: W.W. Norton, 1960.

Friedman, Lester D. *Hollywood's Image of the Jew.* New York: Frederick Ungar, 1982.

Galewitz, Herb, ed. *Bringing Up Father by Geo McManus.* New York: Charles Scribner's Sons, 1973.

Gilbert, Douglas. *American Vaudeville: Its Life and Times.* New York: Dover Publications, 1963.

Gilman, Sandor, and Stephen T. Katz, eds. *Anti-Semitism in Times of Crisis*. New York: New York University Press, 1991.

Gilman, Sandor L. *Jewish Self-Hatred: Anti-Semitism and the Hidden Language of the Jews*. Baltimore: Johns Hopkins University Press, 1986.

Gitlin, Todd. *The Twilight of Common Dreams: Why America Is Wracked by Culture Wars*. New York: Metropolitan Books, 1995.

Glass, Montague. "Some of My Best Friends Are—: The Experiences of a Jew among Gentiles." *American Magazine* 85 (January 1918): 16, 70–76.

———. "The Dominant Tenement." *Saturday Evening Post*, January 29, 1910, 5–7, 28–30.

———. "The Walking Delegate." *Saturday Evening Post*, November 20, 1909, 13–15, 38.

Gleason, Philip. "American Identity and Americanization." In *Concepts of Ethnicity*, edited by William Petersen, Michael Novak, and Philip Gleason, 57–143. Cambridge, MA: Belknap Press of Harvard University Press, 1982.

———. "The Melting Pot: Symbol of Fusion or Confusion?" *American Quarterly* 16, no. 1 (Spring 1964): 20–46.

Goldin, J. David. "Hershfield, Harry." December, 2017. RadioGoldIndex, http://www.radiogoldindex.com.

Goldman, Albert. "Boy-Man, Schlemiel: The Jewish Element in American Humor." In *Explorations: An Annual on Jewish Themes*, edited by Murray Mindlin and Chaim Bermant, 3–17. London: Barrie and Rockliff, 1967.

Grotjahn, Martin. *Beyond Laughter*. New York: McGraw-Hill, 1957.

Gross, Milt. *Nize Baby*. New York: Dorian, 1926.

Gutstein, Morris A. *A Priceless Heritage: The Epic Growth of Nineteenth Century Chicago Jewry*. New York: Bloch, 1953.

Hardy, Charles, and Gail F. Stern, eds. *Ethnic Images in the Comics*. Philadelphia: Balch Institute for Ethnic Studies and B'nai B'rith Anti-Defamation League, 1986.

Harrison Kahan, Lori. *The White Negress, Literature, Minstrelsy, and the Black-Jewish Imaginary*. New Brunswick, NJ: Rutgers University Press, 2011.

"Harry Hershfield." *Who's Who in American Jewry 1926*. New York: Jewish Biographical Bureau, 1927.

Hershfield, Harry. *Hershfield's Jewish Jokes: A Collection of Harry Hershfield's Classics and Those of His Friends and Collaborators*. New York: Simon and Schuster, 1932.

———. "Very Past: The Pre-Twenties." *Cartoonist*, 20th Anniversary Issue, 1966.

Higham, John. "Anti-Semitism in the Gilded Age: A Reinterpretation." *The Mississippi Valley Historical Review* 43, no. 4 (1957): 559–578.

———. *Strangers in the Land: Patterns of American Nativism 1860–1925*. New York: Atheneum, 1963.

Hoberman, J., and Jeffrey Shandler. *Entertaining America: Jews, Movies, and Broadcasting*. Princeton, NJ: Princeton University Press, 2003.

Hodin, Mark. "Class, Consumption, and Ethnic Performance in Vaudeville." *Prospects: An Annual of American Cultural Studies* 22 (1997): 193–210.

Hoffman, Warren D. *The Great White Way: Race and the Broadway Musical*. New Brunswick, NJ: Rutgers University Press, 2014.

Howe, Irving. "The Nature of Jewish Laughter." In *Jewish Wry: Essays on Jewish Humor*, edited by Sarah Blacher Cohen, 16–24. Detroit: Wayne State University Press, 1987.

Hurd, Jud. *Cartoon Success Secrets: A Tribute to Thirty Years of Cartoonist Profiles*. Kansas City: Andrews McMeel, 2004.

BIBLIOGRAPHY

Imhoff, Sarah. *Masculinity and the Making of American Judaism.* Bloomington: Indiana University Press, 2017.

Itzkoff, David. "Simpsons' Creator Matt Groening Says Debate around Apu Is Tainted." *New York Times*, July 18, 2018.

Jaher, Frederic Cople. *A Scapegoat in the New Wilderness: The Origins and Rise of Anti-Semitism in America.* Cambridge, MA: Harvard University Press, 1994.

"Josef Rajzler (Josele Badchan)." In *Sefer Kielce, Toldot Kehilat Kielce, Miyom Hivsuduh V'ad Churbanah,* edited by Pinchas Cytron, 224–225. Tel Aviv, 1957. http://www.jewishgen.org/Yizkor/kielce/Kie201.html#Page222.

Joselit, Jenna Weissman. *The Wonder of America: Reinventing Jewish Culture, 1880–1950.* New York: Hill and Wang, 1994.

Kidman, Shawna. *Comic Books Incorporated.* Oakland: University of California Press, 2019.

King, Jonathan, ed. *A Cartoon History of Australia: A Social History of Australia in Cartoons.* Adelaide, Australia: Savvas, 1979.

Klapper, Melissa R. *Jewish Girls Coming of Age in America, 1860–1920.* New York: New York University Press, 2005.

Kunzle, David. *The Early Comic Strip: Narrative Strips and Picture Stories in the European Broadsheet from c. 1450 to 1825.* Berkeley: University of California Press, 1973.

———. *The History of the Comic Strip: The Nineteenth Century.* Berkeley: University of California Press, 1990.

Lambert, Josh. *Unclean Lips: Obscenity, Jews, and American Culture.* New York: New York University Press, 2014.

Lavitt, Pamela Brown. "First of the Red Hot Mamas: "Coon Shouting and the Jewish Ziegfeld Girl." *American Jewish History* 87, no. 4 (1999): 243–290.

Levisohn, Jon A., and Ari Y. Kelman, eds. *Beyond Jewish Identity: Rethinking Concepts and Imagining Alternatives.* Boston: Academic Studies Press, 2019.

Liebman, Mac (Max). *Vot Is Kemp Life? And a Couple Odder Things.* New York: Lobel-Young, 1927.

Lipton, Sara. *Dark Mirror: The Medieval Origins of Anti-Jewish Iconography.* New York: Henry Holt, 2014.

Lowe, Heinz-Dietrich. *The Tsars and the Jews: Reform, Reaction and Anti-Semitism in Imperial Russia, 1772–1917.* Chur, Switzerland: Harwood Academic Publishers, 1993.

Marks, M. L. *Jews among the Indians: Tales of Adventure and Conflict in the Old West.* Chicago: Benison Books, 1992.

Marschall, Richard. "A Crowded Life in Comics—A Lifetime of Opper-tunities." November 3, 2019. Yesterday's Papers. http://johnadcock.blogspot.com/search/label/F.B.%20Opper.

Maurice, Arthur Bartlett. *The New York of the Novelist.* New York: Dodd, Mead, 1916.

McGeehn, W. O. "The Piker's Rubiayat, a Record of Luck and Adversity." *San Francisco Chronicle*, November 24, 1908.

McLean, Albert F., Jr. "US Vaudeville and the Urban Comics." *Theatre Quarterly* 1, no. 45 (1971): 47–52.

Mencken, H. L. *The American Language: An Inquiry into the Development of English in the United States.* New York: A.A. Knopf, 1919.

Merwin, Ted. "Jew-Face: Non-Jews Playing Jews on the American Stage." *Cultural and Social History* 4, no. 2 (2007): 215–233.

Metzker, Isaac, ed. *A Bintel Brief*. New York: Ballantine Books, 1972.

"Mikel Hershfield." *1900 U.S. Census, Illinois*. 2004. Ancestry.com. https://www.ancestry.com/search/collections/7602/.

Milligan, Amy K. *Jewish Bodylore: Feminist and Queer Ethnographies of Folk Practices*. Lanham, MD: Lexington Books, 2019.

"Montague Glass." *Bookman* 31, no. 6 (1910).

"Montague Glass." 2023. Internet Broadway Database. https://www.ibdb.com/broadway-cast-staff/montague-glass-7483.

Most, Andrea. "Big Chief Izzy Horowitz: Theatricality and Jewish Identity in the Wild West." *American Jewish History* 87, no. 4 (1999): 313–341.

Nahshon, Edna. *From the Ghetto to the Melting Pot: Israel Zangwill's Jewish Plays*. Detroit: Wayne State University Press, 2006.

Newton, Harry L. "Abie Cohen's Wedding Day." In *Some Vaudeville Monologues*, edited by Harry L. Newton, 41–46. Minneapolis: T.S. Denison, 1917.

Niren, Charles P., and Jeffrey A. Marx. "The Elusive Myer the Buyer." *Radiogram* 44, no. 12 (2021): 9–13.

Oberdeck. Kathryn J. *The Evangelist and the Impresario: Religion, Entertainment, and Cultural Politics in America, 1884–1914*. Baltimore: Johns Hopkins University Press, 1999.

Oksman, Tahneer. *"How Come Boys Get to Keep Their Noses?": Women and Jewish American Identity in Contemporary Graphic Memoirs*. New York: Columbia University Press, 2016.

Oppenheim, James. "Montague Glass' 'Potash & Perlmutter." *Bookman: A Magazine of Literature and Life* 31, no. 6 (August 1910): 630–631.

Oring, Elliott. *Joking Asides: The Theory, Analysis, and Aesthetics of Humor*. Logan: Utah State University Press, 2016.

Outcault, Richard. *Buster Brown: Early Strips in Full Color*. New York: Dover Publications, 1974.

Page, Brett. *Writing for Vaudeville*. Springfield, MA: Home Correspondence School, 1915.

Park, Robert E., and Herbert A. Miller. *Old World Traits Transplanted*. New York: Harper & Brothers, 1921.

Pekar, Harvey, and Paul Buhle, eds. *Yiddishkeit*. New York: Abrams, 2011.

Portnoy, Eddy. "A Brief History of Yiddish Cartooning." *Rumpus*. November 4, 2014. Therumpus.net. https://therumpus.net/2014/11/the-new-york-comics-picture-story-symposium-eddy-portnoy-a-brief-history-of-yiddish-cartooning/.

Raskin, Victor. *Semantic Mechanisms of Humor*. Dordrecht, Holland: D. Reidel, 1985.

Ravage, Marcus Eli. *An American in the Making: The Life Story of an Immigrant*. New York: Harper & Brothers, c. 1917.

Reik, Theodore. *Jewish Wit*. New York: Gamut Press, 1962.

Ribak, Gil. "The Jew Usually Left Those Crimes to Esau." *AJS Review* 38, no. 1 (2014): 1–28.

Roback, A. A. "You Speak Yiddish, Too." *Sentinel*, February 10, 1938.

Rosenberg, Edgar. *From Shylock to Svengali: Jewish Stereotypes in English Fiction*. Stanford, CA: Stanford University Press, 1960.

Ross, Leonard Q. (Leo Rosten). "The Rather Difficult Case of Mr. K*A*P*L*A*N." *The New Yorker* 12, August 22, 1936. In *The Education of Hyman Kaplan*, 3–10. New York: Harcourt, Brace, 1937.

BIBLIOGRAPHY

Roth, Henry. *Call It Sleep.* New York: Robert O Ballou, 1935.

Roth, Walter. *Avengers and Defenders: Glimpses of Chicago's Jewish Past.* Chicago: Academy Chicago Publishers, 2008.

———. "Carl Sandburg's Letter to Jacob M. Loeb." *Chicago Jewish History* 24, no. 2 (Spring 2000): 4–6.

Rothermel, Charles T. & Co. *Portraits and Biographies of the Fire Underwriters of the City of Chicago.* Chicago: Monarch Printing and Binding, 1895.

Rubenstein, Aaron. "Devils & Pranksters: *Der Groyser Kundes* and the Lower East Side." *Pakn Treger,* no. 47 (2005).

Rubin, Rachel, and Jeffrey Melnick. *Immigration and American Popular Culture: An Introduction.* New York: New York University Press, 2007.

Sapoznick, Henry. "Broadcast Ghetto: The Image of Jews on Mainstream American Radio." *Jewish Folklore and Ethnology Review* 16, no. 1 (1994): 37–39.

Saunders, David. "Samuel Cahan." 2009. Field Guide to Wild American Pulp Artists. https://pulpartists.com/Cahan.html.

Schiff, Ellen. *Awake & Singing: Six Great American Jewish Plays.* New York: Applause Theatre & Cinema Books, 2004.

Schuddeboom, Bas. "Katherine P Rice." April 21, 2020. Lambiek Comiclopedia. https://www.lambiek.net/artists/r/rice_katharine_p.htm.

Shandler, Jeffrey. "What Is American Jewish Culture?" In *The Columbia History of Jews and Judaism in America,* edited by Marc Lee Raphael, 337–365. New York: Columbia University Press, 2008.

Sholem Aleichem (Solomon Rabinovich). *The Letters of Menakhem-Mendl* and *Sheyne-Sheyndl* and *Motl, the Cantor's Son.* Translated by Hillel Halkin. New Haven, CT: Yale University Press, 2002.

Spalding, Henry D. *Encyclopedia of Jewish Humor: From Biblical Times to the Modern Age.* New York: Jonathan David, 1979.

Stein, Daniel, Christina Meyer, and Micha Edlich. "Introduction: American Comic Books and Graphic Novels." *Amerikastudien/American Studies* 56, no. 4 (2011): 501–529.

Steinberg, Stephen. *The Ethnic Myth: Race, Ethnicity, and Class in America.* Boston: Beacon Press, 2001.

Sudrez-Orozco, Marcelo M. "Everything You Ever Wanted to Know about Assimilation." *Daedalus* 129, no. 4 (Fall 2000): 1–30.

Sweet, Sam. "A Boy with No Birthday Turns Sixty." *The Paris Review.* March 3, 2016. http://www.theparisreview.org/blog/2016/03/03/a-boy-with-no-birthday-turns-sixty/.

Teddy Bergman Scrapbook, 1932–1935. Alan Reed Collection, UCLA Library Special Collections.

Tevis, Britt. "'Jews Not Admitted': Anti-Semitism, Civil Rights, and Public Accommodation Laws." *The Journal of American History* 107, no. 4 (March 2021): 847–870.

"Theatre." *The Encyclopedia of Melbourne Online.* 2008. http://www.emelbourne.net.au/biogs/EM01486b.htm.

Trachtenberg, Alan. *The Incorporation of America: Culture and Society in the Gilded Age.* New York: Hill and Wang, 2007.

Waugh, Coulton. *The Comics.* New York: Macmillan, 1947.

Weinberg, Daniel E. "The Ethnic Technician and the Foreign-Born: Another Look at Americanization Ideology and Goals." *Societas: A Review of Social History* 7, no. 3 (Summer 1977): 209–227.

Weinreich, Uriel. *Languages in Contact: Findings and Problems.* The Hague, Netherlands: Mouton, 1968.

What's in The New York Evening Journal. New York: New York Evening Journal, 1928.

Winsor McCay: Early Works. Miamisburg, OH: Checker Book Publishing Group, 2003.

Yoe, Craig. *The Complete Milt Gross Comic Books and Life Story.* San Diego: IDW Books, 2009.

Young, William Henry. "Images of Order: American Comic Strips During the Depression, 1929–1938." PhD diss., Emory University, 1969.

Zangwill, Israel. *Children of the Ghetto: Being Pictures of a Peculiar People.* Philadelphia: Jewish Publication Society, 1892.

Zemeckis, Leslie. *Behind the Burley Q: The Story of Burlesque in America.* New York: Skyhorse, 2013.

Ziv, Avner. "Psycho-Social Aspects of Jewish Humor in Israel and in the Diaspora." In *Jewish Humor,* edited by Avner Ziv, 47–71. Tel Aviv: Papyrus, 1986.

Index

Abbot and Costello, 79
Abie the Agent: characters of, 4, 10, 69–93, 97–110, 115–131, 137; and city life, 120–124; creation of, 1, 4, 10, 68–76; influence of, 8–11, 132; influences on, 10–11, 71–74, 79, 136–137; and Jewish depiction, 8, 70–82, 89–92, 99, 104–109, 118, 127–134; and Jewish viewpoint, 8; longevity of, 1, 4, 59, 62, 75; marketing of, 91–92; naming of, 75–76, 120; and politics, 110–117; popularity of, 4, 62, 91, 133; reception of, 11, 74; and religion, 120–122, 125, 126; and socio-economic status, 88–94, 103, 120–123, 129–135
acculturation. *See* assimilation
Adler, Cyrus, 114
African Americans. *See* Black Americans
Africans, 67–68, 87. *See also* Black Americans; race
Albee, Edward, 54
alcohol, 7, 107, 122, 159n9. *See also* food and drink culture
Aldrich, Thomas Bailey, 5
Aleichem, Sholem, 72
American Federation of Labor (AFL), 6. *See also* class/labor
American frontier, 9
American Hebrew, 46
American identity, 1, 7, 24–25, 42, 105–106, 114–121, 124–137. *See also* assimilation; nativism
American Jewish Committee (AJC), 49
American Revolution, 116
Anarchist Exclusion Act, 6
anarchy, 6, 9

Ancient Order: of Hibernians, 47
Anglo-Saxons, 5–7, 17, 30, 99–109, 126–128, 133
Anti-Defamation League (ADL), 53–60, 62, 74, 135
anti-Semitism, 10, 20, 22, 51, 54, 129, 133–134
Anti Stage-Jew Ridicule Committee, 54–55, 126, 135
Asian Americans, 28; and Chinese, 3, 8, 17, 22, 76, 98, 134; and Japanese, 22
assimilation, 6–15, 24–25, 35–48, 75–76, 84–89, 105–138
Auctioneer, The, 32, 41, 46, 58, 135. *See also* Warfield, David
automobile, 3, 36, 93–94

Barnett, Sam. *See* Bernard, Sam
baseball, 116
Beck, Martin, 52
Belasco, David, 32, 41, 46
Bell, Benny, 71
Berg, Gertrude, 113, 138
Bernard, Barney, 41, 53, 57
Bernard, Sam, 43
Bingham, Theodore, 29
Black Americans, 3, 8–11, 17–28, 51, 56, 92–99, 109, 133–134, 148n111. *See also* race
Block, Rudolph, 153n13. *See* Lessing, Bruno
booking agents/offices, 23, 50, 54, 56, 68
Brice, Fannie, 54, 68, 75, 138
Bringing Up Father, 4, 24, 74–78, 84–85, 91, 99–100, 109–110, 126–127. *See also* McManus, George
Brinkley Girl, 99, 102–103

Brinkley, Nell, 99, 102
Brisbane, Arthur, 68, 74
brivele, 14
Buffalo Courier, 46, 57
Burkhardt, Addison, 4
burlesque. *See* theater: burlesque
Bush, Frank, 46
Buster Brown, 76–77, 90–91. *See also* Outcault, Richard

Cahan, Abraham, 84
Cantor, Eddie, 69, 138
capitalism, 7–8, 20, 30, 89–90, 92, 108, 134–135
caricature, 16–45, 76, 89, 132–138; and combatting stereotypes, 46–62, 104, 135; definition of, 17, 141n4; history of, 17–18, 24, 138
Carlson, Wallace, 142n13
Carr, Alexander, 41, 43
Carroll, Lewis, 138
Cather, Willa, 37, 41
Catholicism, 10, 49, 51
censorship, 10, 50–62, 73–75, 96
Central Conference of American Rabbis (CCAR), 52–53, 150n40
Chaykin, Howard, 138, 159n14
Chicago Daily News, 63
Chicago, IL, 5, 46, 50–58, 63, 68–69, 74, 117
Chicago Israelite, 53
Chicago Tribune, 54
circus, 22–23, 139, 144n26
civil rights, 97
class/labor, 4–7, 13, 20, 22, 29, 111–114, 133; and strikes, 9. See also *Abie the Agent:* socio-economic status; Jews: social mobility
clowns, 24, 50, 57, 76, 107–108, 144n27, 159n14
clubs and organizations, 51–57, 108, 114, 120, 136
Cohen, Israel, 32
Columbia, 131
comedy acts, 38, 79, 81
comic strips: as artwork, 2, 76; characteristics of, 2, 76, 89–91, 111, 141n4; and ethnic stereotypes, 3, 7, 15, 24, 35, 76, 89–91, 110, 126–129, 141n13; history of, 2–3, 35, 63, 89–91, 111, 141n4; reception of, 2–3, 50
commercialism. *See* capitalism
Committee for the Protection of the Good Name of Immigrant Peoples, 54, 57
Committee for the Suppression of the Comic Supplement, 50
Comstock, Anthony, 50
Congress. *See* U.S. Congress
Conley, Jim, 97
consumer culture. *See* capitalism
Corbin, Austin, 48, 108
Cosmopolitan magazine, 35
crime, 6–7, 29–30, 49, 57
Crumb, Robert, 138
culture (term): definition/use of, 11–14
Curtis, M. B., 32

Damascus blood-libel affair, 49
Dauntless Durham of the U.S.A. See Hershfield, Harry: early works
Debs, Eugene, 111
Dellis, Jane. *See* Hershfield, Jane Dellis
democracy, 5, 107
Democratic Party (U.S.), 6, 51
Desperate Desmond. See Hershfield, Harry: early works
Dick Tracy. See Gould, Chester
Dickens, Charles, 18, 37, 105
Dillingham Commission, 6
Dirks, Rudolph, 73–74, 91, 109–110, 126, 136
disease (fear of), 10, 29
Dominic Fortune. *See* Chaykin, Howard
double consciousness, 15, 143n41
Du Bois, W.E.B., 143n41

education, 7, 88, 107, 117–118, 127
Educational Alliance, 88, 114
Eisner, Mark, 54
Eliot, Charles, 107
Epstein, Jacob, 33
Escher, M.C., 1–2
essentialism, 11–12, 70–71, 137
etiology, 7
Ettelson, Samuel A., 53
eugenics, 5, 49

Fagin. *See* Dickens, Charles
Farrell, James, 4
films, 23, 56–57, 70, 72, 74; and animation, 92; and silent films, 2, 8, 49, 55–56, 81, 103
Fisher, Bud, 4, 63, 82–83, 89, 91
food and drink culture, 12, 37, 91, 107, 120, 136–137
Ford, Henry, 93
Forvertz (Forward), 84
Frank, Leo, 30, 97
Freud, Sigmund, 70, 108
Friedman, William, 52–53

INDEX 191

Fuchs, Leo, 71
Funnyman. See Shuster, Joe; Siegel, Jerry

Gasoline Alley. See King, Frank
gender, 13, 18–19, 99–110, 130, 138. *See also* women
Germany, 113–115. *See also* immigrants: Germans; Jews: Germans
ghettos, 34, 43. *See also* New York: lower East Side
Gibson, Charles Dana, 99–100
Gibson Girl, 99–100, 103, 131
Gilded Age, 6–7
Gimpel Bainish der Shadchan. See Zagat, Samuel
Glass, Montague, 35–44, 57, 73–75, 84, 126–137, 148n107
Gogirl! See Robbins, Trina
Goldfogle, Henry, 54
Gould, Chester, 142n13
Grant, Madison, 6
Great Depression, The, 10
Great War. *See* World War I
Griffith, D. W., 57
Gross, Milt, 38, 109, 138
Guggenheim, Solomon, 54

Hairbreadth Harry. See Kahles, Charles W.
Hapgood, Hutchins, 71
Happy Hooligan, 3–4, 91–92, 136. *See also* Opper, Frederick
Harvard University, 107
Hayman, Joe, 38, 56
Hearst, William Randolph, 3–4, 21–24, 74–75, 91–92, 111, 133–135. *See also New York Evening Journal*
Hebrew. *See* language: Hebrew
hegemony, 12, 17, 128
Hendrick, Burton, 30
Hershfield, Harry, 1, 4, 10, 62, 135; biography of, 10, 63–70, 117, 120, 126, 143n31; early works, 63–70, 72–75, 86, 90, 94, 103, 111, 122; and financial success, 91–93, 126; and gender roles, 99–106, 110; and methodology, 69–80, 84–86, 90, 110, 127; and politics, 110–117; and race, 94–99, 134; and smoothing choices, 10, 45, 73–80, 87–88, 92–99, 120; and theater, 68–84, 90, 92
Hershfield, Jane Dellis, 126–127, 156n80, 158n137
Hess, Sol, 142n13
Hirsch, Emil, 126

historiography, 2–3, 17–20, 25, 49, 70–71, 134
Hogan's Alley, 3, 63, 109, 122, 141n4. *See also* Outcault, Richard
humor, definition/use of, 16–18, 22, 70–71
Hun (German), 89

immigrants, 4–10, 17–26, 88, 109, 120, 124, 132–136; and children/generations, 12–15, 26, 87–89; and Chinese, 17, 25, 76, 98; and community building, 13–14, 18, 27, 128, 136; and Germans, 4, 28, 74; and Greek, 13; and Irish, 8, 10, 28, 48–58, 74–76, 92–95, 109; and Italians, 5, 8, 13, 25, 28, 95; and Poles, 28; and Scots, 28; statistics on, 5. *See also* Jews.
immigration law, 6, 8, 10, 30, 49, 133
Immigration Restriction League, 6, 10, 88
Independent Order of B'nai B'rith (B'nai B'rith), 52–60
Industrial Commission (US), 6
industrialization, 6–7, 20
Irving, Joe, 4
isolationism, 113–114
Israel, 12, 59
Izzy the Painter, 29–30

James, Henry, 5, 14, 43
Jessel, Georgie, 69
Jessup, Stanley D., 41
Jewish-American, 14, 42–44, 105, 114–115, 136–137
Jewish Criterion (Pittsburgh), 51
Jewish Independent (Cleveland), 51–52, 74
Jewish Messenger (Chicago), 46
Jews: and children/generations, 13–19, 26, 31, 42–48, 70, 87–89, 105, 118, 128, 136; and comic voice, 70–72; and cultural identity, 8, 11–15, 32, 42–45, 88, 96, 124–128, 136–137; and Eastern Europeans, 4, 12–14, 29–49, 58, 70–73, 84–97, 113–118, 124–136; and Germans, 4, 13, 27, 42–57, 74, 88, 95–96, 108–116, 134; and Old World ties, 14–15, 33–38, 70–72, 115, 120, 124, 128, 136–137; and Orthodox, 33–35, 43, 88; and population statistics, 3, 19, 30, 70; and Russian, 30, 43–44; and Sephardic, 13; and social mobility, 10, 20, 30, 48, 50, 57, 88–94, 108, 122–130, 133–136. *See also* stereotypes
Jiggs. *See Bringing Up Father;* McManus, George
Johnson-Reed Act, 10, 22
Jones, Ada, 56
Joseph, Charles F., 51

journals, 32–33, 44, 52, 131–132. *See also* newspapers (general)
Judaism, 34, 137. *See also* religion
Judge's Library, 19, 21–22, 131

Kabibble, Abie. See *Abie the Agent:* characters of
Kahles, Charles W., 152n4
Kallen, Horace, 136
Katzenjammer Kids, 3–4, 73–74, 91, 109–110, 126, 136. *See also* Dirks, Rudolph
Keaton, Buster, 81
Kehillah. *See* New York Kehillah
Keith, B. F., 52–56, 68
King, Frank, 70, 90
Klein, Charles, 39–40, 148n107
Kraus, Adolf, 53–55

labor. *See* class/labor
Laemmle, Carl, 57
language, 3–4, 12–13, 38–44, 56, 75, 88, 104, 124, 136; and code switching, 27, 38, 86; and dialects, 25–27, 43, 54, 69, 84, 98, 134, 137–138, 144n19; and French, 44; and German, 4, 27; and Hebrew, 12, 51, 54, 73, 84; and Russian, 68; and Yiddish, 4, 12, 24–43, 60–76, 84–89, 122, 129, 138
latitudinarianism, 47
Laurel and Hardy, 79
law/legality. *See* immigration law
Lazarus, Emma, 5
League of American Pen Women, 50
legislation. *See* immigration law; U.S. Congress
Lessing, Bruno, 35, 43, 73
Levi, Simon. *See* Warfield, David
Levy, Bert, 4, 32–48, 58–62, 73, 124, 134–137
Lewis, Sam M., 75–76
Liebman, Mac, 38, 138
Life magazine, 19, 21–22, 30–31, 108–109, 131
linguistics. *See* language
literacy/literacy tests, 6, 10, 88
literature, 7, 35–36, 41, 44, 50, 91, 118, 132. *See also* Dickens, Charles; Shakespeare, William
Little Ah Sid, the Chinese Kid, 3, 76.
Little Jimmy, 90. *See also* James Swinnerton
Little Nemo in Slumberland, 63, 69, 76, 80, 90, 92, 110. *See also* Winsor McCay
lower East Side. *See* New York: lower East Side

magazines (general), 2, 19–22, 25, 30, 37
Maggie. *See* McManus, George
Marshall, Louis, 54, 97, 114
Martin and Lewis, 79
Marx Brothers, The, 4, 128
Marx, Karl, 141n1
McCay, Winsor, 63, 67–69, 76, 80, 92, 94–95, 110
McClure's Magazine, 30, 35
McManus, George, 24, 76, 78, 84–85, 91–100, 109, 127
media (general), 49
melting pot (term). *See* assimilation
Melting Pot, The, 105, 126. *See also* Israel Zangwill
Mencken, H. L., 37
Merchant of Venice. See Shakespeare, William
Mexicans, 28
Miller, Louis E., 60, 160n43
money. *See* capitalism
morality, 26
Morgen Journal, 3–4
Morris, William, 52
Mortara, Edgar, 49
muckraking journalism, 3, 7, 29–30, 49, 104
multiculturalism, 8
music, 4, 14, 23, 50, 52, 63, 67, 75, 92, 114
Mutt & Jeff, 4, 63, 82–83, 89, 152n79. *See also* Fisher, Bud

National American Woman Suffrage Association, 111
National Association for the Advancement of Colored People (NAACP), 51
National Board of Censorship of Motion Pictures, 50, 56–57
National Council of Jewish Women, 53
Native Americans, 8, 22, 68
nativism (US), 1, 5–33, 41–48, 62, 95, 103–118, 127–133, 138; rhetoric of, 5–6
New York, lower East Side, 5, 25, 30–35, 43, 71–72, 111, 122–124, 138, 142n19
New York Evening Journal, 3–4, 35, 46, 63, 68–74, 92, 99, 103, 111–112, 122
New York Kehillah, 54–55, 57
New York Morning Telegraph, 32–33
New York Society for the Suppression of Vice, 50
New York Times, 32, 55, 125
newspapers (general), 2–3, 7–8, 21–23, 46–55, 84, 111, 131–133
North American Review, 29
novels. *See* literature

INDEX

O'Shaughnessy, James, 53
Ochs, Adolf, 55
Ohio (U.S. state), 51, 53, 74
Old Doc Yak, 89
Oliver Twist. See Dickens, Charles
Opper, Frederick, 21, 63, 92
Osherman, Mollie, 53, 126
Outcault, Richard, 63, 76–78, 90–91, 109, 122

Pam, Hugo, 50, 53
Pantages, Alex, 52
passing (as white), 44, 96–99, 135, 148n111.
 See also race
Patterson, Mary Caroline, 44
Peters, Madison C., 47
philosophy, 117
phonograph records, 4, 9, 23–25, 49, 55–58,
 70–75, 92–94, 115, 132
Plastrick, Samuel. See *Sam'l of Posen*
pogroms, 14, 97
political activism, 9, 46–62, 111
political cartoons, 3, 111
political radicalism (fear of), 10
Pollock, Henry, 54
Potash and Perlmutter, 4, 35–43, 53, 57, 73,
 84, 126, 133–137. *See also* Glass, Montague;
 Irving, Joe
poverty, 7, 122. *See also* class/labor;
 ghettos; Jews: social mobility
print culture, 29–30. *See also* magazines
 (general); newspapers (general)
print technology, 3
Progressive Era, 6–10, 49–50, 53, 142n23
Progressives, 7, 13, 30, 54, 56, 108, 113
Prohibition, 10
Puck, 19–21, 131
Pulitzer, Joseph, 3, 133

race, 5–7, 11–22, 44, 67–68, 94–99, 108, 115,
 134. *See also* Black Americans
radio, 10, 23, 113, 137
railroads, 9, 22, 49
Reba. See *Abie the Agent:* characters of
Reconstruction era (U.S.), 95
refugees, 115
religion, 12–13, 34–35, 47–53, 96, 120–126
Republican Party (U.S.), 6
Rigby, Clarence, 76
Riis, Jacob, 23, 43, 122
Robbins, Trina, 138
Roosevelt, Theodore, 7, 9, 106, 109, 111, 114
Rose, Julian, 56–57
Rosenfeld, Morris, 114
Rosenthal, Herman, 29–30, 49

Ross, Edward, 30
Ross, Leonard, 38
Roth, Philip, 91
Russell, Lillian, 23
Russia, 14, 97, 113–115. *See also* Jews: Russia

Sabath, Adolph, 53
Sam'l of Posen, 32, 46
Samuels and Sylenz (1915). *See* Bert Levy
Saturday Evening Post, 37–40
Schanfarber, Tobias, 46, 53
Schiff, Jacob, 54, 74, 114, 126
science/pseudoscience, 9, 49, 104
Seligman, Joseph, 48, 108
settlement houses, 7
sexual activity/deviance, 29–30, 37, 50, 84,
 105–107
Shakespeare, William, 15, 18, 51–52, 103
Shubert, J. J., 52–54, 56
Shuster, Joe, 141n13, 159n14
Shylock. *See* Shakespeare, William
Siegel, Jerry, 141n13, 159n14
Silverman, Joseph, 46, 52–54
Simmons, Morris, 54
slavery, 8, 29, 95
Smith, Joe, 72
Smith, Sidney, 89–90
smoothing efforts (general), 16–17, 32–33,
 89–90, 96, 104, 120, 132–138; reasons for,
 42–45
social Darwinism, 5
social mobility. *See* Jews: social mobility
socialism. *See* class/labor
Solomon, Hannah Greenebaum, 53
Spanish-American War (1898), 9, 106, 112
Sparkbaum, Bennie. See *Abie the Agent:*
 characters of
Spencer, Len, 56
Spiegelman, Art, 138
sports, 116, 129–131
Statue of Liberty, 5
stereotypes, 17, 31, 45–56, 75–76, 84–94,
 104, 136–138
Stolz, Joseph, 53
Straus, Nathan, 54, 74, 126
Strellinger, Maurice Betrand. *See* Curtis,
 M. B.
suburbs, 10, 90
Sulzberger, Felix, 54
Swerling, Jo, 4
Swinnerton, James, 76

Taft, Howard, 111
Tanguay, Eva, 54

technology, 3, 9, 35, 74, 93–94
television, 10, 72, 113, 137
theater, 2, 7, 15, 26, 32–33, 41–62, 68–69, 132–138; and Broadway, 39–41, 43, 53, 73, 133; and burlesque, 16–18, 37, 47, 73, 79; and costuming, 18, 24–42, 46, 68, 76, 138, 159n14; and nickelodeon, 8; and redface, 68; and slapstick, 24, 37, 81; and vaudeville, 3, 7, 22–59, 67–90, 97–98, 104, 109, 133–137
Triangle Shirtwaist Company fire, 111
Turks, 28
Turner, George Kibbe, 29
Twain, Mark, 128

unions. *See* class/labor
urbanization (general), 8–9, 18, 20, 22, 29, 88–90, 122–125, 137
U.S. Civil War, 17
U.S. Congress, 6, 49, 54, 111

Variety magazine, 52
vaudeville. *See* theater: vaudeville
Victorianism, 9, 50

Walker, Jimmy, 70
war. *See* American Revolution; U.S. Civil War; World War I; World War II

Warburg, Felix, 54
Warfield, David, 32, 42–46, 58, 73, 134–135
Weber and Fields, 38, 79
Weidenthal, Maurice, 51–54, 74
Welch, Joe, 51
Willard, Archibald, 116
Williams, Percy, 52
Wilson, Woodrow, 111, 113
Wise, Stephen S., 114
women, 8, 19, 29–31, 53–54, 84, 99–111, 130–138, 162n93
World War I, 9, 14, 21, 58, 89, 105, 112–116, 161n60
World War II, 10

xenophobia. *See* nativism (U.S.)

yellow journalism, 3. *See also* muckraking journalism
Yiddish. *See* language: Yiddish

Zagat, Samuel, 4, 60–62, 73, 84–88, 94, 112–113, 120, 129–130, 136
Zamberg, Benjamin. *See* Bell, Benny
Zangwill, Israel, 34, 126
Ziegfeld Follies, 75, 158n137
Zionism, 113, 115–116
Zunser, Eliakum, 71

About the Author

Jeffrey A. Marx is an independent scholar, rabbi emeritus of the Santa Monica Synagogue in Los Angeles, and former visiting lecturer at Hebrew Union College–Jewish Institute of Religion. His publications appear in scholarly journals and in popular media on topics ranging from Jewish studies to New York culture.